ART ON TRIAL

DAVID E. GUSSAK

ART ON TRIAL

Art Therapy in Capital Murder Cases

COLUMBIA UNIVERSITY PRESS NEW YORK

Columbia University Press
Publishers Since 1893
New York Chichester, West Sussex
cup.columbia.edu
Copyright © 2013 Columbia University Press
Paperback edition, 2015
All rights reserved

Library of Congress Cataloging-in-Publication Data
Gussak, David E.
Art on trial : art therapy in capital murder cases / David E. Gussak.
pages cm
Includes bibliographical references.
ISBN 978-0-231-16250-0 (cloth : alk. paper)
ISBN 978-0-231-16251-7 (pbk. : alk. paper)
ISBN 978-0-231-53427-7 (e-book)
1. Art therapy. 2. Prisoners—Mental health services.
3. Therapeutic communities. I. Title.
RC489.A7G87 2013
616.89'1656—dc23

2012038918

Columbia University Press books are printed on permanent
and durable acid-free paper.
Printed in the United States of America

c 10 9 8 7 6 5 4 3 2
p 10 9 8 7 6 5 4 3 2 1

Cover image: "Kevin Ward"
Cover design: Lisa Hamm

References to Web sites (URLs) were accurate at the time of writing.
Neither the author nor Columbia University Press is responsible for URLs
that may have expired or changed since the manuscript was prepared.

CONTENTS

Preface vii
Acknowledgments xv

Introduction: Assessments, Art Therapy, and Forensics 1

PART I. ART AND THE MURDERER: A CASE STUDY

1 How It Began 23

2 The Jailhouse Meeting 47

3 More Art and the Follow-up 65

PART II. DEFENDING THE ART

4 The Deposition 77

5 The Testimony 95

PART III. ANALYSIS AND IMPLICATIONS

6 The Case Study: Summary, Reflections, and Ethics 127

7 Art Therapists as Expert Witnesses: Three More Capital Cases 147

8 Forensic Art Therapy Revisited 175

References 183
Figures follow page 94

PREFACE

rt on Trial is about the crossroads of art therapy, criminology, and assessments and the involvement of art therapists in capital murder trials. Until now, there have been a few publications available about forensic art therapy that focus on work with children and families, exclusively in abuse or custodial cases. One area of the field that has never been addressed is the role that an art therapist can serve in criminal and capital murder trials. The impetus for this examination emerged from a professional experience.

THE IMPETUS

In the fall of 2006, I was contacted by a defense attorney in a state other than the one in which I live. She inquired if I could provide expert witness testimony on art created by a man, Kevin Ward,* who was going to be tried for murder and attempted murder and for whom the prosecution was seeking the death penalty. I was contracted by the defense to testify that the large amount of art he had produced before, immediately after, and for several years following the crimes supported the claim that he was mentally ill when he committed the murder. The defense intended to use this strategy to prevent the state from putting the defendant to death.

One of the aims of this book is to explore how the defendant's art was used as evidence to help the defense determine if, indeed, he had suffered from mental illness at the time of the crimes. That he had committed

*With the exception of the three art therapists whose work is discussed in chapter 7, the names of all those connected with legal cases have been changed throughout this book.

these acts was never refuted. It was the mental status of Kevin Ward at the time of the crimes that was in question. This was why I was called in.

The case never went to trial as the result of a plea bargain, in which Ward pleaded guilty in exchange for an agreement that he would not be executed. So the case culminated in a sentencing hearing in the summer of 2009 to determine the length of his incarceration. I was still expected to provide evidence, based on the content of his excessive creative output, that indicated he had a mental illness, in the hope of convincing the judge to impose a sentence of less than life. Despite the long prison term the defendant received—95 years: 60 years for the murder of his elder child, and 35 years for the attempted murder of his younger child—the judge indicated that he did indeed suffer from a mental illness, based on the testimony of the expert witnesses given during the sentencing hearing.

This case has since been presented at various conferences and seminars. As expected, depending on the audience, questions and interest varied—however, all the attendees have been fascinated by the case itself, the role of the art therapist, the legal procedures, and, of course, the art and the way its assessment supported the defense. Eventually, it became clear that the experience and outcome could be written as a journal article or book chapter. Many—art therapists and non-art therapists alike—encouraged the reporting of the case as they heard about the details of the proceedings.

Interestingly, the prosecuting attorney supported the recording and publishing of the case. During the deposition, which is presented in chapter 4, the prosecutor and I half-jokingly talked about the work in this case eventually being published:

WILLIAMS: *Have you published anything out of your work in this case at all at this point?*

GUSSAK: *In this case?*

WILLIAMS: *Yes.*

GUSSAK: *No.*

WILLIAMS: *Well, when can we look forward to that?*

GUSSAK: *I'll let you know.* (Laughter)

When I contacted the prosecutor by e-mail 2 years later for an interview for this project, he answered, "I did joke with you on the publication [of this case], but because of the newness of this application of your area of expertise, I fully expected it to happen. I am glad to hear that you are moving forward in this area."

As writing about the experience advanced, and as the comprehensive assessment of nearly 100 images was recorded, the focus of the project changed. There was too much information to be included in a chapter or an article. A colleague recommended that the account of the case would best be presented as a book.

As the case progressed, I underwent an interesting and intense form of doubt and reevaluation. After the attorneys agreed on a plea bargain, thereby avoiding a trial, I selfishly questioned the dramatic effect of such a publication. If there was no risk of the death penalty, what would be the point of offering this account? At this time, the focus of the intent of this publication began to solidify. Was this to be a book about the case, demonstrating a John Grisham–like dramatic tension, or was it about the value of art therapy in a court of law: the worth placed on such testimony and the detailed steps and copious information provided to demonstrate its effectiveness as evidence? What soon emerged was that despite its lack of drama and intrigue, this book was completed *because* of its nuance. This underscored what it would be about—not the defendant, but the art that was put on trial. Therefore, the structure of this book has been developed to provide an overview of art therapy and its application to the fields of forensics and psychology, a comprehensive and detailed description and assessment of the art presented during the hearing, and the particulars of its defense in court.

THE STRUCTURE OF THE BOOK

Following the introduction, this book is divided into three distinct parts:

- Part I A comprehensive overview of the art in one case study and the final, conclusive assessment that emerged
- Part II A defense of the art assessment
- Part III An analysis and the implications of the case

The introduction provides the information necessary for those in the art therapy field to understand the legal and forensic context in which this art therapist found himself, and for those in the legal, forensic, criminology, and counseling fields to understand art therapy and art-based projective assessments. It offers an overview of art therapy, projective assessments, the tools used by art therapists to elicit information about their clients, and the distinct description and role of the forensic art therapist. Following is a brief exploration of the status criteria for expert witnesses. This chapter is crucial, since art therapy continues to be used in other professional arenas. All parties must develop a shared language and understanding in order to work cohesively.

PART I: ART AND THE MURDERER: A CASE STUDY

Chapter 1 outlines the development of the case, explains why an art therapist was approached to provide testimony, and offers a comprehensive evaluation of all the art pieces provided by the defense attorney. The chapter ends with a description of the defendant and his crime.

The first meeting with the defendant is presented in chapter 2. His reasons for creating each piece of art are explored, allowing for a clear image of his mental illness as displayed in his behavior and allusions. A conclusive assessment is developed and presented to the defense counsel at the end of this chapter. However, after the discovery of additional art pieces, the assessment continues in the following chapter.

Chapter 3 describes a follow-up meeting with the defendant for a comprehensive review of the additional pieces of art. At the end of this chapter, the final assessment is clarified, solidified, and provided to the defense. The next step is to defend the art in a court of law.

PART II: DEFENDING THE ART

Chapter 4 presents the deposition conducted by the prosecutor, and chapter 5 provides the testimony given in the final sentencing hearing. Both chapters include sections of the transcripts of these two proceedings. While appearing at times redundant and divergent of focus, this approach is necessary for two reasons. The extracts from the transcripts clarify how the art was introduced to the prosecution and the courts, and how those outside the field viewed the presentation and assessments of the art. It also

provides a detailed unfolding of the procedures that an art therapist testifying in such court proceedings may experience and the challenges and pitfalls that may develop.

PART III: ANALYSIS AND IMPLICATIONS

A summation of the book and the case appears in chapter 6, providing an evaluation of the legal process, an explanation of the approaches used to assess the defendant, and a brief discussion of the strengths and challenges of using art therapy in such a context. It also explores the ethical and moral ramifications that an art therapist may face in a similar situation.

Chapter 7 provides additional information on the roles that an art therapist may play in capital murder cases through a comprehensive overview of three other cases. In contributing to the defense of people accused of murder, the therapists provided support in varying capacities, which are illuminated in this chapter. By examining transcripts, court and personal documents, and communications with these three art therapists, the various roles an art therapist may play in capital criminal cases emerged.

Finally, chapter 8 offers an overall assessment of the ways in which these particular cases informed and expanded our knowledge about the field of forensic art therapy.

∷ ∷ ∷

The events surrounding the case and the testimony and reactions of an art therapist testifying as an expert witness in a legal proceeding are provided throughout this book, which includes reproductions of many of the art pieces that were used to assess the client and were presented in court. The chapters pertaining to the case include both my personal recollections and information obtained from transcriptions of the proceedings, and interviews with various key participants: the defense attorneys who hired me to provide testimony; the prosecutor; and the judge, who, while sentencing Ward to a lengthy prison term, provided clearance for me to testify and, in turn, validated the procedure of art therapy for a capital murder trial.

WHY A SINGLE-CASE FOCUS?

While this book is not a research study per se, elements of research epistemology and methodology are included to address the overriding questions of the way in which art was used in the defense's presentation of the client's psychological state and the role of an art therapist in a death row case. Despite the intention to write a scholarly and academic treatise on the assessability of art for evidence in a court of law, some of what is included here is presented as a personal narrative. Although this contradicts my own academic perspective of how "scholarly" work should be conducted, what became clear was that the best manner in which to present this information was to report certain experiences as a first-person account.

This book uses personal experiences as data to help inform other art therapists about what they may experience as potential expert witnesses in a capital case and to educate the legal, criminology, and forensic professions on how to use art therapy services as unique evidentiary opportunities. This project also relied on interviews, case vignettes of other art therapists' experiences in capital trials, and content analysis and review of various transcripts. Ultimately, the findings are presented as an in-depth case study.

A case study, simply put, is a form of research, usually qualitative, "in which a single individual, group, or important example is studied extensively and varied data are collected and used to formulate interpretations applicable to the specific case . . . or to provide useful generalizations" (Fraenkel & Wallen, 2009, p. 13). Many early art therapy publications relied on case studies and presentations to investigate the role and effectiveness of art therapy in many different settings, with various clinical and medical populations. In these instances, as Kapitan (2010) pointed out, the researcher was "interested in discovering what can be learned from a particular encounter or encounters in the field that have bearing on art therapy practice" (p. 103). Often questioned for their validity as a form of scientific inquiry, case studies can be an effective means of investigation, provided that the focus is on people and their interactions (Gordon & Shontz, 1990; Kapitan, 2010).

Research in the field has since evolved to include many methodological approaches. Much of my recent work addresses art therapy in correctional settings through rigorous quantitative inquiry. However, this book relies

on a qualitative approach. Similar to what Stake (2000) termed an intrinsic case study approach, this case was predetermined; therefore, without choosing this particular situation, what could be learned from it? The desire for deeper inquiry arose during the process, and it became clear that information could be gleaned from this single event that could then be provided to those "who share commonalities of experience" (Kapitan, 2010, p. 103). The purpose of this approach was to learn something important from a singular experience. That is precisely what evolved—this event has yielded a great deal of information, which, in turn, can be communicated to a number of people who may benefit.

This book has one unique feature. Many books and articles present methods of conducting art-based assessments. Some cover single types of assessment procedures, with illustrations from various participants that support the theories (e.g., Cohen, 1985; Levick, 2001). Others provide collections of a variety of art-based assessment procedures (e.g., Brooke, 2004; Feder & Feder, 1998). Through clear, pragmatic descriptions, this book applies art-based assessment to various art pieces created by one person. As the assessment for each art piece unfolds, so does the story.

IN SUM . . .

Many art therapy texts, including mine on art therapy in prisons (Gussak & Virshup, 1997), try to address the breadth of a particular niche of the field by introducing many cases by many art therapists who have had many different experiences, to provide a comprehensive overview. This book is different. By offering a variety of case vignettes, focusing on one particular experience, introducing and examining a great many art pieces, and presenting details of the numerous steps taken over a long period of time, this book attempts to provide a depth of information that, in turn, educates professionals in several fields. The art and how it was put on trial remains the focus. This book is about the art therapists who have to learn how to prepare their case and defend it. It is about all the mistakes that can be made along the way, the ethical ramifications, and ultimately the validation of art as an evidentiary tool. It is about the pragmatic application of theoretical and empirical understanding of formal art elements to real-world experiences.

While the details of the cases discussed may be fascinating, they are secondary to the true nature of this book. The presentation of the legal proceedings is necessary to provide context, but the focus of this book is how the art was used as evidence to support the defense's claim of mental illness. I would be remiss, however, if I did not end this preface without underscoring that this book recounts true stories about horrific incidences, in which there were innocent victims. Despite the intent of *Art on Trial*, and the tone of the conclusions presented, there were no winners.

ACKNOWLEDGMENTS

Many people have contributed a great deal to this project. Although a simple mention in this acknowledgments does not do justice to their invaluable contributions, I hope they accept this in the spirit in which it is intended.

To begin, I would like to thank those who contracted for my services to participate in this forensic process: the members of the defense team. All of them took a chance in bringing art therapy into their defense, and they trusted me with helping their cause. Even after the hearing was over, and their work with the defendant was complete, they were willing to help me, making themselves available for interviews and providing missing information and details. The lead attorney—who in this book is referred to as Jackie Chief—was especially helpful, allowing me to call at any time whenever I needed information or advice. Although all the defense attorneys must remain nameless, they know who they are, and I hope they realize the importance of their contribution.

As well, the chief deputy prosecutor, who worked hard to disprove my worth in public, and the judge who presided over the case were extremely helpful in making themselves available. They, too, must unfortunately remain anonymous, but without their perspectives, feedback, and support, I would have been able to tell only half a story.

I even appreciate the defendant, his horrific deeds aside, for allowing me to use his art and his case to demonstrate the value of art therapy in the legal arena.

Three major contributors to the field of art therapy, all pioneers—Myra Levick, Maxine Junge, and Sandra Kagin Graves—were extremely generous with their time, their files, and their support. I spent many

hours on the phone with them, and they provided me with extremely rich information. They entrusted me with their stories, and I hope they feel that I did them justice. I do not think it is too much of an exaggeration to say that without their allowing me to tell their stories, I would not have been able to tell mine.

I would also like to thank Marcia Sue Cohen-Liebman, who I consider—and I believe the field would concur—to be the leading authority in the field of forensic art therapy. She was always available when I needed help in untangling various ideas and was a wonderful sounding board as I worked through the manuscript. Her work paved the way for this book to be written. I look forward to continuing our work together as our paths continue to intersect.

Many people from Florida State University deserve my thanks and gratitude, including the faculty of the Department of Art Education, Dean Sally McRorie, my students, and the department staff; all were encouraging and helpful. In particular, Marcia Rosal, art therapist extraordinaire, was always available to provide much needed insight and suggestions; her support for this project was bottomless. Marc Gertz, professor of criminology, deserves a great deal of credit for this project; his patience with my requests for information and feedback was endless. My close friend and colleague Stephen Pfeiffer, professor of counseling psychology, offered much advice on our weekly lengthy bike rides; I owe him for much of this book's success. Thank you.

In my personal arena, I wish to thank my mother-in-law, Nikki LoRe. When I needed a pair of eyes that were not those of an art therapist, a lawyer, or a criminologist to provide much needed feedback about the clarity of the book to those outside the aforementioned fields, she did not hesitate to read the entire draft. She provided me with extremely helpful notes on what could be done to make this a better text. And if your mother-in-law can't be brutally honest, who can be?

My wife, Laurie LoRe Gussak, deserves my undying appreciation and love. Not only did she relentlessly support this project and have to listen to my insecurities and concerns as it began to take shape, but she tirelessly reviewed the manuscript—not only the complete draft, but many of the chapters along the way. Her feedback was direct, clear, and at times frustrating; but without a doubt, this book is better because of her.

I wish to convey my abiding gratitude and regard for someone who worked with me on this from the very beginning—my graduate assistant

Nicole Hoffman. She was brought on board to be my graduate research assistant right around the time that I began to write the first draft of the manuscript. She graduated 3 months after I finished the final draft. In between, she was tireless in her research, editing, formatting, and overall help in completing this project. No duty was too menial; no reread, too long. Her help was invaluable and her feedback priceless. She will go on to become an extraordinary art therapist and, based on her help with this book, writer as well. I am extremely grateful to her for all her work—this book has become hers as much as mine.

This acknowledgment section is not complete without thanking the great people at Columbia University Press, especially my editor, Jennifer Perillo, for their vision, dedication, and support for this project. Without Jennifer's amazing attention, this book would never have been published. The fact that she is also a warm and generous person was just a bonus. I owe the entire team my undying appreciation.

Most acknowledgments conclude with the obligatory thanks to all the countless people who have helped make a book a reality but remain unnamed because of space and time constraints, and this one is no different. However, I truly am thankful to all of them, and to thank them all would . . . well . . . require another book.

ART ON TRIAL

INTRODUCTION
Assessments, Art Therapy, and Forensics

- A man kidnapped, beat, raped, and killed three women in the Midwest over a 3-year period in the 1980s. A fourth would-be victim escaped. The defendant, Benjamin Stevens,* was convicted of three counts of murder and four counts of rape. His prison term has since been commuted to six consecutive life sentences.
- In the early 1980s, a jury in the Midwest convicted Randy Thomas of having murdered two people. Originally sentenced to death, he appealed and his conviction was commuted.
- In the early 1990s, three people were shot to death at a convenience store; exactly one week later, three more were killed at a nearby pizza parlor. Edward Ronalds was tried and convicted of all six murders. He remains on death row.
- Kevin Ward murdered his elder child and attempted to murder his younger. He was sentenced in 2009 for these crimes. Although the prosecution originally sought the death penalty, ultimately Ward was sentenced to a prison term of 95 years.

Although very different cases in four separate states, the defendants had one thing in common—art therapists served on their defense teams. The final case became the impetus for this book.

Art therapists have provided forensic support and expert testimony in court hearings (Cohen-Liebman, 2003; Gussak & Cohen-Liebman,

*With the exception of the three art therapists whose work is discussed in chapter 7, the names of all those connected with legal cases have been changed throughout this book.

2001; Safran, Levick, & Levine, 1990). However, they generally have been involved in family, custody, and child abuse cases (Cohen-Liebman, 1994, 1999; Lyons, 1993). Before now, there has been no literature on art therapists testifying in capital criminal proceedings. This book is the first detailed examination of the role of the art therapist in capital murder cases.

Although the majority of readers of this book may be art therapists, it is anticipated that professionals in other fields—criminology, psychology, law, and counseling—can benefit from learning how art therapy intersects with their concerns. Therefore, this chapter begins with an examination of art therapy, a summation of art-based assessments, and an overview of forensic art therapy. For the art therapist not knowledgeable about legal criteria for expert witness testimony, an overview of legal principles and standards follows, specifically referencing the *Frye* and *Daubert* rules, the statutes used to determine who can qualify as an expert witness and how, and the types of court proceedings, key concepts, and personnel as they relate to criminal cases.

A BRIEF OVERVIEW OF ART THERAPY

Many people may believe that an art therapist can "interpret" a person's drawings and, by merely looking at an art piece, can understand the inner workings of the artist with little additional information. It's not quite that easy. An art therapist can certainly assess a person using his or her art to provide some information, but can never "read" an art piece. Assessing an art product to help provide some insight into a person's issues and traits is just one part of the many responsibilities and tools that an art therapist can use to aid a person therapeutically.

The American Art Therapy Association's Web site defines art therapy as

> a mental health profession that uses the creative process of art making to improve and enhance the physical, mental and emotional well-being of individuals of all ages. It is based on the belief that the creative process involved in artistic self-expression helps people to resolve conflicts and problems, develop interpersonal skills, manage behavior, reduce stress, increase self-esteem and self-awareness, and achieve insight. (http://www.arttherapy.org)

Complicated in breadth, depth, and scope, art therapy spans the continuum between two diverse points: art as therapy, focusing on the process of art making, and art psychotherapy, focusing on the finished product (Kramer, 1993; Naumburg, 1958; Ulman, 1992). How art therapy is used depends on the setting and the clinician's theoretical orientation. While some art therapists may champion the notion that the end product can be used as a catalyst for exploring issues and defenses, others may underscore that it is the process of art making that is therapeutic. Some rely on the synthesis of the two (Ulman, 1992).

In 1961, Ulman (1992) first proposed that a synthesis was necessary to reconcile the perceptions that art is separate from therapy and the process of art making is separate from the product: "Communication and insight may take priority over development of art expression. On the other hand, when no fruitful consolidation of insight can be foreseen, the exposure of conflicts may be deliberately avoided in favor of artistic achievement. But anything that is to be called art therapy must genuinely partake of art and therapy" (p. 74). Along this continuum exists the understanding that art making can be both therapeutic and informative. With a full understanding of the characteristics of art materials and the degree of structure within an art directive (Lusebrink, 1990), an art therapist can use the art-making process to facilitate expression, catharsis, and sublimation of aggressive and libidinal impulses (Kramer, 1993). Art making also has the potential to enhance problem solving and self-awareness, and can assist in improving mood and locus of control (Gussak, 2006, 2009). The act of art making can validate an individual's sense of self-worth (Garai, 2001) or can aide a client in gaining control over anxiety through centering or grounding (Fincher, 1991; Rhyne, 1973/1996). In many cases, the art-making process can provide therapeutic change without the need for verbal interaction (Gussak, 1997a).

At the same time, with varying degrees of effectiveness, reflecting on a completed piece can be a catalyst for the artist to uncover subconscious or unconscious thoughts and beliefs, very similar to what dream analysis was to Freud (1965; Naumburg, 1966/1987). The final piece can also serve as a transitional object used by the client or patient to move from dependence to a healthy individuation process (Robbins, 2001) and may be used to facilitate communication and increase the sense of self-worth. The finished product created throughout a series of sessions can also provide a permanent record that can be used for reflection and as a map of

progress. And, indeed, it is also possible to utilize the finished art piece for assessable data on the artist/client.

THE HISTORY AND USE OF ART-BASED ASSESSMENTS*

Imagine three people lying on their backs on a grassy hill and looking at clouds in the sky. One person, on noticing one of the clouds, says, "I see a dog"; the second says, "I see a cow"; the third says, "I see the signing of the Treaty of Versailles." Each person has projected meaning onto the cluster of ambiguous shapes that are in the sky. Others may use a particular response to understand something about the person who made it. Evaluating what the person is like based on his interpretation is truly a simple projective assessment procedure.

Now, imagine that you prompt someone to create a cloud and that you ask what it means to her and what it may indicate. Perhaps you can even learn about the person based on the way she made the cloud, through the materials she used and the investment she has in this cloud making. This is essentially what art therapists do when they ask their clients to make artwork They are assessing the clients' choice of materials, the manner in which they create the art pieces, and the final pieces themselves. Add to this another dimension of what the clients say their pieces mean to them—and this is very important in validating the clients, by having them involved in the process—and the result is a very complicated process that has its share of pros and cons. This begins to illustrate the complicated notion of projective testing and assessments for the art therapist.

PSYCHOLOGY-BASED PROJECTIVE ASSESSMENTS

In projective testing or assessments, the person being assessed projects meaning, emotion, and value onto a neutral image or prompt. A person may be assessed by how he responds to ambiguous images. One example of such a procedure is the *Thematic Apperception Test* (TAT). A client is shown 8 to 12 cards from a total of 20 that depict a variety of images and scenes. After the client looks at the ambiguous scene, he is asked

*This section is adapted from a paper presented as the keynote address at the conference of the Korean Art Therapy Association in the fall of 2009 (Gussak, 2009).

to tell a story about the image—what is happening in the scene, what took place immediately before, and what will occur after. The assessor looks for themes that emerge from the person's responses and, based on the standardized procedure, can determine information about the client's characteristics (Bellak & Abrams, 1997).

Although not art based, such procedures provide the art therapist with tools with which to better assess a client by looking for patterns and themes that she may project onto the images that others create. An art therapist takes this skill one step beyond: the client is asked to create her own scene and tell a story about it. With the right dialogue, the therapist can understand the client's cognitive and personality characteristics. The very nature of the projective assessment, however, relies on the individual and her personal reflections; such open-ended responses stress the notion that there are as many responses as there are people.

Early projective drawings, the projective assessment procedures associated with art-based and art therapy assessments, were developed by psychologists, not art therapists. They include Florence Goodenough's *Draw a Man*, Karen Machover's *Draw a Person*, and John Buck's *House-Tree-Person*. Later, other drawing assessments were added, including *Draw a Family*. Each requires a simple drawing procedure, using a pencil on an 8½ × 11 inch sheet of white paper, and the participant is given simple directions, as the name of each test implies. Some of them may involve a series of drawings, such as Draw a Person (three drawings: a person, a person of the opposite sex, and yourself) (Harris, 1963) and House-Tree-Person (three drawings: a house, a tree, and a person) (Groth-Marnat, 1997). These assessments, established to evaluate cognitive functioning and personality traits, have evolved over the years. Some, such as *Chromatic House-Tree-Person* (Buck & Hammer, 1969), have included color because it was believed that color choice indicates personality traits or current emotional states.

Some techniques have added new dimensions to invoke further personal meaning, such as *Kinetic Family Drawings* (Burns & Kaufman, 1970), in which a participant is asked to draw a picture of his family doing something, thus revealing how he views the dynamics and significance of the family members' interactions. For *Kinetic-House-Tree-Person* (Burns, 1987), a participant is asked to draw a house, a tree, and a person—all on the same page—with the person doing something. What the figure is doing and how the three items relate to one another are supposed to

indicate how the client interacts with others, her relationships, and her cognitive processing.

What also emerged with these early drawing assessments was the significance of the "formal elements" of a drawing—that is, *how* the drawing was done, not the symbolic content. The way in which the lines are drawn is considered just as important as the scene they create: a shaky or sketchy line quality may indicate anxiety; dense, pressured lines may signal frustration or aggression; faintly drawn lines may evince loss of energy and/or feeling melancholy.

The amount of space used on the page may also be meaningful. The smaller the image or figures and the greater the space left on the page, the more likely the person is depressed, sad, un-invested, or just plain lazy. Once color was introduced, it added a whole new dimension; some believe that the combination of black and red may indicate aggression and anger, whereas replacing red with pink may suggest suicidality. However, no such conclusions have been supported. What is more significant is the number of colors (color prominence) and the proper application of colors for accurate representation (color fit). The *Bender-Gestalt* drawing procedure (in which the participant actually copies images from cards onto a sheet) uses a range of 12 indicators reflecting the formal elements of how consistently shapes and lines are copied to determine possible organic disabilities, such as Dementia (Lacks, 1984).

FROM PSYCHOLOGY-BASED TO ART THERAPY ASSESSMENTS

Art therapy pioneer Margaret Naumburg (1980a, 1980b) has been credited with providing a bridge from psychology-based to art therapy assessments. Her pioneering work was published in *The Clinical Application of Projective Drawings* (Hammer, 1980), a psychology-based text that includes chapters by many well-established drawing assessors.

Early on, art therapists developed what they considered to be art assessments as they proceeded in their own practices, some borrowing elements from previously designed procedures, others inventing their assessments out of whole cloth, and yet others falling somewhere in between. In a survey conducted by the American Art Therapy Association in 1991, it was revealed that many art therapists either modified existing tools or created new ones, rarely relying on published techniques (Mills & Goodwin, 1991). Some of them developed their series of art-based assessments

through their own experiences—what they felt provided them with valuable information about their clients.

Some art therapy assessments are fairly unstructured. The *Kramer Art Assessment* (Rubin, 1999) entails having a child create three art forms using drawing materials, paints, and clay and then assessing general tendencies and states. Judith Rubin's *Art Interview* (1999) offers clients of all ages a wide range of materials to choose from, followed by a discussion about their art piece. Several of the directives are more structured, such as *Bridge Drawing* (Hays & Lyons, 1981), *Favorite Kind of Day* (Manning, 1987), and *Bird's Nest Drawing Assessment Procedure* (Kaiser, 1996)—each of whose title is self-explanatory.

Some art therapists developed assessments focusing on specific types of clients; Myra Levick's *Levick Cognitive and Emotional Art Therapy Assessment* (LECATA) assesses children, whereas Hanna Kwiatkowska and Helen Landgarten created assessments for families. The LECATA (Levick, 2001) requires a child to use standardized art materials to complete a free drawing with an accompanying story, a drawing of the self, a scribble drawing with one color, a drawing of a place he would like to be or one that is important to him, and a drawing of a family. Kwiatkowska (1978) asked each family member to complete a series of six drawings, of which the first and last were free drawings. The second drawing was of the entire family, the third was an abstract family portrait, the fourth was a scribble drawing, and the fifth was a joint scribble drawing (Feder & Feder, 1998). Landgarten (1987) first asked families to divide into two teams, with the team members communicating with one another only through an initial drawing. All the family members were then instructed to come back together and work on a second drawing, and then create a third joint drawing in which they can talk with one another about what they wish to do.

The *Face Stimulus Assessment* (Betts, 2003) was established to specifically assess the capabilities of children with autism. The *Silver Drawing Test of Cognition and Emotion* (Silver, 2002), intended to evaluate cognitive functioning—originally an assessment for deaf children—has since been standardized for a variety of ages and conditions. This assessment requests a predictive drawing (the participant is asked to predict changes in the appearance of objects that are provided in linear form), drawings from observation, and a drawing from imagination. *Draw a Story* and *Stimulus Drawing Techniques* (Silver, 2002) take the drawing test even

further, relying on images on cards to stimulate the imagination and cognitive processing.

Several other art therapy assessment procedures rely on several drawings or art-making tasks, such as the *Ulman Personality Assessment Procedure* (Ulman, 1965), which involves four drawing exercises: a free drawing, a movement exercise translated onto the page, a scribble drawing, and a choice between a scribble drawing and a free drawing. Gladys Agell picked up where Elinor Ulman left off and spent many years trying to standardize the procedure, which initially was fairly open ended, and create a rating scale that would provide the clinician with information about participants' personality traits as well as their possible responses to art therapy as a form of treatment. The *Diagnostic Drawing Series* (Cohen, 1985) requires three drawings: a free drawing, a picture of a tree, and a drawing of how the client feels, using lines, shapes, and colors. This assessment procedure relies on a self-published manual to aid the clinician in deriving meaning from the three images.

One relatively recent standardized yet simple assessment procedure, and relevant to the primary case discussed in this book, is *Person Picking an Apple from a Tree* (Gantt & Tabone, 1998), a test in which a person is asked to draw what the title of the directive implies. The drawing is then rated using the *Formal Elements Art Therapy Scale* (FEATS), found to be both valid and reliable. Intended for adults, this procedure assesses a client for the presence of four distinct diagnostic criteria: Schizophrenia, Depression, Bipolar–Manic Type, and Organicity and Dementia. Along with these diagnoses, this technique can also be used to assess for such traits as problem-solving skills and socialization. Although a fairly robust assessment, it is narrow in scope and use.

FOR AND AGAINST

As with many subjects that are addressed by art therapists, there are factions that support and others that reject the use of art-based and art therapy assessment procedures. Many clinicians subscribe to the value of the art-based assessment procedure. Art therapy instruments are recognized as "alluring with their ability to illustrate concrete markers of the inner psyche" (Oster & Gould Crone, 2004, p. 1). They are deemed to be less threatening than other tests and can be easily assessed (Anderson, 2001). Gantt (2004) acknowledged that assessment and reassessment are

the center of good art therapy practice, and "standardized assessments are fundamental to all disciplines that deal with intervention and change" (Betts, 2006, p. 425). The images themselves can illustrate the change that can occur in therapy, which all clinicians are pressured to demonstrate. Such information is valuable for the client and the agency or institution that may be funding the treatment. Such knowledge of change can also provide valuable information about how to proceed with treatment (Deaver, 2002). Julliard, Van Den Huevel, and Suzanne (1999) reminded therapists that "art can tell us much not only about what clients feel but also about how they see life and the world" (p. 113).

Nevertheless, over the years, projective assessments, while gaining new ground within the art therapy field, seem to be going out of vogue in the psychology arena. Psychologists have a tendency to not be as readily trained in them and prefer assessments akin to the *Beck Depression Inventory* (Beck, Rial, & Rickets, 1974; Beck & Steer, 1993) and the *Minnesota Multiphasic Personality Inventory* (MMPI). Both are valid and reliable assessments, but neither relies on drawing procedures for information. In addition, the *Handbook of Psychological Assessment* (Groth-Marnat, 2003) removed the chapter on projective drawings from later editions: "Because of the decreasing use of projective drawings combined with continued research that questions the validity of many, if not most, of the interpretations based on projective drawing data, the chapter on projective drawings included in the previous three editions was omitted to make room . . ." (p. xiv).

Even in the art therapy community, art-based assessments have met with some challenges. Art therapists have recognized that after 50 years of research on projective drawings, there have been only mixed results (Gantt & Tabone, 1998). Many attest to their lack of scientific rigor, and McNiff (1998) indicated that the interpretation of pictorial imagery is subjective. Betts (2006) argued that in many cases, "those who choose to assess clients through art have neglected to convincingly address the essence of empirical scientific inquiry" (p. 427). Hacking (1999) cited many art-based assessments and studies that used unsuitable methods to determine reliability (Betts, 2006).

Aside from the lack of empirical support, several art therapists have argued philosophically against assessment procedures, as some believe that "art-based instruments are counter-therapeutic and even exploit clients" (Betts, 2006, p. 228). In longing for "magical tools" (Wadeson, 2002) that will allow the discovery of pathology hidden in their clients,

art therapists reduce the art to a rigid classification, which takes away from the creative expression originally intended. McNiff (1998) even contended that all this is beside the point: art-based assessments are ineffective, regardless that the variance within clients will yield a variety of imagery, making it futile to find meaning in the image. Rather, therapists should focus on using the art to transform and overcome the conditions that may limit their clients' daily existence.

While many of these arguments may be rejected or verified as more studies are conducted, art therapists should certainly pay credence to them and be careful that when using assessments, they continue to acknowledge the human behind the image. They should also make sure that the tools are properly administered and have robust evaluation and research behind them to justify their use. Rosal (1992) cautioned that assessments should be researched and evaluated to "discover the predictive ability of a variable or a set of variables to assess or diagnose a particular disorder or problem profile" (p. 59), and those developing such assessment techniques should be prepared to "devote a considerable amount of time and energy to such a formidable task" (Betts, 2003, p. 77). Upon reviewing a number of art therapy and art-based assessments, Neale and Rosal (1993) discovered that "idiosyncratic projective drawing techniques were found to be the weakest . . . when solid research methods were employed, the strength and quality of the study was apparent" (p. 48).

A PERSONAL REFLECTION

After teaching projective assessments, both psychology- and art therapy–based, over many years, I have come to my own understanding of projective assessment procedures. Whether or not an art therapist plans to use formal assessments in his clinical practice, it behooves him to learn the information that assessments may provide. Even if an art therapist does not administer a formal assessment, she must constantly and diligently assess the work that comes out of daily sessions to ascertain progress and help make decisions on the direction of the treatment.

For example, many art therapists administer the scribble drawing as a treatment-focused directive. This simple procedure requires the client to scribble on a sheet of paper and try to find an image or images within the lines created. Whether they know it or not, the clinicians are administering a projective assessment. It is not a coincidence that several art therapy

assessments rely on the scribble drawing as one component of a battery of instruments, such as the LECATA (Levick, 2001), Kwiatkowska's (1978) family assessment, and the Ulman Personality Assessment Procedure (Ulman, 1965). Cane (1983) relied on the scribble drawing alone to provide much needed information on the children with whom she worked. It is a true projective technique in that the viewer *projects* onto the ambiguous form he has created an image that contains meaning for him. For this reason, many continue to administer it as a directive that is useful in its ability to amuse the client while providing information in the course of treatment. This is just one example; many other directives allow art therapists to do that. While they may not formally ask clients to draw a picture of a person picking an apple from a tree, they can still use their knowledge of the formal elements derived from the FEATS and other standardized assessment procedures, applying this knowledge to the image to informally assess the treatment progress of the clients who created the art pieces.

An assessment is arrived at only after a great deal of information is obtained; it's not enough merely to look at an art piece and arrive at a conclusion. Recent studies have attempted to demonstrate a computer's ability to assess drawings by individuals (Kim, Kim, Lee, Lee, & Yoo, 2006). While I am fascinated by these studies, and certainly find a place for them within the scientific community, I caution against relying on *only* this method for finding out information from the art-making client. The art process is just that—a process. The assessment procedures rely on this process; however, so much of art making depends on human interaction, which is logical—the human element is part of everyday life, and helps define us and makes us what we are. By removing the human element in assessing the image, clinicians run the risk of objectifying the art making. Only a creative, art-making human being can understand the difference between a sketchy line created out of anxiety or timidity and a similar line created out of an aesthetic decision; the size of the drawn object and the amount of space that it takes up on a page are indeed important, but art therapists do not know in which direction it is important—as an unconscious representation of depression or a means to impart symbolic meaning important to the structure of the composition—until they witness it, question it, and assess it with their own eyes.

Computers, as they work now, cannot do this. They can stipulate various theorems based on the thickness of a line, the amount of space on a page, and the degree of shading used. But without human interaction,

the computer cannot distinguish aesthetic and creative judgment from pathology—or if, indeed, they are one and the same. It is for this reason that art therapy assessments must continue to be scientifically studied, be developed in a standardized fashion, and maintain levels of validity and reliability in order to be deemed effective as tools in the therapist's tool box. But clinicians must not remove themselves from the equation to provide creative insight into a deeper understanding of the art.

FORENSIC ART THERAPY

Several art therapists have drawn on their skills as evaluators to provide support to lawyers and offer expert testimony in court, using the assessment of art pieces as evidence—that is, deriving meaning from the art. One well-known forensic art therapist is Marcia Sue Cohen-Liebman, who often provides expert art therapy support—and sometimes testimony—in family and child abuse cases. She has written several well-received articles on the role of the forensic art therapist.*

Forensic art therapy—a term coined by Cohen-Liebman (1999)—is investigative, applying art therapy assessments, principles, and practices to assist in the resolution of legal matters. The combination of art therapy and standard forensic procedures and protocols produces a hybrid that is fundamentally investigative fact-finding, with clinical overtones.

These fact-finding enterprises require meticulous and thorough inquiry. Procedures are dictated by constrained practices, which demand specially trained and skilled investigators. Forensic investigators, evaluators, and interviewers adhere to forensically governed standards when collecting evidence. In addition to fact-finding and addressing corroboration and credibility, an investigator may be called in to determine competence for investigative or court-ordered purposes. The primary task of a forensic evaluator is to gather information that will be useful within the legal system and assist with legal determinations (Haralambie, 1999; Mannario & Cohen, 1992). Information is procured in a manner that is objective, developmentally sensitive, comprehensive, and forensically defensible (Cohen-Liebman, 1999; Davies, Cole, Albertella, McCulloch,

*This section is based on Marcia Sue Cohen-Liebman's portion of Gussak and Cohen-Liebman (2001). Special thanks to her for allowing me to adapt it for this book.

& Kevekian, 1996); considerate of the needs of the client; and compatible with the procedures of the court. The forensic art therapist is often compelled to communicate his or her findings at a court proceeding, thus requiring knowledge of professional ethics and case law.

Forensic art therapy clients are often involuntary and may be remanded by the court or an investigative body to participate in an interview or evaluation. Clients are referred because of a forensic or legal matter or dispute that requires an investigation to resolve. Possible referral sources include law-enforcement personnel, prosecutors, defense attorneys, representatives of child protection agencies, child advocates, or judicial officers (such as judges); a referral may result in a court-ordered investigation. Clients may be children, adolescents, or adults. They and/or their guardians (if the client is under 14 years old) may be resistant to cooperating with an investigative agency or unmotivated to resolve a legal dispute, depending on the case and the allegation. Generally, allegations associated with a forensic clientele include child abuse and neglect, domestic relations and/or violence, and custody and visitation rights; forensic art therapy is also used with those who were witnesses to crimes (Cohen-Liebman, 1994, 1999, 2003; Gussak & Cohen-Liebman, 2001).

THE FORENSIC ART THERAPIST

Because the art therapy process and subsequent discussions are communicated to the investigating agent, the forensic art therapist must know and understand legal tenets, case law, judicial processes, and professional ethics. At times, the forensic art therapist may be required to explain his processes and present his findings in court. It is necessary that the forensic art therapist be able to speak the language of the courts when presenting her behavioral and psychological findings.

Just as forensic child psychiatry utilizes the fund of information of the child psychiatrist (Schetky & Benedek, 1992), the forensic art therapist depends on theories and practices developed by art therapists as well as drawing from related fields. Education that includes theory and research about life-span development; psychopathology; behavior of individuals, families, and groups; principles of psychotherapy; assessments; and the creative process are essential. Because the forensic art therapist may be asked to testify at court hearings, judicial and forensic training is also basic. A forensic interviewer or evaluator is trained in additional arenas.

For example, the forensic art therapist who is investigating allegations of child sexual abuse (a common role for a forensic art therapist) must be experienced and trained in myriad competencies: child development, including memory, suggestibility, cognitive capabilities, concept formation, and expressive-receptive capabilities; normal sexual development; offender profiles; credibility assessment; legal issues; state criminal codes; question continua; current research; special populations; cultural competency; and clinical versus forensic interviewing.

FORENSIC VERSUS CLINICAL PROCESSES

Inherent differences exist between forensic and clinical processes (Raskin & Esplin, 1991). These distinctions are identified in the role and style of the interviewer and the intent, context, and collection of information. In a forensic process, the interviewer assumes a neutral state, retains an objective point of view, and refrains from interviewer bias. Adherence to forensic procedure is strictly governed and is mandatory for the process to be legally defensible in court. The interviewer must also be able to defend the practice and purpose of the forensic process.

In contrast, the clinical interviewer's primary role is as an advocate for the client. The therapist does not take a nonjudgmental stance, but validates the client's thoughts and feelings. Most clinical interviews are not governed by strict standards of procedure and process. The manner in which data are collected is not integral to the process. The forensic evaluator's task is to gather information and discern the truth through the acquisition of factual material, while the clinician provides support and intervention.

THE FORENSIC ART THERAPIST'S USE OF DRAWINGS

According to Cohen-Liebman (2003), drawings function in one of three ways in a forensic process:

- As an investigative implement
- For forensic/charge enhancement
- As evidentiary material or judiciary aids

As an investigative implement, drawings are used to support an investigation. In the capacity of forensic/charge enhancement, drawings may

provide contextual information that can contribute to the determination of charges as well as the identification of additional areas to investigate. Drawings as judiciary aids provide evidentiary material that is admissible in a judicial proceeding. In some jurisdictions, they are considered to be novel scientific evidence and are subject to a special admissibility hearing (Cohen-Liebman, 1994). Drawings have also been identified as enhancing and increasing the productivity of the interview process (Farley, 2000). It is therefore necessary that the forensic art therapist be familiar with art-based assessments.

ART THERAPY FOR CAPITAL CASES

Generally accepted as having a role in providing testimony for family courts and abuse cases, art therapists have not been extensively portrayed as playing a part in capital cases, specifically cases that involve murder, resulting in the pursuit of the death sentence. While this book does not take a position on the death penalty, it does advocate the use of art as a means to provide expert testimony for such cases. Relying on the tenets put forth by Marcia Sue Cohen-Liebman, and on an understanding of assessments and the formal elements of art to offer evaluative qualities, this book focuses on how the use of art as evidence, and the role of art therapist as expert witness, can be applicable in death row cases. This idea is often considered to be counterintuitive, for while art therapy has been regarded as a means to help the victims of crimes such as neglect and abuse, art is used in capital cases for the sake of those who perpetrated major crimes. However, the role of the art therapist as an expert witness is as a fact-finder, relying on the art to provide insight into a defendant's state of mind at the time he or she committed the crime, to determine the potential for rehabilitation, and perhaps even to reveal patterns that offer insight into the impetus having committed such an act. In this manner, the art therapist may not have a bias for or against the client. When asked by the defendant's attorney to be an expert witness in the death row case presented in this book, I stressed that I would be testifying neither for nor against the client, but on the art.

ESTABLISHING AN EXPERT WITNESS STATUS: A BRIEF REVIEW

Expert witness testimony is only one of the multitude of responsibilities of the forensic art therapist. Providing such testimony, however, is not

necessarily the purview of just the forensic art therapist; rather, as has been discovered, any art therapist, provided that she meets the necessary criteria, can present expert testimony in court. A number of art therapists around the country have earned the right to be expert witnesses; each of these clinicians had to proceed through a verification and validation process (Cohen-Liebman, 1994). Special attributes and considerations must be taken into account before someone is granted such a status.

Before any formal clarification of or judgment on who could be considered an expert witness, there was an initial litmus test—the *Frye* rule. The *Frye* ruling (*Frye v. United States*, 1923) states that "scientific testimony is admissible only if the witness's tests and procedures have gained 'general acceptance' within the relevant scientific or technical community" (Lubet, 1998, p. 4). This ruling, established to determine the admissibility of a lie detection method, determined:

> The rule is that the opinions of experts or skilled witnesses are admissible in evidence in those cases in which the matter of inquiry is such that inexperienced persons are unlikely to prove capable of forming a correct judgment upon it, for the reason that the subject-matter so far partakes of a science, *art* [emphasis added] or trade as to require a previous habit or experience or study in it, in order to acquire a knowledge of it. When the question involved does not lie within the range of common experience or common knowledge, then the opinions of witnesses skilled in that particular science, *art*, or trade to which the question relates are admissible in evidence. (p. 4)

The *Frye* rule formalized the understanding that "somewhere in this twilight zone [between experimental and demonstrable stages] the evidential force of the principle must be recognized, and . . . the thing from which the deduction is made must be sufficiently established to have gained general acceptance in the particular field in which it belongs" (Blau, 1998, p. 6).

In 1975, the Supreme Court revisited the question of who could be considered an expert witness, and the justices developed the Federal Rules of Evidence, which essentially established formal rules for how expert witness status is granted, otherwise known as Rule 702 (Bennett & Hess, 2006):

Rule 702. Testimony by Experts

If scientific, technical, or other specialized knowledge will assist the trier of fact to understand the evidence or to determine a fact in issue, a witness qualified as an expert by knowledge, skill, experience, training, or education, may testify thereto in the form of an opinion or otherwise, if (1) the testimony is based upon sufficient facts or data, (2) the testimony is the product of reliable principles and methods, and (3) the witness has applied the principles and methods reliably to the facts of the case. (quoted in Bennett & Hess, 2006, p. 624)

Soon known as the *Daubert* rule, named after the first case in which it was applied (*Daubert v. Merrell Dow*, 1993), it designates the trial judge as "gatekeeper, deciding whether the proposed testimony is reliable enough to be helpful to the fact finder . . . the judge must initially determine whether a novel theory is sufficiently supported to qualify as evidence" (Lubet, 1998, p. 4). If an opposing attorney believes that an individual does not qualify as an expert witness, the judge may hold a "*Daubert* hearing" and arrive at her own conclusion. This law has been commonly accepted as the guiding principle for qualifying an expert witness by many state courts.

Essentially, the difference between *Daubert* and *Frye* is that the "*Daubert* ruling substitutes a reliability test for a relevancy test" (O'Connor, 2006, para. 8). Since Rule 702 has been revisited, the revised ruling now requires that "an opinion from an expert who is not a scientist should receive the same degree of scrutiny for reliability as an opinion from an expert who purports to be a scientist" (Bucklin, 2010, para. 4).

Regardless of the federal statutes, the decision about whether to measure the validity of someone's position as expert witness is left up to the states. While some states have adopted the *Daubert* standard, others adhere to the *Frye* standard: "[O]ver the years a number of states have formally adopted the *Daubert* standard. . . . [H]owever, many states have expressly rejected the *Daubert* and chosen to retain the *Frye* standard" (Cheng & Yoon, 2005, p. 473). Still others have not adopted either rule and will either develop their own procedures for measuring a person's ability to provide expert testimony or create a hybrid of the two existing standards. Therefore, each art therapist who has been accepted as an

expert witness must be verified and validated through the court system of the state in which they are testifying. For example, if an art therapist is testifying in Indiana, he may be reviewed under *Daubert*, whereas if he is testifying in Florida, *Frye* standards may determine his admissibility. While this discrepancy may be relatively easy for a practitioner in an established profession, such as endocrinology, to navigate (although this was not always the case), an art therapist may find herself floating somewhere within a "twilight zone"—still unique enough to be processed through intense scrutiny.

SIMPLE CONCEPTS OF CRIMINAL TRIAL PROCEEDINGS FOR THE NON-LEGAL EXPERT

There are several stages in a criminal case in which an expert witness, such as an art therapist, may be called to testify.* An expert witness may be questioned during a grand jury procedure: "A grand jury's purpose is to investigate alleged crimes, examine evidence, and issue indictments if they believe that there is enough evidence for a trial to proceed" (USLegal. com, n.d., para. 1). If the grand jury determines that there is enough evidence to indict the defendant, he then proceeds through a criminal trial to determine his guilt or innocence, based on the evidence provided. In both proceedings, an expert witness would be asked to validate or refute any physical evidence discovered. A mental health professional as an expert witness may also be used to help determine and testify to the defendant's state of mind during the commission of the crime for which he is on trial.

If the defendant is found guilty or pleaded guilty, thus bypassing the necessity of a juried trial, a sentencing hearing is held to determine the length of the sentence the defendant is to receive. The death penalty may also be considered for capital cases if applicable. The judge may impose the sentence; the jury may no longer be involved in the sentencing stage. While both parties have the opportunity to request a specific sentence,

*This overview is far from comprehensive, and criteria for criminal trial proceedings vary from state to state. Therefore, it is recommended that art therapists who become involved in forensic procedures and are called to provide expert witness testimony familiarize themselves in much greater detail with what is expected in the criminal system in which they will participate and at what stage they will be entering the process.

ultimately the judge makes the final decision. In some cases, if a plea bargain is reached during or before a criminal trial, a cap may be placed on the length of the sentence determined during the sentencing phase. Even if the sentence was tentatively agreed on during the plea bargain, however, the judge can ignore it and make his or her own recommendation. Overriding the plea agreement is an unusual move, and the judge can impose a sentence only within the limitations mandated by the state for the particular crime. At such a hearing, both the prosecution and the defense provide evidence to attempt to influence the judge's final decision on the length of the time that will be served. In these situations, mitigation is often considered.

Mitigation is when evidence is provided by the defense that determines if extenuating circumstances are present to offset the physical evidence in order to obtain a lesser sentence, which would include ruling out the death penalty. This includes testimony by relatives and friends to, in essence, determine the worth of a person and, in a sense, "humanize" the defendant. Mitigating evidence may also be used to ascertain the mental health status of the client; many states maintain that a defendant may not be sentenced to death if it can be determined that he or she acted as a result of insufficient or impaired faculties. Such mitigation may also be provided during criminal trial proceedings and is weighed differently by the states.

A mitigation consultant may be used whose responsibility is to discover any such evidence by researching the defendant's background through social histories, psychological assessments, and behavior reports. This consultant may also advise the defense team as to who might be an effective expert witness for the defense.

If the defense decides to appeal a decision, the case is remanded to an appellate court, whose responsibility is to review the decision made by the lower court. In some cases, a post-conviction review may be held. A type of appeal, the post-conviction review makes available new evidence that demonstrates a violation of constitutional rights in the initial hearings. For example, new evidence may indicate that the original defense counsel did not properly or fully investigate mitigating evidence. Thus the jury and/or the court can consider anything that may help them decide the fate of the defendant; as Stetler (1999) stressed, in post-conviction reviews, "empathy-evoking facts are needed to persuade a new court to be merciful and find harm in legal error. Powerful new evidence is needed

to undermine the reliability of an original capital murder conviction" (para. 2). During the review, anybody, including an art therapist, who can provide a new perspective of the defendant that runs counter to the prosecution's image, and can elicit new evidence that evokes compassion, is a valuable asset to the defense. Having said this, an art therapist, as will be demonstrated in the following chapters, can be an important contributor at all stages of criminal proceedings.

PART I

: : :

ART AND THE MURDERER

A Case Study

1

HOW IT BEGAN

On November 1, 2006, I received a telephone call from an attorney named Lisa Peters. The purpose of her call was to ask if I would consider serving as a consultant for a capital murder case, with the possibility of providing testimony should it go to trial. She offered no information about the case—only that the defendant was on trial for murder and the state district attorney was going to seek the death penalty. The defense was investigating the possible history of a mental illness, and the defendant had a long history of creating his own artwork. I was intrigued.

Lisa Peters, attorney at law, had been practicing for Jackie Chief Law Offices since she became an attorney in 2003, after she attended "law school relatively later in life." Before attending law school, she earned a bachelor's degree and a master's degree in art history. After traveling quite a bit and teaching in Japan and London, she worked as a substitute teacher, teaching English while pursuing her master's degree. After finishing her degree, she realized that there were not a lot of employment opportunities for an art historian, so she decided to attend law school. It was there that she met Jackie Chief, who suggested that when she completed her education, she join her law firm.

Although she originally intended to pursue law that would allow her to advocate for hospital patients addressing end-of-life issues, once she began "taking more criminal law classes, I realized that was my home. I never looked back." Although opposed to the death penalty in principle before working as a defense attorney, after a few years she became "deeply opposed to it on every level: politically, economically, but most of all, I just believe that every individual has worth and value, and that no

one in our society, in our government, in our courtroom, has the right, the authority, or the moral authority to make a decision to end that person's life." Thus, during this case, Peters's art background and strict opposition to the death penalty led to her decision to try to use an art therapist as a witness for the defense.

Shortly after Jackie Chief Law Office received the case—to defend a man accused of the murder of one of his children and attempted murder of his other child—Peters saw the defendant's art. She was fascinated with the pieces: "[T]he moment I saw some of the works that he had done, I said 'he's an artist. We need to get an art therapist in here to talk with him.' It was just an instant connection . . . this is going to help us tell the story." Peters credits her background in art history in training her to look at images in a way "that maybe your average lawyer wouldn't look at them. . . . I'm not claiming any special knowledge or anything, but I just think that experience caused me to look at some of the artwork . . . with that eye." Previously, Peters had a vague notion of what art therapy is, learning about it in graduate school from a roommate's friend who had hoped to pursue the profession. She then proposed the idea to Jackie Chief, the lead attorney in the case:

> Jackie is an art lover and immediately saw the value of talking to someone who could connect the images that he was making with the psychology. She was on board with it right away, and said, "Okay, let's see if we can find someone." . . . [M]y experience level was fairly limited when this case came around, but Jackie's experience is vast, and I don't think that she had ever heard of anyone using an art therapist. At the time, you know, in the beginning, I don't know that we ever thought that an art therapist could testify or [pause] we didn't have a clear picture of the outcome, but we just immediately [saw] that it would be good to talk to an art therapist.

Peters indicated they were most interested in finding a therapist who had an academic focus rather than one who was in practice, anticipating that there might be some "expert witness testimony down the road." Presumably, such an academic would be more versed in educating those who are unaware of the field; more used to supporting his or her research with facts, data, and scientific inquiry; and more comfortable speaking to a

large audience. She had originally tried to contact some local art therapists, but "nobody wanted to touch it." The case, locally and infamously renowned, "had a little bit of notoriety, and I think that was off-putting."

After first speaking with the American Art Therapy Association, Peters was referred to an art therapist in Pennsylvania who was known as a forensic art therapist. Because of the nature of the case, however, the therapist with whom she spoke indicated that I might be a better candidate for such services. I was recommended because I had a history of working with aggressive and violent men, including prison inmates.

When Peters phoned me and told me about the case, I informed her that I had no experience with testifying in court. She stressed that this was not what was important; what was important was the experience I had, my professional history, and my ability to conduct an art-based assessment and evaluate the art. We ended the conversation with my intention to think it over, and I would respond via e-mail if I was interested. She did request that if I agreed, I was to include a copy of my vita and a "fee schedule" for my services.

Once the vita was received, she would submit it to the court, along with the fee schedule, to determine if her firm would be allowed to contract for my services. At this time, I did not know what went into this decision, and no further information was afforded. However, Peters later indicated that at this stage, in order to get approval for the funds for my services, the defense attorneys had to provide the judge with my qualifications and their justification for why these services were important to the case. Before hiring me, "[and] before we can make any arrangements to hire someone, we have to have permission from the courts, and that involves filing a petition with the judge, asking that the court appoint an expert and allocate money for payment." Once the judge approved, I would be "hired as an expert witness." Although this status could be, and would be, questioned in a criminal trial by the opposing counsel, from this point I was considered an expert witness. No formal hearing would be held, and the prosecutor was not involved in the decision; "this was all done ex parte." However, the supreme court of the state in which this case would be tried follows the Criminal Rule that was "promulgated for the purpose of allowing to the appointment of counsel, and allocating funds in capital cases." No additional specifics of the case were provided.

Later, lead counsel Jackie Chief informed me that the idea of involving an art therapist in this case was first discussed with the other "psychiatric experts"—a psychiatrist and a psychologist:

I wanted their opinion of doing it. . . . I didn't want to get caught in a situation where I would bring an expert on board who was looking at this from what I perceive to be a relatively new field, and have my other experts then say "we think that this isn't a valid basis for researching a conclusion, and we don't want to be a part of it," or something like that. They did not say that. We also talked to the client about it, and he was agreeable.

A week later, I e-mailed my vita and committed to providing my services if needed. I spoke with several colleagues about their experiences as expert witnesses, asked what I would have to do to prepare for this responsibility, and wondered what would be a suitable fee to charge. The more I thought about it, the more I considered this a valuable professional opportunity as well. I felt that I could be fairly competent in evaluating the art. I had been teaching projective assessment courses to psychology and art therapy students for a number of years and had been conducting assessments in my own prison studies for approximately 5 years (Gussak, 2004, 2006, 2007a, 2009). I believed that I had the necessary skills and aptitude. I had worked with violent people and knew my way around a prison, if it came to that.

What I did not realize was that this situation was still theoretical for me: I knew that the defendant was a murderer, but that was it; I did not think about the fact that I would be offering testimony that could potentially keep someone alive and that by testifying for the defense, I would potentially be taking sides in the case. It never occurred to me at the time to consider whether the defendant deserved to live after having committed his crimes. It was still academic to me. Despite a long history of being involved with several prisons in three states, two of which maintained the death penalty, I was never put in a position to strongly consider my stance. I just knew that this experience could be fascinating.

It was not until the spring of 2007 that I heard from Peters, indicating that the court had approved the use of my services by the defense team. Although it seemed like a lengthy delay, there were good reasons: "As excited as we were about exploring what these images might mean and

how they might help us tell his story, there were other things that were more pressing . . . [and we had to] go through the process of getting approval from the court, the state, and things like that too." She wrote that she would send me a contract and a confidentiality form to sign, along with some of the defendant's images.

I contacted Jackie Chief's office after I received the forms and asked if a stipulation could be made that although I would maintain confidentiality until the end of the case, I would be allowed to present and publish material on the case after it was completed. The attorneys assented, and changes were made to the forms. After I signed and returned them, I was sent a file that included a brief summary of the crime and a compact disc that contained about 100 art images. I was also provided with the name of the defendant, Kevin Ward, but I deliberately chose not to research him or the details of the crimes.

There was no information about a possible mental illness and no indication of other expert witnesses testifying for the defense. The images on the disc were not labeled, and no pertinent information about them was included. I was given the task of reviewing the images and coming up with a preliminary analysis if I believed that Ward had a mental illness, and specifying what that illness might be. I was to provide a verbal report on May 1, complete with an explanation and a justification for any conclusions I developed.

THE ART: THE INITIAL REVIEW

The introduction to this book stressed the advantage of having the opportunity to observe the artist create the art pieces and to ask questions during and after the session in order to develop a more accurate conclusion than could otherwise be obtained. This preference was not available yet; the only way I could protect the client from any erroneous label provided without substantial triangulation was to quantify my statements and make it clear that no conclusion could be finalized without additional information received directly from the artist.

Furthermore, there was an additional challenge: I was not provided with certain information that may have aided in the final assessment. There was no mention of the size of the pieces, no indication of how long it had taken to create them and when they had been completed, no

hint about what materials had been used to create them, and no "artist statement." Never have I been in a position to conduct an assessment with such little information. However, I did have some advantages based on my experience of reviewing many types of art over the years.

THE CHOICE OF MATERIALS

Although I was not provided with a summary of the materials that Kevin Ward had used to create the pieces, I was able to fairly easily assume the media. The choice of materials is important because their varying properties, as noted in chapter 2, can influence the way an image was completed and ultimately is viewed. It may even provide a glimpse of the artist's temperament or cognitive abilities.

The properties of the materials used for a given art task may determine the ultimate affective, cognitive, or symbolic response to the finished piece (Lusebrink, 1990). Some materials are quite resistive and easily controlled; others are more fluid and less easy to manage (colored pencils as compared with watercolor paints). Some materials are more easily manipulated than others. Drawing with a pencil is obviously simpler than painting with oils or making prints. Art therapists can control the direction of a session by assigning a directive and the materials to be used. They are also aware that certain pathologies do not mix well with certain materials. Pathologies that may weaken a person's orientation to reality, which may induce hallucinations or delusions, may not respond well to materials that elicit emotional or affective responses, such as watercolor or tempera paint.

To provide grounding and needed structure to someone who is at the moment experiencing a loosening of boundaries and cognitive disassociation, more resistive, easily controlled, and simple materials—such as colored pencils, oil pastels, or collage materials—may be introduced. Often, if an art therapist is not available to provide this direction, the client/artists may themselves instinctively know what may loosen their boundaries further and choose materials that are more grounding and structured— much like self-medicating. This is not to say that everyone who selects pencil and collage over finger paint, watercolor, and chalk pastel is doing so to avoid a loosening of boundaries, fragmentation, and pathology. However, in doing so, an artist may instinctively be deciding to focus primarily on cognitive processing and control over affective expression.

It is my experience that those with a mental illness, whether burgeoning or prominent, may gravitate toward more structured and simplistic materials in order to "keep a lid" on what is bothering them, to maintain a semblance of control when it seems to be slipping away. The mental illness sometimes may be too overwhelming, and even the act of trying to maintain control through structured materials and directives may result in a loosening of boundaries, a fragmentation within the seemingly controllable process. Such loosening within an art experience may be associated with the deterioration of the client's own mental health experiences and control.

THE PORTFOLIO

My initial impression, on beginning to evaluate his work, was that Ward had some artistic background; he certainly demonstrated a talent for drawing. One of the first pieces on the disk reveals a certain playfulness with the materials and color (figure 1),* with heavily layered oil and chalk pastels making a rather colorful, ambiguous composition that divides the page into thirds—the top and bottom thirds revel in bright colors, whereas the middle rectangle is drawn in black and white, displaying a martini glass–like shape on the left-hand side. Upon closer examination, the pastel is layered thickly in the middle, appearing as if the artist was able to scratch disjointed lines onto the surface with his fingernails.

Another colorful piece is remarkable in its simple composition and ability to convey a beautiful female form with broad painterly strokes, bright splashes of color, and disorderly lines (figure 2). The figure seems a bit too disjointed, however, while the features that could make this a recognizable person seem to be lost. The facial features are highlighted through painterly strokes, but seem incomplete and formless. The shape of the head loses its definition, blending further into the background.

*The images discussed throughout the book follow page 94, and the original color versions are on the page for this book on the Columbia University Press Web site (http://www. cup.columbia.edu/static/gussak-art-on-trial-images). They were chosen to represent Kevin Ward's entire body of work. Many more will be introduced and presented in later chapters to correspond with events detailed there. Each image will be discussed in the order it was received, as the chronological order was not known. However, as patterns began to emerge, I reevaluated previous images and revisited them throughout this book for comparison to demonstrate relationships and consistency as they contributed to the evolving conclusions.

The background colors encroach onto the white body shape, while there are few lines to help structure the female form. It seems that the figure is losing its integrity. Although not immediately apparent, a second figure emerges in the upper-right area of the page. All that defines it is a vague highlight of an arm and a hand—everything else fades into the background. While the painting reveals a great deal of talent, and is quite aesthetically pleasing, it seems that the represented figures are lost.

Figure 3 shows a sort of triptych—a single work composed of three separate panels that are related in style and theme. There is a commonality between the first and third images: both contain the statement "a game of you" seemingly woven into the panels' compositions. Otherwise, the three images, composed of what appears to be mixed media (paint, photo collage, and oil pastel) are significantly different from one other. Their vague line qualities, insubstantial shapes and forms, and muddy colors are reminiscent of those in figures 1 and 2. The three compositions feel too active, uncontrolled, and erratic to be contained by the rectangular forms that enclose them. They also contrast sharply with the colorful matte board that frames them. Painterly and insubstantial strokes of shades of gold and yellow surround the panels and partly veil what appears to be a metallic, die-cut form of a cathedral. Although a beautiful composition, it is ambiguous in its presentation.

It was not clear if the ambiguous, disjointed, and, at times, uneven style and forms of figures 1 to 3 were the choice of the artist: Were they a deliberate fragmentation of the composition for creative expression or a result of the suspected mental illness that had not yet been identified? I had to review all the art before making a decision, rather than relying on the single slide. Alone, these three images may have represented an eccentric yet creative individual; and, indeed, they do. Taken in conjunction with all of the other images, however, they reveal a pattern of someone who, in addition to being talented, most likely had a mental illness.

Many of the images are line drawings on what appears to be paper from a standard-size drawing pad. Several of the compositions include a number of unrelated and disjointed images that reveal a range of talent and ability in portraying faces and symbols (figures 4–9). In addition to inconsistencies among the drawings, several of them, such as figure 6, demonstrate internally discrepant style and line quality.

All of them depict incomplete forms and vary from sketchy to heavy pressured line quality—at times hesitant in the way some lines were

applied, while overly confident and somewhat aggressive in others. These diametrically opposed styles suggest a heightened level of anxiety: the sketchy and disjointed, unclear lines reveal an unwillingness to draw the image, whereas the heavily scribbled lines seem to confront the anxiety and attack the page. If taken alone, the drawing style of each piece may not be significant. However, the emerging pattern of disjointed and inconsistent lines throughout all the images—sometimes within one drawing—makes them noteworthy.

Several of the drawings seem to be incomplete; some are missing body parts or are simply not finished. This is especially conspicuous because Ward demonstrated the ability to complete an entire figure in several of his other compositions. Figure 8 depicts what at first appears to be a blue mountainscape, but eventually reveals a reclining female form. However, the figure has no head, feet, or arms.

Figure 9 seems at first to be a successful exercise in conveying movement through simple linear forms. The top composition appears to be of a figure swinging a bat, whereas the bottom arrangement seems to be of a figure swinging "his" arms—perhaps a baseball pitcher. When studied closely, however, the figures are incomplete. Those at the top have no feet, and several overlap in a confusing way. Those at the bottom are even less organized, and, at one point, the artist began to superimpose disjointed and unrelated geometric shapes on several of the figures.

Ward also marred the page with a scribble that begins with broadly drawn lines that tighten into a denser series of strokes and finally intersect at the right side of the top composition. At the time of my initial review, it was not clear why this scribble was included. It seemed that Ward had lost his patience or control while drawing and, out of frustration, had scribbled across the page. As I progressed through his images, I came to realize that the scribble repeatedly emerges in his sketches (for example, figures 7 and 9–11).

Figure 12 provides an example of a drawing that uses heavy-handed lines that combine broad, controlled strokes with uncontrolled scribbles. Despite its dramatic appearance, this composition seems to be better structured—although unrecognizable—than some of Ward's other images.

Several of the drawings include recognizable faces, albeit with exaggerated features, cartoon-like emphases, and unusual countenances. Some of these faces are disconnected from their bodies (figures 4–7). Several

drawings portray faces that are barely recognizable: figure 13 is a portrait composed of angular lines and geometric shapes, while figure 14 is made up of many unconnected forms, in the middle of which is a large, bulb-like shape. Embedded in this bulb is a recognizable face, with eyes, a mouth, and a hint of a nose. It was surmised that this is a balloon, tethered to the bottom quadrant of the page by a scribbled line similar to those noted earlier.

Figure 15 is the most diffuse. There is barely a hint of a face; indeed, there may not be one at all, except the layout and composition make it appear to be so. If it is a face—which was later confirmed by Ward—it is quite bizarre. The scribbled lines are disconnected, fragmented, erratic, and inconsistent. The large, wedge-like shapes in the top-left quadrant of the composition resemble wide-open eyes, with the large scribbled mass below them reminiscent of a bearded mouth. Written under this is a statement—"Take me away for I am nothing today! Just a thought [unclear]"—that seems to be rather unconnected to the composition.

Viewed together, figures 13 to 15 suggest a gradual deterioration of the face, reflecting perhaps decompensation in the artist. However, it was not clear when he drew these pieces. Once again, it would be important to speak with Ward to determine not only the time at which the art was created but also the state he was in at that time.

Ward added words to several of his compositions that seem to be unrelated to the images. In addition to those in figures 3 and 15, for example, figure 11 includes the words "Law of flight" and "Help." In the middle of a disorganized and chaotic figure 16 appear the terms "Star baby" and "Tired." Figure 17 displays the phrase "Mind Cage," with the names of various emotional states written within the depiction of a brain. While such details were noted in my initial assessment, they became even more significant when additional images were received at a later date (chapter 5).

Some color sketches from the drawing pads reveal the same disjointed, fragmented, and unrelated composition seen in the monochromatic pages. Yet some works display a contained explosion of color. For example, figure 18 is a brightly colored drawing whose intricate shapes and tightly controlled forms made up a confusing and fragmented composition. Difficult to see are several faces embedded within the colors. Because of the way Ward used the colors, these faces blend into their background, making it difficult to differentiate the identifiable forms

from the kaleidoscopic shapes. The drawing seems unfinished, yet there is a human face, an animal face, and jagged shapes lightly sketched in a haphazard composition to the right of the colorful mass; although it is illogical in appearance, it seems intentional.

In comparison with figure 18, figure 19 is a well-rendered composition that depicts a man's naked torso, presumably an homage to Michelangelo's *David*. However, embedded within the male torso is a nude female form. The rest of the torso is filled with chains and unrecognizable shapes and objects. Color is used sparingly, as if to emphasize specific forms, with control and intention. Beneath the male torso are inconsequential renderings of a cartoon-like three-armed figure, stylized animals, and a burning building, as well as some cross-hatching of colors in the lower-right portion of the page. While the central form reveals talent, Ward seems to have lost his focus and the control and intention that the central figure offered, and the rest of the composition is tangential.

Several color drawings, such as figures 20 and 21, are solemn yet simple and deliberate compositions. Both pieces are drawn with oil pastels. They have central images surrounded by concentric areas of muted colors. Figure 20 appears to be either a tunnel with an orange light coming toward the viewer or a head in profile. Although the central form appears to be composed of one color, it is actually made up of many layers of dark colors swirling within a constraining shape. Figure 21 depicts a relatively small, incomplete female form placed in the center of concentric circles. While this masked figure has few facial details and no arms and legs, her breasts are emphasized. Compared with some of Ward's other images, these two compositions appear to be well focused, with a single idea.

Some of Ward's images are even more simple, bordering on minimalistic. Figure 22 depicts a diffuse hourglass shape painted with yellow watercolor in the upper-left quadrant of a piece of drawing-pad paper. A single yellow line of the same shade and tint as the rest of the form bisects it. There are no other images on this dirty piece of paper, but it is ostentatiously signed and dated in the bottom-right corner.

Another medium of choice was collage (figures 23–25). A collage is a composition made from a combination of various materials—such as magazine clippings, photographs, and previously created art forms—of various shapes and images that are glued onto a surface. Figures 23 and 24 demonstrate order and focus. Figure 25 reveals otherwise. It is a piece of cardboard covered in photographs, advertisements, and a newspaper

clipping with the headline "Medicine: 'It's a matter of priorities.'" The images, which contain photographs of family members (blocked out to protect their identity), are arranged in a haphazard manner. Whereas some of the images seem to have been carefully cut, others appear to have been ripped, causing jagged edges. This composition, built up of layered imagery, seems to reveal a loss of control and focus, with a great deal of frenzy and ill-defined energy.

The portfolio included a large number of photographs, most in sepia tones. Some are of people whom the defendant obviously knew; one woman is repeatedly represented, perhaps a relative or a significant other. Due to their identifiable and personal nature, the only examples in this book show no recognizable features, such as figure 26. It seems to have a deliberate, yet unusual composition.

The photographs—some quite humorous, and others eerie—reveal the most control and focus of all the artwork in the portfolio. The camera offered distancing from the intended creation, allowing cognitive control and reflection. Of all of Ward's pieces, the photographs are the most consistent.

That is not to say that all of Ward's imagery is not in some way consistent. The 26 figures in this chapter were chosen from almost 100 images. The defendant's style and talent were unvarying, and the graphic indicators and formal elements remained generally unchanged: he had a tendency to develop fragmented, inconsistent compositions, with additional objects that seem out of place. Composition does change; some of his art pieces are fairly constrictive or barren, whereas others are fairly expansive, with a great deal of energy. While these images demonstrate talent, it seemed to me that they also reveal the presence of a mental illness.

A TENTATIVE CONCLUSION

The idea that art can reflect the mental state of a person dates back to Hans Prinzhorn, who, in the early twentieth century, was the first person to systematically catalog and categorize the art of the mentally ill. Prinzhorn evaluated approximately 5,000 art pieces completed by 450 patients with mental illnesses while he worked at the Psychiatric Institute of the University of Heidelberg (Caiger-Smith & Patrizio, 1997; Prinzhorn, 1922/1995). Since then, many psychologists and therapists, and later art

therapists, have seen the value of artistic and creative expression for those suffering from various mental illnesses; an understanding exists that there may be a fine line between creativity and "insanity." Indeed, "artists are driven to create by their psychological issues" (Panter, 1995, p. xii).

As an art therapist, I am not in a position to diagnose a client. I have neither the credentials nor the certitude that would allow me to do so; it is certainly out of the purview of my professional identity. However, my education and experience have provided me with the skills and ability to evaluate the art of an individual to determine the possible presence of a mental illness and to use this knowledge to support diagnoses prepared by other clinicians and influence a treatment trajectory. I made this clear to Lisa Peters during our initial conversation. She recalled that "you said in an early conversation that what you could do was not make a diagnosis, but you could support a diagnosis, and I recalled that and when you said that, I thought, well that's good." Therefore, it was important that I offer a general conclusion, not a definitive diagnosis. In order to do so, I spent a great deal of time reviewing the art and drawing from my own experiences and the available literature before arriving at a conclusion.

DIAGNOSTIC CONSIDERATIONS

My experiences and review of thousands of pieces of art over the past 20 years allowed me to conclude with some confidence that Kevin Ward had a form of mental illness. However, I had to narrow it down to what kind. Various elements in the art forced me to vacillate between a dissociative disorder and some type of Schizophrenia. To provide a comprehensive understanding of the ambiguity and complexity of this evaluation process, I begin by explaining why I first thought this art could reflect a Dissociative Disorder.

Dissociative Disorder

Dissociation is defined as a "complex process of change in a person's consciousness that causes a disturbance or alteration in the normally integrative functions of identity, memory, thought, feeling, and experience" (Cohen & Cox, 1995, p. 296). Often brought about by trauma, such as a severe accident or ongoing child abuse, dissociation, in its extreme, is often recognized as Dissociative Identity Disorder (DID):

"the presence of 2 or more distinct identities or personality states (each with its own relatively enduring pattern of perceiving, relating to, and thinking about the environment and self)" (American Psychiatric Association, 2000, p. 519).

At first review, several elements in some of Ward's art pieces were possibly indicative of dissociation. Relying on Cohen and Cox's *Telling Without Talking: Art as a Window into the World of Multiple Personality* (1995), I compared several of the defendant's images with the categories the authors highlighted. To be frank, although I had worked in a psychiatric hospital in the late 1980s that included a unit specifically geared toward treating those believed to have multiple personality disorder (now known as Dissociative Identity Disorder), I probably would not have referred to this text, let alone this possible diagnosis, until a colleague with whom I consulted suggested that I do so. It was she who lent me the book and urged me to look at the specific categories.

Cohen and Cox (1995) listed several categorical foci of the art of a client with Dissociative Identity Disorder that when synthesized with the "process, structure, and content levels of pictures facilitate the . . . identification, exploration, and gradual understanding of therapeutic art productions by dissociative clients" (p. 17):

- *System pictures* reflect "an array of individual elements forming and working as a unit that represents the current internal organization of part-selves" (p. 17).
- *Chaos pictures* illustrate extreme distress through disordered or exploding elements.
- *Fragmentation pictures* reveal a sense of disconnection and disunity, depicted by fractured or shattered elements.
- *Barrier pictures* include structures that show separation of elements, reflecting a separation of self from reality or of ego states.
- *Threat pictures* contain menacing imagery, representing warning to an altered state.
- *Induction pictures* "feature primitive markings or [are] characterized by dotting, spiraling, or meandering lines; they reflect the process of going into a trance state" (p. 17).
- *Trance pictures* communicate information that cannot be put into words by combining a variety of visual strategies to create scenarios that defy objective reality.

- *Abreaction pictures* graphically record aspects of repressed or disso-ciated memories and experiences before, during, or after their recall, release, and processing in psychotherapy.
- *Switching pictures* concretize shifting from one ego state or person-ality to another, evidenced by changes in media, strategies, styles, and graphic development.
- *Alert pictures* simultaneously reveal and conceal experiences of abuse, dissociation, or multiplicity by making use of the multi-lev-eledness of images.

Many of Ward's images can be, and have been, described as fragmented, with disconnected and shattered elements. Many of his compositions are chaotic, illustrating distress and disorder. Many of his sketches include incomprehensible shapes and forms with no clear relationship to one another. The collage in figure 25 certainly seems chaotic. The scribbled line highlighted in figures 7 and 9 to 11 could contain features of induction pictures. The backgrounds in figures 20 and 21—diffuse, pastel-colored concentric circles—are evocative of induction as well, for, as Cohen and Cox (1995) pointed out, "the process of making the artwork and the diffuse effect . . . facilitate the client's shift into an altered state that is free-floating and without boundaries" (p. 134). The changes in style and composition among the images may even reveal switching pictures. Many of his works that represent pain or attack, such as the collage in which a tiger is attacking a person (figure 24), may reflect alert pictures.

Despite the intriguing possibility that Ward had such an exotic, con-troversial, and unusual malady as Dissociative Identity Disorder, after careful deliberation, I rejected this diagnosis. There are certain types of drawings that Cohen and Cox (1995) indicated are necessary for a diag-nosis of dissociation, but they do not readily appear in the portfolio I received from the attorneys. They include system, barrier, trance, and abreaction pictures—categories that I would expect to be required for those who dissociate and develop multiple personalities.

Those suffering from dissociation do so because of repressed memo-ries of horrific experiences, often causing trance states, a "splitting" or fragmenting into different personality states, and a need to erect "barri-ers" to protect the fragile ego. Eventually, someone with such a condi-tion may develop a "system" in which the various personalities create an internal working condition. According to Cohen and Cox (1995), those

suffering from a dissociative disorder reveal their symptoms through the types of images that the authors cataloged. If these kinds of images are not present, the remaining pathological symptomology reflected in the art is likely caused by another type of mental illness.

At first review, the differences in style and composition among Ward's pieces may have been considered to represent a "switch." However, there is enough similarity among all the works that the differences are most likely *not* due to a shift between ego states or personality. Rather, they may result from a change in mood and an acute exacerbation of a mental illness not yet considered.

Some of the types of pictures that Cohen and Cox (1995) outlined— chaos, fragmentation, threat, and induction—contain characteristics that are reminiscent of diagnostic criteria other than those of Dissociative Identity Disorder, and each of Ward's pieces would have to be evaluated and considered in relation to all the others. I decided to examine the images again to look for a criterion that could be more inclusive. My experience providing art therapy services for many people with a range of mental illnesses, along with a more thorough review of the art, led me to instinctively contemplate some form of Schizophrenia.

Schizophrenia

In the early twentieth century, Kraepelin (1919) "combined three syndromes (catatonia, hebephrenia and paranoia) into a single disease concept termed 'dementia praecox'" (cited by Carpenter & Strauss, 1979, p. 291). Recognizing that it was not really a form of dementia, and after undertaking a comprehensive and systematic examination of this illness, Bleuler (1911/1968) relabeled the cumulative symptoms as "group of schizophrenias." Later, simplified to "Schizophrenia," the term "emphasized the fundamental psychological effect—the splitting of associative processes" (Carpenter & Strauss, 1979, p. 291).

In essence, Schizophrenia is "best characterized as a process of psychic disorganization whereby personal experience becomes distorted in unusual ways. Typical of such experiences are deterioration and fragmentation of perception, thought and emotion which can lead to social withdrawal and a dysfunctional reality orientation" (Amos, 1982, p. 131). Rabin, Doneson, and Jentons (1979) indicated that Schizophrenia results in a loss of ego boundary and self, developing into a diffuse sense of

identity: people with Schizophrenia have difficulty with "disintegra-
tion . . . of boundaries of self, time, space, motion and perspective"
(p. 213), and "represent much more radical breaks with reality" (Badcock,
1983, p. 133). The individual suffering from Schizophrenia may exhibit
greater fragmentation and disorganization in thought processes. Crespo
(2003) stressed that

> what has occurred is that the person's ego has ceased functioning as the
> mediator and synthesizer between the unconscious paralogical inner
> world of emotions, thoughts, and wishes in regard to the conscious,
> logical and conceptual world of outer reality. [This results in] ego
> regression and disorganization; confusion of self and fusion between
> self and non-self . . . depersonalization in which emotions are felt to be
> separate and unreal from thoughts and actions. (p. 184)

Ultimately, this results in someone who is essentially unable to relate to
others and is confused between what is real and what is not real.

Little has changed over the years on how to describe the Schizophrenic
syndrome. The diagnostic criteria, however, continue to be methodically
and meticulously strengthened and clarified, with a clear description pro-
vided for systematic consideration. At the time Ward's art pieces were
reviewed, the revised fourth edition of the *Diagnostic and Statistical
Manual of Mental Disorders* (American Psychiatric Association, 2000)
was used for referencing mental illnesses. Schizophrenia was included in
the section on psychotic disorders, which elicit hallucinatory and delu-
sional symptoms, and may also include disorganized speech and disorga-
nized or catatonic behavior: "The essential features of Schizophrenia are
a mixture of characteristic signs and symptoms . . . that have been present
for a significant portion of time during a one month period . . . with some
signs of the disorder persisting for at least six months . . . associated with
marked social or occupational dysfunction" (p. 274). These symptoms
include two or more of the following: delusions, hallucinations, disorga-
nized speech (for example, frequent derailment or incoherence), grossly
disorganized or catatonic behavior, and negative symptoms (affective
flattening, alogia, or avolition) (p. 285). Schizophrenia has five subtypes:
paranoid, catatonic, disorganized, undifferentiated, and residual.

While it would be impossible, not to say clinically unethical and mor-
ally unfair, to label someone with such an illness without meeting with

him, certain characteristics of Ward's art lend themselves to supposing the presence of symptoms that characterize this diagnosis. Or, as Crespo (2003) noted, "schizophrenic artists reveal their symptomology through their artwork" (p. 186).

The art of people with Schizophrenia presents a number of consistent characteristics reflecting this disorder. Jakab (1969) recognized that it reveals their poor psychological experiences. Amos (1982) indicated that there are "expectations . . . that broken contours may be reflective of indefinite or permeable ego boundaries" (p. 133). He also explained that permeability of boundaries and transparent objects may also reflect ego diffusion. There may be the omission of major body parts (Crespo, 2003), and drawings may signal perceptual disorganization. The composition may be badly or densely organized, with floating figures and disconnected body parts (Jakab, 1969), or open, poorly filled space may be prevalent (Cox, 2000; Lane, 1982). Crespo (2003) pointed out that the artist with Schizophrenia may fill all the space with shapes "until there is nothing left empty" (p. 185). Arnheim (1977) indicated that this response to open space may be a result of what he termed a "horror vacui" (p. 116), a fear of open space. The art may exhibit "bizarre condensation"—that is, combining body parts of animals and people for impulsive rather than for creative expression (Crespo, 2003). While the lines of a drawing may alternate from tentative and static to bold and dense, the organization may be fragmented and loose.

Honig and Hanes (1982) recognized that those with Schizophrenia suffer from *ego boundary diffusion*, which may result in creating elongated or floating figures; using bright, poorly integrated colors at times and, cool, dark, or too few colors at other times; not finishing projects and compositions; poor "grounding," with confusion of background and foreground; and labeling images with highly idiosyncratic symbols. Crespo (2003) believed that the fusion between object and background is a result of the tendency to fill all empty space with a dense and disorganized composition. It may also be due to a "lack of boundary in perception . . . [resulting] in an inability to distinguish between self and non-self" (p. 186).

Bender (1981) indicated that a child with Schizophrenia may experience anxiety "resulting from lack of differentiation and disorganization in all functions, including the visceral, motility, and perception, and also because he had difficulty in matching perception to reality" (p. 6). These

characteristics, which I do not believe are restricted to just children, materialize in creative expression. They emerge through disorganized, yet prolific drawings that lack spatial orientation and have poorly planned compositions. Such anxiety may also be revealed through timid line quality (a hesitance or resistance to committing to a line) or dense lines (more of a tendency to scribble or attack a sheet of paper), to help alleviate or redirect the anxiety.

Although the five subtypes of Schizophrenia make it difficult for art therapists to pinpoint exact artistic benchmarks for the disorder, many of the characteristics already mentioned serve as indicators for the general malady. Despite the advanced age of some of the literature, many of these criteria are consistently cited in current research. Along with the aforementioned indicators, current assessments reveal the presence of a bizarre gestalt to an entire composition (Gantt & Tabone, 1998; Teneycke, Hoshino, & Sharpe, 2009; Ulman & Levy, 2001), with fragmented or poorly integrated composition; overwhelming detail (Lane, 1982); deformed imagery (Gantt & Tabone, 1998); and, at times, the inclusion of words or numbers that are unrelated to or unnecessary for the composition (Cohen, Hammer, & Singer, 1988; Gantt & Tabone, 1998). The addition of excessive words, numbers, and phrases is reminiscent of the identifying characteristic of "word salad," an extreme loosening of associations, usually presented verbally, that signals the presence of a thought disorder (American Psychiatric Association, 2000). This may present itself as "an irrational telegraphic style of utterance, almost totally lacking in sustained sense" (Badcock, 1983, p. 141).

In sum, the characteristics in artworks that may reflect Schizophrenia include

- Fragmented imagery
- Chaotic and disorganized composition
- Floating figures
- Disconnected or omitted body parts
- Diffuse imagery that at times makes it difficult to distinguish background from foreground
- Varying and inconsistent line quality, at times light and sketchy, and at other times, heavy and dense
- Inclusion of words and numbers that are bizarre or unrelated to the rest of the composition

These characteristics seem to be pervasive throughout Ward's entire collection. For someone who has talent and skill, he appears to include an abundance of bizarre forms and unsystematic, haphazard, and deformed imagery in his work. Most of Ward's images reflect chaos and fragmentation. Many of the compositions in his sketchbook disregard any organization. The images and symbols are jammed together and are replete with floating forms, including heads. He demonstrates inconsistent line quality, ranging from light and sketchy to dense and heavy, at times ripping through the page or combined with words and phrases unrelated to the piece. There is a tendency toward condensation in several of his compositions: for example, bicycle wheels morph into the eyes of a face (figure 4); a human figure transforms into a landscape (figure 8); faces are embedded in a multicolored pillar (figure 18); and animals appear beneath a naked torso (figure 19). There seems to be an inability or unwillingness to distinguish background from foreground (figure 2). Although not readily apparent in the black-and-white reproductions, color appears to be used indiscriminately at times (figures 2, 11, and 18). A number of unclear symbols crop up throughout the compositions, including flames or fire, various animals, explosions, and stylized figures. The indiscriminate inclusion of scribbled lines, marring the intricate forms on the page (figures 7 and 9–11), seem to reflect a loss of control and focus.

As made clear throughout the literature, a telling indicator of Schizophrenia is the presence of poor orientation to reality, exhibited through delusions or hallucinations. I could not definitively conclude from my evaluation of the images that Ward suffered from such tendencies, and I was not sure if he demonstrated disorganized speech or behavior, reflecting a disorganized cognitive process. This could not be ascertained until I met with him. Until then, while the art may reflect such benchmarks and characteristics of Schizophrenia, these conclusions remained an assumption. I would, therefore, have to be careful when presenting these perspectives to the defense attorneys.

ANOTHER DIAGNOSTIC LAYER

Another criterion that became conspicuous while reviewing Ward's compositions was the varying energy levels revealed in them. While the literature supports the view that condensed, intricate compositions and extensive use of space can be just as indicative of Schizophrenia as a

minimalistic composition, I suspected that the variation of space and color use may have been caused by another mental condition. I began to surmise that he may also have suffered periodically from a mood disorder, specifically Depression.

Those with Depression demonstrate a marked lack of energy, psycho-motor retardation or agitation, difficulty focusing and concentrating, and a depressed mood (American Psychiatric Association, 2000). Indicators of Depression emerge in Ward's art through the constricted use of space, lack of detail, absence of color or use of unusually dark colors, and nonexis-tent environment (Gantt & Tabone, 1998; Groth-Marnat, 1997; Gussak, 2007a, 2009). While some of Ward's works reflect a heightened energy level, an expansive use of the page, and colorful imagery, others demonstrate a minimal or no real color choice, a limited use of the page, and simplistic imagery. Figure 22 is just one example of a decrease in energy and detail. While Schizophrenia may not fully account for such images, Ward may have had a concurrent difficulty with a mood disorder. Such a combination of schizophrenic-like symptoms and a mood disorder is labeled a Schizoaf-fective Disorder (American Psychiatric Association, 2000, p. 319).

A Schizoaffective Disorder is a combination of the symptoms noted for Major Depression, Mania, and/or Bipolar Disorder, and those for Schizophrenia. The criteria include hallucinations, delusions, disorga-nized speech, and bizarre behavior (American Psychiatric Association, 2000)—thus my conclusion that Ward's art reflects a Schizoaffective Dis-order. Due to my reluctance to provide a definitive diagnosis, I chose to present my conclusions with descriptors rather than a diagnostic label.

FOLLOW-UP WITH LISA PETERS

On May 1, 2007, several weeks after receiving the disk of images, I spoke with Lisa Peters on the telephone to discuss my findings. We both referred to a copy of the digital portfolio. I once again reiterated my reluctance to offer a diagnosis and my belief that the best I could provide was a tentative assessment; I would have to meet with the client, talk with him about his art, and conduct an art-based assessment before I could be more certain. I also underscored that if I agreed to do this, and if the firm agreed to use my services, I would not be testifying for or against the client; I would testify strictly on the art. Peters clearly understood these conditions.

I proceeded to outline for her the strategy I had undertaken in reviewing the art, all the diagnostic criteria I had considered, and the reasons for my having done so. I was honest with her, indicating that I initially had considered Dissociative Identity Disorder. However, after contemplating it for some time, I turned to a more likely condition, Schizophrenia, with a possible mood disorder. She asked me to be very clear about how I had reached this conclusion and to indicate, using the digital portfolio, the images and the characteristics in each image that had prompted it.

We reviewed almost all 100 slides; some we discussed for only a few seconds, while others we considered at length. I described the images, paying particular attention to line quality, space on the page, composition, color use, and perceived content. I also offered tentative assumptions about when the pieces may have been completed in relation to one another, speculations about any education the defendant may have had, conjectures about moods he may have been experiencing when completing selected images, and thoughts about when he may have been exhibiting an exacerbated symptom of the schizophrenic-like illness.

Once I finished presenting my initial conclusion, that the art reflects Schizophrenia and Depression, Peters offered no additional information and no opinion about what I had presented. It was only in a recent conversation with Peters that she revealed that she had become excited that my verbal report corresponded with the conclusion arrived by the psychologist and psychiatrist—a diagnosis of Schizoaffective Disorder.

Before ending the conversation, she explained that she had to consult with Jackie Chief, but it was likely that they would contract for my services. She also indicated that they would eventually expect me to prepare a formal report on what we had discussed; however, I was not to write the report until I heard back from her. Over the next 2 months, I received e-mails from Peters reporting that Chief still had not received the funds for my services from the court, but that I would eventually hear from the firm. It would be almost 2 years before the defense team contacted me again.

During those 2 years, I continued to review the art, purely out of personal fascination. However, I was somewhat frustrated that I was unable to use the images for even educational purposes—since I had signed the confidentiality form that prevented me from using the art for anything other than the legal case—until the trial was finished. I had not written the report on what I believed the art reveals, since I was asked to wait

until I heard from the defense team. I also did not have any additional information about the defendant. I would not learn about the details of the crime until I met with him, and it was not until just before I was to testify that I would discover how much of what he told me was accurate and who he really was.

WHO WAS THE DEFENDANT?

Who was the man I would be asked to support? I did not learn much about the defendant and what had led up to his crime until well into the process.

Kevin Ward was in his mid-30s at the time of his sentencing. He had experienced, according to his family members, a tumultuous childhood. His parents divorced when he was young, after his father was accused of molesting his stepdaughters. Ward was very close to his father, who was described as inconsistent with his attention.

As a child and an adolescent, Ward moved several times. He did not have a good relationship with his stepfather. His mother, during her testimony, indicated that Ward was depressed a lot during his adolescence. He did not socialize well, he slept a great deal, and his personal hygiene deteriorated. He got into some run-ins with the law and was once ordered by the court to attend counseling. His schooling was erratic, and he eventually dropped out of high school.

He had serious difficulties with drug use, which resulted in an arrest for possession of a controlled substance. He also was arrested on several occasions before his final offense.

He was homeless at one point, but began to "blossom" when he got a job in the food-service industry. This culminated in a good position at an upscale restaurant. He eventually left this job and moved to a different state to be near a family member. While he later managed to hold down a few other jobs, his employment opportunities weakened. He became depressed again.

He married and had two children. Shortly after his children were born, his marriage—and his mental health—began to deteriorate. The family's house soon became cluttered with trash. According to his social history, Ward was described at this time as being obsessed "with bizarre religious beliefs." He seemed to do well at another local restaurant, but soon left

because of his "inability to interact with people." Despite all this, he seemed to flourish in the art classes he attended at a local community college.

His marriage continued to decline. According to his wife, he began to abuse drugs and was becoming violent; he hit her on several occasions. She ordered him from their home. Shortly before the crime took place, she filed for a restraining order, with plans to file for a divorce. After his wife called Ward to tell him of her intentions, he became upset.

A short time later, while brandishing a knife, Ward took his two young children from the home of a relative with whom they were staying. Four hours later, an Amber Alert was issued. Despite being located in a secluded area by the police, who attempted to intervene, Ward attacked both children with deadly force.

The police officers were able to rescue Ward's toddler-age child, who, although suffering from severe wounds, was soon listed in stable condition. They were not so lucky with his older child, who died immediately. Ward was also hospitalized for self-inflicted wounds. Medical tests revealed that he had drugs in his system.

The prosecution insisted that that crime was committed because of Ward's drug use. The defense contended that he had a mental illness, which resulted in his son's death. I did not know any of this before meeting him in the early summer of 2009—several years after the murder.

2

THE JAILHOUSE MEETING

A month before I was scheduled to meet with Kevin Ward, I was told that the defense team had accepted a plea agreement with the prosecution and the court—Ward would plead guilty and, in return, would not be put to death. However, he would still have to appear before a judge to receive his prison sentence, which was not to exceed 100 years.

Despite the plea bargain, I was still expected to meet with Ward and provide an assessment report to the defense team. The sentencing hearing was scheduled for the following month, and the defense attorneys planned to include my report with the documents they would be submitting to the judge for final consideration. Following my 4-hour session with Ward, the defense counsel requested that I testify in person at the sentencing hearing, so the judge could "see the art and hear what I had to say."

MEETING THE DEFENDANT

ARRIVAL

I arrived at the county jail just after noon on an early-summer day in 2009. Kevin Ward was not yet ready to see me. The sheriff and an officer were quite accommodating. Unfortunately, they were short-staffed that day and were delayed in getting him out of his cell. Ward stood by the door of his single-person cell at the end of the hallway and watched me talk with the officer behind a monitoring desk. The officer told me that Ward was eager to speak with the "art professor." This was reassuring,

since Jackie Chief had warned me that he was unpredictable; he may be either gregarious and cooperative or resistant to speak.

Shortly before 1:30 P.M., I was taken to the small meeting room where I would speak with Ward. It was several paces from the first locked entrance, in a short hallway that led into the main jail. It was furnished with a small wooden table on wheels and three loose, metal chairs. Although no guard was posted inside or by the door, the officer behind the desk monitored our interactions through the video-surveillance camera. There was also a panic button to the right of the door, should I feel threatened. I was allowed to bring in a laptop computer to show the defendant the images I had of his art pieces so we could talk about them. Shortly after, he was brought into the room.

KEVIN WARD

Kevin Ward was of average height, bordering on overweight; he had a pale, unshaven complexion. He was expansive and affable, asking many questions about my role as an artist. He spoke loudly and with pressured and rapid speech, which became more so as the session continued. He waved his hands around wildly when he spoke. At times, his thoughts and comments became tangential and unrelated, until he finally lost the focus on what the current discussion was about. He frequently had to be redirected and refocused. When asked, he indicated that he was not taking any medications. From the beginning, it was apparent that Ward and I had different agendas—I wanted to assess his mental health, and he wanted to speak with someone who knew something about art. I did explain in detail what was expected of me from the defense counsel, and I told him that I was there to assess his mental health and would provide the defense counsel with what I found. He signed the release form that allowed me to use his art for educational and publication purposes.

One of the dangers of writing about someone who may have a mental illness is that some of the statements and concepts expressed may be unclear, ambiguous, or unrelated, making it difficult to maintain the focus of the reader. A choice, then, has to be made whether to present the statements verbatim or edit them to allow for clarity. The best solution is to attempt to do both—develop a clear narrative with hints of the inconsistencies, disconnections, and ambiguities to provide the reader with a semblance of what is experienced. This is what I have aimed for here.

However, I do not want to convey the impression that Ward was never lucid; at times he was. This made the digressions and fragmented statements that much more apparent.

He had with him a disheveled, brown accordion-file folder stuffed with a drawing pad, magazines, and books. He opened it to show me some of what he had been working on in his cell, images of dancers drawn with a blue ballpoint pen. The magazines and books were about subjects that "caught his interest." While pulling out his artifacts, he stressed that he was quite intellectually gifted and enjoyed learning. For example, he was currently teaching himself Greek. He was also religiously astute, at times referencing the Bible by book, chapter, and verse—for instance, 1 Corinthians 4:9 and Hebrews 13:2. He simultaneously apologized about the quality of the art I had been provided, indicating that the images demonstrated little to no talent. He qualified this apology by stressing that I had seen none of his paintings, which reflect his real ability; what I had received were merely "thumbnails."

Ward maintained that he had no art background and no true understanding of art history. When asked how he had learned about art, he answered that he had "picked up some knowledge here and there." He did express appreciation for Paul Cézanne, pointing out that he, too, had not become known until later in life—implying, of course, that he would soon be known for his art. He referred to his copy of Galenson's *Old Masters and Young Geniuses* (2005), stressing that I would better understand him after I read it.

He made several extravagant and self-aggrandizing statements about his art. He signified that his responsibility in creating the art was to "capture the unseen . . . the other side; life, death, love; I capture these emotions."

He did reveal his strong motivation to create: "I had to get it out . . . [and] to create or I would explode." He hated drawing while he was growing up, choosing to focus on painting and photography. His favorite type of photograph was created by setting different objects on fire and combining digital and infrared film to "challenge the viewer . . . is it a painting, a picture? I would push the boundaries . . . show the sign of the time."

His art had been found in his garage, in what he referred to as his "studio." He said that others thought his garage was a "real mess," calling him a "real slob," but he was proud that his "studio" was "disorganized."

He referred to an article that he had read about the messy studio of the twentieth-century artist Francis Bacon; he enjoyed it, gleaning a sense of validation. However, it was not clear until later that day, when the defense team showed me photographs of it, that I found out how messy his garage really was. His concept of "messy" was greatly understated.

He complained that those who had found his art had done a poor job of choosing pieces that represented him and that the images had been handled carelessly. He pointed out one example of the way the art had been treated. It is just a fragment of a larger work that was ripped as a result of having had to be peeled off the floor (figure 27). However, what he failed to understand was that the condition of the piece was his responsibility, not the fault of those who had collected his work; he did not, or refused to, understand that the piece had stuck to the floor because of the sloppy state of the studio.

Other pieces had been stored at a relative's house, works that he claimed particularly reflected how he had felt at the time he committed his crime. Without these pieces, he said, it was impossible to really understand him. He said that his relative claimed to have burned the paintings, but he believed that she chose to keep them rather than return them. This seemed to be more of a paranoid response. This complaint spiraled into a sequence of unconnected statements about conflicts he experienced with others, including family, who did not understand him.

He believed that his relationships with others suffered because of his need to focus on his art: "[I]t's like having two relationships, art being a mistress as well." He saw himself as the misunderstood, suffering artistic genius. He said that he spent a lot of energy trying to convey his perspective. He believed that he was a messenger who had been given the responsibility to show the world what he knows—the difference between good and evil, and between angels and devils—and to illuminate the pathways between everyone. According to him, these themes emerged throughout his portfolio.

He indicated that his marriage had allowed him little time to do art. This resulted in his feeling "bottled up and depressed." When he was reminded that he still had been artistically productive when married, he indicated he was able to "satisfy both mistresses after getting onto meth[amphetamines], which allowed me to stretch time." This was his first reference to his drug use. It should be stressed that many of the pieces in the portfolio had been done before his addiction.

He interrupted himself to say that "in this room there's as—load of angels listening and enjoying this conversation." He blamed the devil for the way he felt; it was he who ultimately had led him to the path of his crime. However—and it was important for him to clarify—it was not the devil who had forced him to commit the murder, but he had done so out of love, a desire to protect his children from "all the evil of the world." He "too" had experienced much abuse; he recounted the struggles that he had undergone. He wanted to keep his children from such suffering. His speech became more pressured, and he gestured even more wildly with his hands.

Such diversions indicated possible delusional tendencies and tangential thought processes. However, he was easily redirected when he was encouraged to speak about his art. He stressed that "the farther I get away from myself, the more real the art becomes." He indicated he had been doing art since the first or second grade: "[E]ven then I knew tragedy was coming. . . . I knew I was different." However, he was unable to explain how being regarded as different had resulted in the murder: "I am simply a tool . . . any good [art] I do, it's Him doing it through me. Any bad I do, it's the devil." He admitted that, although it was the process of the art making that was more important, the product had its importance in conveying his messages. He insisted that he wanted to make these messages clear by describing each of his images. He was assured that he would have that opportunity, but I explained that I first wanted him to complete a few art directives.

ADMINISTERING THE ASSESSMENT

I preferred to begin with a structured, standardized assessment. In my opinion and experience, when a person is given a blank piece of paper and asked to draw whatever is on his mind, he may feel intimidated and resistant. Although this reaction may provide valuable information, such resistance may permeate the entire session, a detriment if it is unclear how much time the therapist will have with the client or if the meetings are limited. A standardized art task provides direction and focus while still allowing for creative expression. Therefore, the first assessment procedure that Kevin Ward was asked to complete was the *Person Picking an Apple from a Tree* (PPAT) drawing, which was

rated using the *Formal Elements Art Therapy Scale* (FEATS) (Gantt & Tabone, 1998).

The PPAT requires that standardized art materials be used to draw a picture of a person picking an apple from a tree. These materials include a 12 × 18 inch sheet of white paper and 14 Mr. Sketch scented colored markers. This assessment procedure focuses on the formal elements of the drawing, rather than on the meaning of its content. The formal elements are rated through a series of 14 scales, the FEATS (Gantt & Tabone, 1998):

- *Prominence of color*: How many colors are used in the entire picture?
- *Color fit*: Are the colors appropriate for the objects depicted?
- *Implied energy*: How much energy was used to make the entire picture?
- *Space*: How much of the page was used for the entire drawing?
- *Integration*: To what degree are the items in picture balanced into a cohesive whole?
- *Logic*: To what degree is the response to the drawing directive logical or bizarre?
- *Realism*: To what degree are the items in the picture recognizable and realistically drawn?
- *Problem solving*: Does the person get the apple out of the tree and how? Is it reasonable?
- *Developmental level*: Which of Lowenfeld's (Lowenfeld & Brittain, 1987) developmental stages of creative growth in children does this image most reflect? This scale ranges from a 2-year-old level to an adult level.
- *Details*: How many details are included for each element in the drawing?
- *Line quality*: How much control does the person seem to have over a variety of lines in the picture? This scale ranges from broken, "damaged lines to fluid, flowing lines."
- *Person*: Does the figure look complete and three-dimensional rather than a stick figure?
- *Rotation*: How much tilt does the tree or the person present?
- *Perseveration*: How much repetition of a single graphic element or motor act is present within the drawing? (Cuneo and Welsh, 1992)

Each element is rated along a continuum from 0 to 5. For example, if the drawn image(s) use less than one-quarter of the page, a score of 1 is accrued for space; if the entire page is used, the score is 5. The rating is completed with the standardized rating manual (Gantt & Tabone, 1998).

This rating scale was designed primarily to assess the presence of four major diagnoses:

- Major Depression
- Bipolar Disorder, Mania
- Schizophrenia
- Delirium, Dementia, Amnestic, and Other Cognitive Disorders

The diagnostic categories are assessed based on the ratings of a combination of several characteristics. For example, because Schizophrenia is revealed graphically through primary-process thinking, fragmented composition, inclusion of words or numbers unrelated to the task, additions that seem out of place, and bizarre colors, then it is expected that there will be low ratings for prominence of color, color fit, integration, logic, realism, problem solving, and person. Depression, though, may be evident through lack of color or use of dark colors, constricted use of space, no environment, and absence of detail; therefore, there will be low ratings for prominence of color, color fit, implied energy, space, realism, details, and person (Gantt & Tabone, 1998, p. 26).

Ward began the assessment reluctantly. As he accepted the materials, he complained, "I really don't like markers." He uncapped most of the markers, crumpled the paper, flattened it out on the table, and began to scribble marks on the page. He tried to blend them with his finger; when he realized he could not do so, he added water from a water glass he carried and tried to smudge the marks on the page.

He sat back and looked at the picture with a "critical eye," using open hand gestures and seemingly grandiose movements as if he were undertaking a significant art project rather than a simple drawing. It seemed important to him that he portray himself as a serious artist.

The line quality is simultaneously erratic, yet controlled. He used few colors: brown for the tree, black for the stick figure, and red mixed with green for the apple. Before he completed it, he re-crumpled the top of the tree and added a few green lines. It took him 4 minutes to finish the drawing (figure 28).

He spoke incessantly while drawing. He explained that the tree represents Jesus's cross, depicting what "the Greeks were most correct about—that Jesus was crucified on a stake-like tree." This reference seemed unclear and apropos of very little.

When the drawing was finished, Ward was given the choice to do another drawing of anything he wanted. He was offered oil pastels, chalk pastels, colored pencils, markers, and ebony pencils. He chose a large sheet of white paper and an ebony pencil. The disorganized composition, which took him 6 minutes to draw, is filled with various sketches of faces, busts, unidentified symbols, and animal shapes (figure 29): "I like to keep the pencil moving, keep it loose." The line quality is erratic, energetic, and somewhat fragmented. The images are unrelated to one another.

Immediately after and without prompting, Ward began a new drawing with the chalk pastels and oil pastels on 18 × 24 inch paper. He soon became self-conscious, explaining that he was feeling "tension" because someone was watching him work. He pointed out that he might be more comfortable if I talked about myself. For the next several minutes, I answered innocuous questions and deflected personal ones as I watched him out of the corner of my eye. He soon relaxed, talking more while applying thick layers of colored pastels. He drew and spoke frenetically, interrupting his work from time to time for various reasons, such as pulling from his file an article or a photograph from a magazine that was significant to him. His thought process remained generally unfocused and tangential. He said at one point, rapidly and without preamble: "[The murder] was tragic, but it all pushed me to be what I need to be . . . but I don't yet know what that is. . . . I really like layering stuff, man [*waving his hand over his drawing*]. There is so much hidden in there, you can really pull stuff out. And what people see is different for each person . . . didn't David murder, did not Moses murder?"

While speaking, Ward vacillated between remorse for his crime and justification of it as an act of love for his child. He stated that he was not happy with the plea agreement: "Death row doesn't faze me. First off, you can't kill me; we have eternity in us." He explained that he was willing to accept the consequences of wanting to "protect my kids by sending them back. . . . [However,] I won't be able to convince anyone until I become omnipotent." He did not explain this thought any further.

To regain his focus, I asked questions about his art and related experiences. I wondered how others felt about his work. He became increasingly

agitated while recounting that his wife did not like or understand his art. To refocus him, I asked Ward to talk more about the drawing (figure 30), which took him approximately 40 minutes to complete.

While working on this drawing, Ward remained unfocused, tangential, and fragmented. This is reflected in the final product. He started to draw a landscape on the vertical plane, with a pale blue sky, dark gray mountains, and a dark blue river. This morphed into a reclining female form, similar to an earlier drawing (figure 8). Halfway through the drawing, he turned the paper to the horizontal plane and sketched a face similar to those in previous works. He also emphasized the figure's single naked breast, but layered colors on top as if to cover it. He completed it with a red background, blending the colors together. He said very little about this drawing. Afterward, we began to look at his artwork on the computer.

MY SUMMARY

The following conclusions were based on the three assessment images, the way Ward completed them, and his behavior and statements made throughout the process.

According to the FEATS, he scored relatively low on prominence of color (1–1.5), implied energy (2–2.5), space (2.5), realism (2.5), details (1.5), line quality (2.5), and person (2.5), and moderately on integration (3) and problem solving (3). Accordingly, the combination of these scales demonstrates an overlap between two of the four diagnostic categories: Major Depression and Schizophrenia. The majority of the scales support possible Depression through limited use of color, absence of environment, few to no details, and constricted use of space. Schizophrenia, although not prominent, appears to emerge by the way the person is drawn, the integration of the objects, and the lack of problem solving (figure 28). It was not until he continued with two more drawings that the symptoms of Schizophrenia became more readily apparent, specifically through incoherence, impairment in abstract thinking, and loosening of associations as recognized through primary-process thinking, fragmentation, and unintelligible pictures.

As he progressed through the drawings, Ward exhibited less control and focus, displaying more bizarre behavior and loose associations. His speech became more pressured and rapid. His artwork displays a

loosening of boundaries, an erratic line quality, unrelated imagery, and no clear focus. He progressively lost personal control. It seemed that he was able to maintain focus when given a structured directive with controllable materials. However, as the directives became open-ended, ultimately finishing with more fluid materials, it may have been more difficult for him to maintain control.

The second image, drawn with an ebony pencil, displays many unrelated amorphous forms on the page, with no semblance of organization or clarity (figure 29). It may be that choosing such a rigid material, the pencil, was an attempt to "keep a lid on it." Once Ward began to use more fluid and colorful materials, it became even more difficult for him to maintain control as he exhibited increasingly bizarre behavior. The third image reveals his inability to maintain any focus; the composition possibly reflects the fluidity and tangentiality of his own cognitive limitations (figure 30).

While working on this drawing, Ward rotated the page so that he completed different images on both the vertical and horizontal planes. The drawing morphs from one image into another, with no clear relationship or rationale. He added many layers, under which previous forms and images can no longer be seen. The completed product reflects his disorganized, confused, unrealistic, and disoriented statements and concepts. It demonstrates his fluid and amorphous thought process, indicating a possible cognitive dissonance.

Despite Ward's obvious talent, elements in the three drawings, seen in many of his previous works, support the presence of mental illness: the tangential forms, amorphous and ambiguous compositions, images hidden beneath layers of complex materials, fragmented structures, erratic line qualities, and bizarre subjects. These works, triangulated with Ward's behavior while completing the assessment drawings, allowed me to conclude that he may have been exhibiting some form of Schizophrenia with Depression. The language I chose to express this conclusion allowed me to qualify this statement without offering a definitive diagnosis of Schizoaffective Disorder. I refrained from placing this label on Ward *until the hearing*, which presented some difficulty during the cross-examination (chapter 5).

KEVIN WARD'S REVIEW

After Ward finished the assessment drawings, we began to discuss his previous art pieces, referring to the images on the computer screen. I had

made tentative conclusions from them, based on their formal elements, but this review would provide me with an opportunity to hear Ward's recollections of his thoughts when he had created these works. He was quite eager to do so; he was excited at the prospect of talking about his work. He assumed that, because we both "believed in the power of art," I would understand him. Over the next couple of hours, we reviewed approximately 100 images that provide a pictorial narrative of 15 years of Ward's life.*

Ward became irritated when I showed him the first image in the computer file: a drawing with a poem written on the back (figures 31a and 31b). He said that it was a Christmas gift for his mother, made when he was in the county jail after the murder; he wondered why she had given it away. He eventually relaxed when he was reassured that the image was well done and must have made his mother very happy. He accepted that by giving the picture to the defense team, his mother was obviously trying to help.

Many of the pieces caused him to reminisce about his time in the city in which he had lived: dumpster diving, his experiences before, during, and after using methamphetamines, and some of the people he had known. Several of the images represented a "visual journal," sketches kept within one bound sketchpad.

It became clear how important his responses were, as his reasons behind some of the images were very different from my assumptions. For example, I had believed that the sketch of various facial features separated in boxes was an exercise for an art class to depict the details of facial features, reminding me of similar exercises I had completed as a student (figure 32). I was surprised to learn that Ward had done this drawing on his own. Each box portrays an emotion—he called it "different 'pick-ups,'" indicating that we can learn to "pick up [emotional] signs from looking at people." However, his description of each box was devoid of emotional terms. From left to right, top to bottom, he indicated that they are "window, pungent, lips, eyes are different, deadpan and little details."

An issue with certain mental illnesses is the inability to recognize emotional cues or the tendency to be "blunted" toward feelings. Ward

*Some of them are not presented in either chapter 1 or here, since they contributed no additional insight. Those that are discussed, along with Ward's comments on them, revealed clear patterns.

revealed that he practiced identifying emotions through various facial "pick-ups," and yet, even in the drawing's description, he did not succeed in doing so. He was unable to relate to any emotion. When I reflected that the composition seems somewhat "fragmented," he retorted, "I've always been one to fragment people."

Several images are sketches for bigger pieces that "held a great deal of action, a lot of explosions." This was because "life is never stable, always moving." Several of these images depict what Ward called a "pathway" (figures 7, 10, and 33). In some works, this amounts to nothing more than a rapid scribble that divides the page, seemingly added as an afterthought in the midst of other, unrelated images. For Ward, this symbol represented a journey, a need to travel along to learn and gain understanding. The symbol remains consistent over time; figure 10 was completed well before he was ever in jail. Rather than admit to losing control and focus in the middle of drawing a portrait with a scribble (figure 33), Ward indicated it was a tie that became a "pathway."

Another term he used often was "synergy," which means "the combination of actions or functions." However, it was never clear how Ward was using this word. He tried to explain that it refers to a mystic sense of connection among the various symbols, but his explanation became disjointed and confusing.

A drawing often sparked a memory for him, in some instances causing him to digress and make bizarre and unclear references. For example, in the middle of figure 16 are a star plus a little figure, and together they became "Star baby." Ward remembered, "My wife told me that I told her 'You didn't marry a person, you married a star,' and I never said that. It's easy for others to interpret 'Star baby' as supporting this, but it actually comes from the devil." To shift him from this symbolic equation, which seemed to instigate anxiety, I asked him about the word "Tired" on the same page; he sighed and said, "I've carried a lot of weight for a long time." Incidentally, the elongated, square shape with facial features in the bottom half of the page was also described as a "pathway."

While this may seem like an incidental assertion, it is not unusual for those who have developed a mood disorder (Fortune, Barrowclough, & Lobban, 2004) or mental illness such as Schizophrenia (Schneider et al., 2004) to describe their symptoms through pressure and weight, feeling weighed down. Ward already revealed that making art allowed him to relieve pressure. This was echoed clearly through the image he labeled

"Mind Cage" (figure 17): "That's how I felt—I'm the person inside the cage; it's the art wanting to get out. Without the tools or skills to project it; I could see it but I couldn't get it out."

It was also common for him to refer to the devil or evil: "One thing I really enjoyed was bestiality; mixing animal parts with human parts [in drawings] . . . these are raw . . . he knows he's ugly, look at the sorrow—its me . . . and everyone . . . everyone doubts themselves . . . its what the devil does to everyone." This is the first time he identified with a strong emotion: sorrow. While he seemed to admit to an emotion, he first negated it by subscribing it to everyone, and then blamed it on an outside force: the devil. Through this one sentence, he demonstrated his unwillingness or inability to maintain emotional connections.

Those with a mental illness may also believe that they are possessed; for some, possession may be easier to understand:

> It is no great mystery . . . why so many patients, utterly perplexed and bewildered by their symptoms, reject outright the banal medical or behavioral models of mental disorder and powerful pharmaceutical remedies foisted upon them by well-meaning physicians and psychotherapists. . . . By comparison, the outmoded (though evidently still very meaningful) myths of the "devil" or of "demons" provide a far more viable (yet still woefully inadequate) alternative hypothesis to hang onto. (Diamond, 1996, p. 122)

Despite the 15-year span of time these images encompass, they are consistent in style and format. All of them show a heavy-handed application of marks on the page, almost revealing urgency and insistence. However, within the regularity are differences that reflect the deviations in mood and states that Ward was capable of experiencing within brief periods. This is evident in the three assessment drawings (figures 28–30). It can also be seen in figures 22 and 34. In figure 22, Ward sketched what he referred to as both a woman and an hourglass. The barrenness of the form, uncertainty of the lines, lack of grounding, and expanse of the page reveal a stunted emotion, perhaps Depression. This contrasts sharply with figure 34, completed shortly after. He even revealed, "This is when there is overload."

The layers cover up images of the female form, similar to what was done in the third assessment drawing (figure 30). There is a definite lack

of control and a loss of focus; the erratically filled composition and dis-regard for the careless marks put on the page exhibit a level of mania and anxiety, perhaps even an internal struggle of pressure and explosion. Such disarray, although present in many of Ward's other images, is much more pronounced in this one.

Both images reflect a tendency to disregard the human figure, through either objectifying or covering it. In figure 22, the female form is simply an hourglass, similar to the transformation that occurs in figures 8 and 30, in which the reclining female form becomes part of the landscape. This seems to dehumanize the figures. In several works, such as figure 34, Ward did not transform the human figure but layered colors on top until it is no longer recognizable. These pieces demonstrate an interesting contradiction—he accentuated the human form in some of his images, and suppressed it in others.

When Ward discussed his photography, he indicated that he enjoyed "playing with the shadows" to demonstrate the "contrast between fire and shadow." Figure 35 captures not only his talent but also a dark con-tent. By manipulating the perspective, light, and shadows, he depicted one figure choking another.

Another photograph is of a girl reading a burning newspaper (figure 36). While a fairly ordinary shot, what is chilling is how he prepared the model. Before snapping her picture, he told the little girl to "read it [the burning newspaper] as if you found out that a horrible thing happened to your family." The prescience of this statement seemed unintentional and yet, in hindsight, was quite foreboding.

Unfortunately, this narration, albeit sprinkled with fantastical state-ments, does not clearly capture Ward's difficulty with staying on task and focused. He often had to be prodded to speak clearly, finish his thoughts, and refrain from making nonsensical statements. This seemed to worsen as the session continued, as if the more tired he became, the less strength he had for "keeping it together."

After we finished discussing the images, Ward continued to ask ques-tions about his techniques. He was also quite interested in the possibility of taking part in art therapy after he went to prison and became excited about the chance to get an education while incarcerated: "You can get a Ph.D.!"

By the end of the session, Ward seemed more resigned toward the plea agreement and recognized it as an opportunity to continue getting his

message out. While he concluded the meeting by insisting on his determination to communicate the message of good versus evil for his fellow inmates, it seemed as if he had used up much of his energy; he went back to his cell quietly. The session ended at 5:25 P.M.

OVERALL CONCLUSION

As discussed in chapter 1, after viewing the original collection of artwork I had concluded that the art reflects a form of Schizophrenia with a possible mood disorder. After my meeting with Kevin Ward, my conclusions remained consistent. His bizarre behavior, loose associations, tangential thought processes, and, at times, delusional grandiosity, combined with remnants of paranoia, contributed to the notion of a mental illness. This, coupled with the indicators in the art pieces—many of which maintain fragmented composition, unrelated writing and numbers, and additions that are clearly out of place—denote some form of Schizophrenia.

Some of his images reveal sparse composition and constricted use of space, lack of detail, and markedly diminished energy. Others show a great deal of activity and agitation, bordering on loss of control; layering of many colors; expansive use of space; and abundant yet unrelated details. These graphic markers seem to support a swing from depressive tendencies to an expansive mood, indicating a possible mood disorder. Together, the conclusions derived from the original review of the art and the assessment remained steadfast: Ward exhibited schizophrenic-like symptoms coupled with a mood disorder—essentially, a Schizoaffective Disorder.

The graphic indicators are consistent throughout all the images: some of them were completed well before the commission of the crimes (including a time before he was using methamphetamines); some, just before the crimes; some, while he was in jail; and three, for the assessment. This indicates, perhaps, that Ward had these symptoms for some time, and they were in fact still present. The prosecution would stress that his symptoms, and eventually the crimes, were a result of drug use. While he may have been on methamphetamines at the time of the murder, it seems that the images show that he suffered from a mental illness that had gone unchecked well before his drug abuse. The symptoms, and the graphic indicators in his art, did not change over the previous 3 years,

long since he had last used drugs. Therefore, my professional conclusions led me to believe that Ward's drug use had been a means to self-medicate, as an attempt to alleviate the symptoms he experienced from his mental illness—the drugs did not induce the symptoms. Ward committed the crimes because he had a mental illness.

While the conclusion connoted a Schizoaffective Disorder, which, in turn, forced Ward to self-medicate through drugs, I continued to resist offering a definitive diagnosis. I was not equipped to assert a specific verdict. It was within my scope, however, to offer impressions based on the assessment procedures, the artwork collected, and Ward's behavior. My conclusions would be used merely to support the overall conclusions drawn by the other expert witnesses.

MEETING THE DEFENSE COUNSEL

Following my session with Kevin Ward, I met with the defense counsel, Jackie Chief, in her office for a preliminary review of the assessment. Chief was not tall—close to my height, to be precise—but had a strong presence. She had a tendency to be direct in her assertions, statements, and questions. She was quick on her feet and refrained from arriving at opinions until her questions were answered. She maintained a direct and unwavering gaze when speaking with someone, making it clear that the speaker had her undivided attention. Her attention to detail was astounding—nothing seemed to get past her. Chief, who "always had an interest in the death penalty," began her work as a defense attorney in 1980: "Within the next year or two I got a death penalty case. . . . I litigated it, and was successful in getting him off death row." She has since "been hooked" on working for "capital *habeas* work" and has successfully litigated 16 death row cases, losing none. To be clear, while many of the defendants are serving life sentences for their crimes, the cases were considered successful if Chief was able to get them off "the row."

The original intention was for me to supply the defense counsel with a written report of the day's events and conclusions based on my assessment and review of Ward's art. The computer was set up, and the drawings completed that day were offered to provide specific examples. Chief asked many questions. Eventually, we got into a pattern where I mentioned one aspect of what the art revealed and she asked for specific

examples and clarification in straightforward terms—she wanted to see exactly what I was seeing.

During the discussion, Chief's co-counsel on the case was asked to enter the office. While Chief and her co-counsel were top attorneys in separate law firms, they collaborated at times, alternating the responsibility of lead counsel. In this case, Chief served as lead counsel. I was asked to repeat much of what I told Chief.

The manner in which he began to ask questions indicated that he was more wary of an art therapist serving as an expert witness for the defense than was Chief. However, as the conversation progressed, the questions became more pointed, specifically about elements of the drawings that supported my conclusions. He grew less cautious and more interested in what art therapy could offer the case.

I was asked to reiterate certain terms that I had mentioned and to define others. The lawyers wanted me to clarify the words "fragmented" and "tangential"; they said it would be important for me to use terms that are straightforward and clearly reflect a mental illness, rather than jargon specific to the clinical field. Eventually, the attorneys indicated that, rather than my submitting a written report, they felt there would be a greater impact if the art was shown in court and the judge heard the descriptions in person. Because I would be testifying before the judge and would be cross-examined by the prosecutor, I would have to give the state a deposition before the hearing.

Then Chief told me that I had not yet seen many pieces collected by the defense team; they were stored in another office. Peters and Chief took me to the office where the art was collected, revealing a number of drawings and one "sculpture" that proved to be significant to my final conclusion. It was important for me to review these pieces and visit with Ward again before the deposition to talk about this new body of work.

3

MORE ART AND THE FOLLOW-UP

In the summer of 2009, I was scheduled to meet with Bill Williams, the chief deputy prosecutor of the county, to give a deposition. Before being deposed, I visited Kevin Ward to review the latest images received from Jackie Chief.

THE ART: THE SECOND REVIEW

After I was taken to the office where several pieces of Kevin Ward's art were stored, I was given the opportunity to photograph a number of them for evaluation before my next meeting with Ward. He had completed most of these works since his arrest, but several of them had been done in his studio. For some unknown reason, they had not been included in the original portfolio.

Some of these compositions show a greater sophistication and ease with the materials than do the earlier pieces. For example, figures 37 and 38 seem to demonstrate acumen and skill. Ward's figures are well rendered, displaying a propensity for the materials and an understanding of shadow and proportion. However, the figures in figure 37 are still somewhat fragmented. The well-proportioned male torso is missing a head, arms, and one leg; while reminiscent of a classical sculpture, it is fairly jarring in this rather complete composition. The horse that dominates the top of the page appears somewhat lifeless and mechanical. The background is diffuse and has penciled lines that form geometric patterns, a contrast to the rather organic and amorphous forms. Figure 38, while more complete than previous renderings, is unfinished and colorless, the figure blending into the background.

The same unfinished quality is much more pronounced in figure 39, a colorful image with a number of dancing figures that make up the central composition of the single scene. Similar in size to figures 37 and 38, it seems to combine elements of both: geometric mapping of the figures over a brightly colored yet ill-defined background, with the figures left incomplete. The background emphasizes a frenetic energy, as seen through the application of the oil and chalk pastels; Ward seems to have lost control of the media at times. It is not clear what he intended to do with the dancers. They are blocked in with pencil, but there is no clear progression on how they would be completed. This is a well-done drawing with a subtle hint of uncontrolled energy. As with figure 38, it seems that Ward simply lost interest.

In contrast, figure 40, also of dancers, is much more complete. The composition is cleaner, with a well-mapped scene, and appreciably darker in tone. The figures are more organic, less geometric, and less distinct. While they seem to be encircling something, it is not clear what, since the tree is in front of them. This image demonstrates a tendency to layer, but Ward appears to have been a great deal more focused and in control. Nevertheless, the aspects of other works in the portfolio—frenetic line quality, layered material, diffused images, unidentified figures, and illogical composition—are present, albeit much more subtly. This piece illustrates that although Ward had a great deal of talent and could, at times, maintain a semblance of focus and control, fragments of the drawing elements that reveal his mental illness still emerged. This may not have been noticeable if this picture had been evaluated by itself, highlighting the need to assess a number of images and not come to a conclusion about a client's mental health status from simply one source.

Several of the newly discovered images were drawn with an ink pen. Figure 41 depicts a number of people standing in an arc and holding drums. Those in the background are unclear and mostly incomplete, blending into the background. The most pronounced figures are the four in front; although they are defined through careful shading, with details in the clothing, the faces are vague. The eyes appear darkly shaded, making it difficult to distinguish them. While the drawing may be an attempt to create the illusion of space and perspective, the anonymous figures seem to reinforce Ward's ambiguous and paradoxical self-image. The line quality remains erratic and fragmented. Although this is a characteristic of works drawn with an ink pen, it may reveal Ward's anxiety and fragmented self-concept.

The composition of figure 42 is similar to that of the illustrations in his visual journal, with unrelated elements in the background; the portrait is the central focus. It is clearly detailed, with much attention paid to the facial features and hair. However, the lines are pressured; Ward seems to have ripped through the page in places. Such pressure may indicate anxiety or perseveration. While it appears that Ward maintained control while completing the image, he had the potential to lose his focus. The hair seems to be "scribbled," with lines coming off the top, suggesting that it would eventually become ill defined and Ward would decompensate if he continued to draw.

Images discussed in chapter 2, such as the third assessment drawing (figure 30), reveal a tendency to layer the media. This is very pronounced in figures 43 and 44. In both, the materials were so thickly applied as to create texture; it is unclear what images are hidden underneath. Metaphorically, this may reflect layers of confusion.

Upon close examination, the layers in figure 43 seem to be hiding several horses, which are difficult to see in the reproduction. They probably would not have been as noticeable if figure 45 had not been discovered at the same time. Indeed, the same horse shape is present in both pieces. However, the horses in figure 43 blend into the background, drawn emphatically with lines and shapes that become diffused and break apart. This differs greatly from the horse in figure 45, which is much more distinct.

Figure 45 seems to demonstrate Ward's ability to manipulate art materials. He exhibited a unique capacity to control the media and displayed a willingness and propensity to explore bright colors. Of all his pieces, this one appears to be the most controlled and focused. While the figure seems to be well composed, however, the erratic lines and diffuse shapes and boundaries linger. The horse, created with a great deal of energy, is too massive to be contained within the boundaries of the page. It exhibits an interesting juxtaposition of talent, forced control, and burgeoning decompensation and frenzy that so far is restrained.

The images discussed so far demonstrate a range of talent and focus. Several show Ward's capacity to illustrate well-rendered forms and figures, but some others reveal his tendency to lose focus and present erratic and diffuse compositions. Together, they represent a pattern of highs and lows, various degrees of decompensation, fragmentation, and diffusion. Laid side by side, they could reveal Ward's

mental health trajectory. The following images (figures 46–49), however, reflect no such ambiguity or control and focus—they clearly reveal acute symptomology.

In chapter 1, artwork that contains words unrelated to the composition are underscored as potential indicators of Schizophrenia (figures 3, 11, and 15–17). Whereas pieces in the first portfolio have a few such tendencies, several pieces emerged in the second collection in which such indicators are prominent. Such a composition is reminiscent of a "word salad": "During an expression of 'word salad,' the schizophrenic patient may use any combination of language, including coherent words and non-coherent words. Additionally, the words may be jumbled in an improper sequence and may be unintelligible" (Cadena, 2007, para. 2). While a word salad is a thought disorder related to speech, the concept is relevant to Ward's art—a number of unrelated words and concepts joined together, representing loose associations.

Figure 46 includes a number of unrelated statements: "Be still and know that I am God," "Koan—A puzzling paradoxical statement," and "How do you assuage your guilty conscience?" This piece corresponds with two more documents collected from the storage area (figures 47 and 48). Each displays many unrelated words, sentences, and phrases, at times accompanied by doodled images. However, the differences among the three are remarkable; while all represent unrelated concepts and terms, they demonstrate a gradual deterioration.

Figure 47, written in pencil on a 36 × 48 inch sheet of paper, reveals an obsessive focus; the terms are aligned on and enclosed in carefully drawn lines. In contrast, figure 48 contains unorganized sentences and unrelated phrases, scribbled with black ink over a full, stained sheet of paper with prescription medication information. Many of the words are scratched out, and no care is given to neatness. The terms are much more aggressive, with statements like "Your horror, I adore, you treat me like I'm no more," and "Believe, disease, its all about the truth." Many of the statements on both sheets are nonsensical; for example, "Night takes flight." In the upper-right corner of figure 48, Ward wrote the word "Blue," flanked by a pair of weeping eyes.

One visual journal image has a small face sketched in the bottom-right corner (figure 49). Some of the face, specifically the hair, is composed of tiny, unrelated words. These four pieces, when viewed as a group, correspond with several benchmarks of Schizophrenia.

One of the pieces was startling in its presentation. The defense attorney revealed that the investigators had discovered a human-size wooden figure staked to the ground outside Ward's garage. They carefully detached it and stored it in a box with the rest of the art pieces (figure 50). Although it looked as though it had been painted a pale color, possibly white, it had deteriorated greatly; otherwise, it had not been altered. It was loosely accepted as one of Ward's art pieces, but it was unclear at the time what it represented.

Overall, the images continued to support my original conclusion, while revealing a fairly complex psyche. My intention was to meet with Ward again. While some of the discussion would center on a few of the more intriguing images, I wanted to learn more about him. I would have approximately 1½ hours to talk with him before the deposition; therefore, I had to be careful in selecting the pieces that we would discuss.

THE SECOND MEETING

Since my last visit, Kevin Ward had been relocated to the county jail closer to the courthouse. This was in preparation for the deposition, for which Ward would be present, in addition to the sentencing hearing scheduled for the following month. This jail was much bigger, darker, and crowded than the one in which Ward was previously held. There were more correctional officers monitoring the halls at all times. Jackie Chief accompanied me to the jail, but left me with an officer who escorted me to a small room on the third floor. The room was in the middle of the hall, which was lined by small cells. It was small, furnished with two chairs set up very close to each other. There was a storage closet with cleaning supplies behind my chair. I was allowed to bring my laptop computer to the meeting, but there was no desk, so I rested it on my knees. Shortly after I arrived, an officer brought Ward into the room.

Ward seemed genuinely happy to see me. Holding an ink cartridge from a pen, he had brought several issues of the Arts section of the *New York Times* for me to read, telling me that he enjoyed providing such reading material for others. He said that he had been thinking about the work he had done for me last time and asked to look at the first assessment drawing: Person Picking an Apple from a Tree (figure 28). It was

important to him that it be known that the green and red of the apple represent "bitter-sweet, both positive and negative attributes." He did not explain further.

I told him that I wanted to spend some time talking more about him and his past, so that I could get to know him better. We also discussed what he could expect from my testimony during the deposition; I reminded him why I had been asked to testify on the art and pointed out that although his artwork was very good and demonstrated remarkable talent, I would still be referring to the art elements that support mental illness. He understood and then said, with a wry grin, "[M]ental illness is crap," indicating that he did not believe he had one.

I reminded him that he had signed a release form allowing me to use his art for publication and educational purposes. I explained the ramifications of using his art for such reasons and the ways art therapy assessments and the art of a client have been used in legal cases. He said, "Well, then this is a big deal for you. I'm glad. So this is a special case." He believed that art could be used for such cases, saying that one of the members of the defense team "was also skeptical at first, but has told me how important this could be."

We then looked at some of the art I had recently collected. He seemed preoccupied with what we were looking at rather than with talking about himself. We considered figure 46. He pointed out that the image in the top-right corner is a fish and that he had included so many words because he "loves words; love[s] communication"; he then asked me, apropos of nothing, if I had read the book *The Alchemist* by Paulo Coehlo. Despite his love of "communication," there seemed to be no real attempt to maintain cogent thoughts.

When I asked Ward about the sculpture that had been staked down in his yard (figure 50), he informed me that it was a mannequin that had been deliberately exposed to the elements. He intimated that it had been outside for a very long time, well before his use of methamphetamines: "Eventually it was to be set on fire. This is about decay, this is the real me." He had placed it next to an anthill so the ants "could start working on it. . . . [I]t's the real me you don't see." He was able to remain focused enough to compare this process to his own experience, feeling that he, too, had decomposed. He indicated that this piece could represent what methamphetamines had done to him, similar to what the elements and the ants had done to the mannequin.

I asked him about the small face in the bottom-right corner of figure 49. When questioned about the words that made up the face, he simply said that this piece reflects "multiple eyes."

When we examined figure 44, Ward indicated that layers were very important, and he spent a great deal of time making sure that several of his pieces were covered with multiple layers of materials and media. Completed in jail, figure 43 had been made with coffee and toothpaste. Completing art pieces with such materials is a common practice in prison, representing unique and creative ways to overcome the limitations of the materials available. For some prisoners, the will to create supersedes the limitations placed on them (Ursprung, 1997).

Ward was shown figure 45, the colorful drawing of the horse. It soon became clear just how important this piece was to him. He explained that it was "one of the best pieces. . . . [T]his was the horse that [*child's name*] rode. That's why . . . this piece is so emotional for me." As an afterthought, he added that "[*child's name*] was the one that died."

Several dynamics were revealed in this interchange. He had to draw this picture to capture the spirit of who his child had been for him; it certainly revealed a great deal of emotion and affection. By creating the horse without the child, however, he symbolically distanced himself from the real emotional connection with his child. Furthermore, by pointing out that "[*child's name*] was the one that died," he seemed to be separating himself from the murder, as though he were a passive and detached observer. Similar to the objectified figure drawings introduced previously but more subtly, portrayal of the horse appeared to be Ward's way of remaining emotionally uninvolved with the crime, maintaining strong symbolic defenses despite the emotion-laden impact of this piece. For the rest of the meeting Ward, no longer talked about his art, but focused on the murder and his current situation. Many of his statements seemed disjointed and incomplete, as if I had arrived in the middle of a discussion.

For example, he related a rather convoluted and disjointed story about a fly that he inadvertently had killed. This upset him. He explained that it happened when he was playing basketball; he kept looking at the fly and saying, "'[D]ude, I know I'm going to hit you, you need to move'—and it wouldn't move. . . . I became upset when I hit it." When asked why he became upset, Ward said, "Its life." He then moved the fly to the side of the basketball court to save it, but he knew that it was dead and he was upset. But then, he explained, it came back to life. "God spoke to me,

telling me, 'Why did you move him? I was looking out for him.' When I went back to the fly, it woke up. Now, some would say that it was alive, but stunned, but dude, I know . . . it was dead, and it was brought back." While delusional on one level, this story also demonstrated an interesting dynamic: despite his not wanting to kill the fly, it was clearly beyond his control; therefore, it was not his fault. This seemed quite similar to how Ward felt about his crime.

The meeting ended shortly thereafter, with a review of what he could expect during the deposition. Ward commented on his prison sentence, lucidly indicating that although he would not be sentenced to death, "I already know I'm not going to die of old age." At the end of the meeting, I was escorted downstairs, where I met Jackie Chief. We proceeded to the office of one of the members of the defense team to discuss what could be expected at the deposition.

∷ ∷ ∷

The additional images and the second meeting with Kevin Ward served to confirm my original conclusion—that he had Schizophrenia with a Mood Disorder, or a Schizoaffective Disorder. He continued to demonstrate a tendency to lose focus; become tangential in his recall, requiring redirecting and refocusing to keep him on topic. He told fantastical, grandiose, and almost delusional stories. His statements were peppered with scriptural quotes. The discussions and the vast collection of artwork revealed a remarkably complicated and damaged individual. Ward was a paradoxical combination of severe insecurity and fear of losing his identity, with grandiosity and delusional superiority. He demonstrated remarkable talent and was able, at times, to maintain a facade of control. At other times, however, the talent and drive to create could not mask his severe mental illness. His defenses were so ingrained that they presented themselves through a delusional reconstruction of self. He had committed the crime; there was no doubt about that. But he managed to convince himself that he had done so for his children's best interest. This sentiment battled with his immense sense of loss and guilt. It became clear that the images reflected a prevalent mental illness that spanned many years. Perhaps further examination of his art and his stories would reveal where it

had come from and how it had emerged. There was no time, and that was not my job. I would have to keep the deposition and evidentiary conclusions simple and direct. Therefore, I chose specific images to talk about and planned to focus my testimony on the original question: Did Ward's art reveal a mental illness and, if so, which one? I believed that I was ready for the deposition.

PART II

:::

DEFENDING
THE ART

4

THE DEPOSITION

Shortly after my meeting with Kevin Ward, the defense counsel accompanied me to the office of the chief deputy prosecutor, Bill Williams, in the courthouse. A tall, relaxed, and clean-cut man, Williams had a genial manner and was courteous and friendly throughout the deposition. He had worked as a deputy prosecutor in various counties since graduating from law school in 1999. Before earning his law degree, he was a certified legal intern in a prosecutor's office, a caseworker in a "child support division," and a receptionist in another prosecutor's office. He had even served as a probation officer for a period of time, "so . . . I primarily went back to law school to be involved in the law enforcement side of the legal system." Williams indicated that his opinion about the death penalty had evolved over the years. He was supportive of the death penalty; however, time spent trying death row and murder cases had "certainly tempered" his view. He believed that it should be conservatively applied in only the most egregious circumstances. We convened in a conference room with a court transcriber.

Ward was brought in soon after. He appeared almost jovial, saying hello to Williams, Jackie Chief, and her co-counsel before greeting the court reporter by her first name. However, when Ward heard that he was to sit quietly and would not be allowed to ask questions, it visibly upset him. His defense counsel requested a few moments to speak with Ward alone; Williams, the court reporter, and I left the room and waited outside for about 10 minutes.

Williams and the court reporter were friendly, asking many questions about Tallahassee and Florida State University, and making some vague inquiries about art therapy. We were quite careful not to discuss

too many details about art therapy, since it was the crux of the deposition. Williams did quip, "The only reason I really wanted to subpoena you for a deposition is I am very interested in what you do and what art therapy is." Although this could have been a way to get me to lower my guard, I believed him to be truly curious. Much of the deposition bore this out, as many questions focused on defining art therapy and the elements of art-based assessment procedures. We then were invited back into the room and informed that Ward had agreed to the limitations. We could proceed.

We sat around a long, rectangular conference table; there was enough room to get around the table, but not much more. The court reporter sat at one end, I sat to her right, and Williams sat to her left, directly across from me. Ward sat at the other end of the table, between Chief and her co-counsel. A laptop computer and a digital recorder were set up in front of me; I was sworn in.*

Williams clarified the purpose of the deposition as "essentially, for all of the parties involved to have an idea of what your testimony would be, should you be called as a witness at a hearing or trial." He explained the proceedings and that they would be audio-recorded.

The next several questions addressed my current employment and my professional credentials. Williams then asked about art therapy. I was mindful of the time allotted for the deposition and understood that a great deal of the process would include educating the attorneys about art therapy along the way. Therefore, the answer I provided was fairly general: "Art therapy is using art as a therapeutic tool to bring about a change in a client. The qualities or the inherent nature of the materials that you use can help bring about emotional or psychological change. It can also be used for assessment purposes. By using the art, you can help determine a person's current state and trait." Williams asked me to clarify the difference between assessment and therapy, a question that would later shape his argument. I explained that a good art therapist should do both at the same time: "[Y]ou should continuously assess the work [your client] produces to determine how well they are progressing in treatment. There are formal assessments that you can provide prior to

*The transcripts of the testimonies quoted in chapters 4, 5, and 7 were edited, but their content and intent were not altered. Words or terms not in the transcripts appear in brackets to clarify the intent of the statements.

starting treatment; and certainly, you can use assessments after treatment is over to determine change." I then described what I meant by formal assessments, using the FEATS as an example:

> One I like to use is the Formal Elements Art Therapy Scale developed by Gantt and Tabone [1998]. It is a standardized and valid art therapy procedure where you actually have specific criteria and specific tools and materials that you ask a client to use for a particular drawing. Based on that drawing, you now have a standardized scale in which you can then assess a person's . . . diagnostic criteria.

Williams asked questions that focused on this procedure: How long had it been around? When had I first learned of it? How many times I administered it? I confirmed that I had used the FEATS with Ward.

Williams next asked about my particular involvement with professional associations and credentialing bodies. I explained my relationship with the American Art Therapy Association, the Art Therapy Credentials Board, and other professional organizations. He continued:

WILLIAMS: *You've been published in the Art Therapy Credentials Board journal?*

GUSSAK: *No.*

WILLIAMS: *No?*

GUSSAK: *I'm sorry. The Art Therapy Credentials Board is a separate credentialing body. They don't have their own journal. I have been published in the American Art Therapy Association journal,* Art Therapy: Journal for the American Art Therapy Association. *I have been published in the* Arts in Psychotherapy, *which is an international journal that covers a number of different creative therapies, as well as other journals.*

It was clear that Williams had reviewed my file and vita and had probably undertaken preliminary research about the field, but did not fully understand what he was reviewing. While my answer may appear flippant, I believed that it was important to make a clear distinction between the roles of the membership organization and the credentials board. Williams

next asked about my understanding of ethical guidelines of the field. I indicated that I was familiar with the guidelines established by both the membership organization and the credentialing body.

Referring to my vita, he noted that I had published a number of articles and asked if any of them addressed assessments. I replied that although I had not published any that specifically concerned assessment techniques, all those about the prison research projects relied on art-based assessment procedures for the pre- and post-test evaluations (Gussak, 2004, 2006, 2009). Despite my explanation, Williams contended that only one article addressed assessments directly and asked, "The majority of your publication would be related to not necessarily the assessment but to the therapeutic side of what you do." While his assertion could have been refuted, this was probably not the time to do so; I simply let the statement go without comment, thinking that it would be best to know where the line of questioning was going.

Williams asked if I had any prior relationship with the defense counsel and if I had any experience before this in providing assistance in criminal or noncriminal cases. I indicated neither prior relationships nor earlier experience. The discussion next focused on if and how I was paid for my work for the defense team. Obviously, such a referral was intended to dilute the defense's testimony. The inference is that I would financially gain by providing the information the defense attorneys wanted, which would ultimately taint and bias any conclusion. This is, of course, disingenuous, as many expert witnesses receive a fee (Shapiro, 1991). The maneuver is more common in court, in front of a judge or jury (as evidenced in chapter 5).

The next series of questions required me to recount when and how I had been contacted to participate in this case. I explained that the initial request from the defense counsel was to "find out whether or not I could be considered a viable witness, expert witness, or . . . whether or not my testimony would be viable for looking at or determining a person's mental health." I explained that I had signed a confidentiality form before receiving the file of the defendant's artwork. I likened it to a blind-review process, since I did not know anything about the defendant except that he had killed someone and the state was seeking the death penalty. I also reiterated that I had received no information regarding any mental health diagnosis. This continued to be a focus for the prosecution.

Despite my assertion that I had no prior knowledge of the case, I was asked if I had consulted any resources before receiving the art. I explained that since I did not know anything about the case, I did not know how to prepare. I explained that once I got the art, I

> reviewed all of the drawings, went through each one individually. I looked for patterns. . . . I went into this blind. I wanted to determine if these images revealed any mental illness. Aside from that, I was also impressed with the artistic quality, and I realized that I would have to separate the artistic ability from the information that these images contained. I then tried to find resources that would have similar images, and I tried going back through some of my own work just to see if I had seen any pieces similar [in style].

I explained that I had been sent more than 100 images on the compact disc and that the reproduction quality was sufficiently clear for me to "be able to ascertain texture, line quality, proper color," for what I needed.

> WILLIAMS: Okay. If you would, for someone who is art illiterate like myself, what do you mean by "they were clear enough for texture, line quality"? Describe what these characteristics are that you just named off.

> GUSSAK: Sure. When you use a specific type of material, it is going to leave a different type of texture on a piece of paper. It could also determine, based upon the texture, how much pressure was added to the material on the paper. Line quality is going to indicate how faint or how dark or how stressed the line was on the page. Was it deeply ingrained in the page? Was it briefly drawn over the page? Are they faint lines? Are they sketchy lines? Are they erratic lines? Are they lines that fill the page? I'm looking at space. How much of the space does the image take up on the page? I'm looking at the denseness of the quality. Are there layers of color on the page versus a coating of the page of just certain colors? I was able to determine through the photographs, for the most part, what materials were used, which is important . . . for the most part, it was very clear.

Williams asked me to clarify what I meant by "trying to determine if the images reveal any type of mental illness; what are you looking for in the

images to make that determination?" I explained that drawings consist of formal elements—the way a drawing is completed rather than its content:

I am looking at line quality. I am looking at the way shapes are combined or used. I am looking at the amount of space on the page. How dense is the material on the page? Have they scribbled through the page? It's going to provide different information than if the drawing was faintly drawn. Whether or not the image is a small little tiny figure on the bottom right is different than if they filled the entire page with color and they seem to take the image off the page. I was looking for things like fragmentation, which indicates whether or not a form seems to be breaking apart or there are sharp angles that don't seem to coalesce on the page. I am looking for shapes that don't seem to compositionally work together. I am looking at whether or not the different images on a page compositionally fit well together. I am looking at how many colors are used as well as how appropriate that color use is.

I said that I had reviewed the images over many hours during the previous 2 years. I also explained that although the FEATS relies on one drawing for the assessment procedure, I based my conclusions on several drawings. Williams seemed to try to discredit the FEATS assessments, since they are based on one drawing. I countered that although the FEATS is strong enough to stand on its own, specifically in establishing criteria for the four diagnoses for which it was designed, I also had several drawings that Ward had completed during my first meeting with him and a number of earlier drawings on which to base my conclusions.

Williams asked me to clarify which diagnoses the FEATS can determine. When I responded, he reiterated that this assessment would not provide for any other "DSM-IV analysis here. . . . How about addiction issues? Does it address addiction in your assessment process at all?" I explained that although the FEATS was not designed for such an issue, it might reveal Organicity, a by-product of a severe and lasting drug problem.

The questions shifted to what I had thought of the drawings before meeting Ward the month before:

WILLIAMS: *In your analysis of the drawings that were provided to you or the artwork that was provided to you, were there any particular items*

or particular pieces that stood out to you as being more important than the others, or were you taking this battery of items as a whole?

GUSSAK: *Both. I took the battery as a whole to determine the level of decompensation and a history. But there were certain images that certainly jumped out that indicated some level of fragmentation, decompensation that led me to believe that there was . . . a development of mental illness or that there was mental illness present.*

WILLIAMS: *Did it hamper your evaluation that you didn't have a chronological order on these?*

GUSSAK: *Not at all.*

WILLIAMS: *Why not?*

GUSSAK: *Because . . . I think it made it more authentic for me to be able to look at the artwork and say . . . at this stage, we start to see more of a decompensation. Perhaps there was a little bit of stability here. But for what we're seeing here is a development of more acute mental illness . . . it put the onus on me as the assessor to determine if I could determine if a person, during that time, had more of an acute mental illness than at others.*

I was asked to provide my initial reaction to the images as a whole:

Well, first off, right off the bat, this man had talent. On another level, patterns emerged throughout all of the drawings. There were levels of fragmentation; there were levels of decompensation and images that may not have fit well with each other. Some of the images seemed to indicate levels of decompensation while the drawing was being done where it looked like it started off fairly stable and fairly well composed then developing into erratic line quality, more emphatic or emphasis with the materials; almost . . . less control of the materials.

When I was asked what I meant by "fragmentation," I suggested that I show Williams the images on the laptop. He asked me to identify each

photograph by its number or title so that the transcript could identify the image on the disc.

The first two images I showed him were figures 6 and 12, as examples of fragmentation and decompensation. I pointed out that some of the sections are more fragmented than others, almost as if they were broken apart. I explained that some parts of their compositions seem disjointed when compared with images on other areas of the page, and some areas appear to lose focus:

We have something that emerges here that may indicate some loss of focus and almost a breaking-apart in the composition. You'll see that the line quality here has a great deal of emphasis. We have here fragmented lines where they're not really connecting. They're not really joining up with each other. They're not really completing the composition. Somebody could probably mark it up to be sketchiness, but this isn't. There's a difference between sketchiness and a fragmented form.

Williams stopped me to ask Ward, who was sitting quietly at the end of the table, if the mark in the bottom-right corner of figure 12 was actually his signature. After he affirmed that it was, Williams asked if other drawings were signed and dated. I answered that some were, and he wondered if that had assisted me in developing a chronology. I explained that this was not possible because the dates are unclear on many of the images; not until I spoke to Ward did I realize that some apparently stray marks on several of the compositions are signatures and dates.

I next referred to figure 51 and explained that it is one of several images that seem to have been part of a visual journal. I described its disjointed nature:

You have a well-developed image in the upper right of this couple that's kissing. Very clear, very distinct, well done, well rendered. Compare that to down here, the bottom right, where you have a fragmentation. You have lines that don't even make sense, that don't coalesce into an actual composition. They seem to have been put there almost as an afterthought. Compare this ability to this caricature down here at the bottom right where, although the face seems very well developed, the body image starts to break away. And compare that to the face on the bottom left that just seems like an angry, unformed doodle.

Williams astutely asked if there was any way to determine when each of these different areas may have been put on the paper. While I indicated that it was not really possible, figure 51 seems to be in direct contrast with some of Ward's other compositions that were carefully constructed. Still, this was something I would have to clearly address.

Figure 2 gave me the opportunity to demonstrate that what, on the surface, appears to be a well-done, singular composition, in fact reveals fragmentation. For comparison, I presented figure 7:

I would guess was done all at the same time because [Ward used] similar materials that were done throughout the entire composition. But you see how disjointed all the forms are together? For somebody who had the ability to do the drawings that I showed you earlier to then do these types of faces and this type of activity makes you wonder if there's some level of decompensation that's happening here.

Williams asked what my conclusions were, based on my "initial analysis." I replied, "My initial thought was that this person did have a mental illness, quite possibly Schizophrenia. As an opinion, some type of Schizophrenia." He then wondered if any particular drawings "led more strongly to that conclusion than other drawings." I answered, "Absolutely," showing him figure 33: "We have a well-developed, well-sketched-out face. And as you see, for example, here his tie seems to digress into a fairly erratic line. . . . [I]t leads me to think that as the person was doing the drawing, there seems to have been a momentary lapse, momentary loss of control, momentary decompensation."

Williams wanted to know if having reviewed the initial portfolio of drawings influenced how I approached my first meeting with Ward. Although I said no, I then reconsidered:

I knew I wanted to do assessments on Mr. Ward. I knew I wanted to go through each one of these drawings and talk with him about them. I knew that I wanted to watch him evolve in his drawing style through the assessments I would provide, and that was the right decision. I had him do three drawings, a formal art therapy scale, and [two] free drawings. And over the course of those three drawings, he . . . decompensated . . . [demonstrated] more fragmentation in the drawing style as he proceeded. The FEATS coupled with the other two drawings

made me realize that there was almost a de-evolution between the three drawings, almost a loss of focus.

I said that my initial meeting had occurred over 4 hours in 1 day and that the three drawings had been completed in my presence:

WILLIAMS: *Is it important for you to be able to observe the actual construction of the composition as its taking place, or are you just interested in the end result, as far as your assessment?*

GUSSAK: *With the FEATS, it's not necessary that I be there. In this case, it was interesting to watch him work on it. Mr. Ward had done things that I had never seen done to a FEATS drawing. He was very creative in that way and also lent itself to more information. But no, I don't need to be present for the FEATS. It was helpful that I was present for the two free drawings. . . . The three drawings provided me a lot of information.*

For some reason, I felt a need to refer back at this point to the earlier exchange between Williams and me regarding my experience with assessment techniques, and I explained that although I had not published articles about projective assessments, I had, in fact, taught a course on projective assessments at two universities, including in the Department of Psychology at Emporia State University, over the previous 12 years. I was asked to clarify the term "projective assessments"; after I defined it, I exhibited Ward's Person Picking an Apple from a Tree (PPAT) drawing (figure 28). I wanted to defend my experience with assessments before presenting my assessment of Ward.

I told Williams that I had never seen anyone crumple the paper before drawing the PPAT. I explained how Ward's drawing was rated and listed the score for each of the elements, pointing out that

it is not colored in; so in terms of prominence of color, it would score very low. [He was] given a palate of 12 colors—and he only used four, and that includes black. Color fit indicates . . . whether they're proper color use. . . . He scored very low on that . . . the problem solving is fairly low—which is one of the scales, in that the way a person picks an apple from a tree is judged. In this case, the apple—he's able to

reach up and grab the apple. It's already in his hand. There's no clear idea how he got that apple. He happens to be tall enough to be able to reach up to the apple. It's about a little less than half a page. There's an absence of anything other than that tree, person, and apple. Again, that's important. There's just the one apple that designates what he's picking. There's no background; there's no environment; there's no sense of real placement for this figure; it's not grounded; there's no feet or hands. . . . [He does not have] any ability to control the environment, so to speak. My overall assessment of this drawing is that I would document that this person has levels of Depression as well as leaning toward evidence of Schizophrenia.

I told him that in order to get a "certain type of effect," Ward had tried to blend the colors using water. After I answered some particular questions about the PPAT drawing, I considered Ward's second assessment drawing, or first free drawing (figure 29):

*He was then given [another] piece of paper, somewhat larger—18 inches by 24 inches. I put out a number of materials, including Cray-Pas [oil pastels], pastels, the markers, and pencils, and he chose a pencil, which is telling. To go from something that perhaps Mr. Ward was uncomfortable with, such as the markers, was shown by his inability to blend the colors with the water. It seemed to have frustrated him. He chose a material he had more control over. This is a great example of what I mean by a composition that is fragmented. It doesn't seem to coalesce. He did this all in one sitting, which allows me to go back to some of those earlier drawings and say perhaps some of these were done all in one sitting. And again, stand alone, some of these images are interesting, and a couple of them are really well done and very intricate. All together, this seems to [reflect a] diffusion.**

*Throughout these assessment discussions, I used the word "diffusion" several times. That was probably not the right term to use. However, the transcript does not capture the rapidity of the questioning and discussions. Because of the instant responses that the deposition demanded, despite attempts to pause and think of the proper responses, I used several words that were probably inaccurate in light of what I wanted to say. In employing the word "diffusion," I was referring to Ward's tendency to lose focus while drawing the images, creating a composition in which there seems to be a disconnect.

I noted that Ward seems to have employed a technique known as contour drawing for this image. A contour drawing results when an artist draws an object, a person, or a scene with one continuous line, without lifting the pencil from the paper. Often, the final form may be somewhat distorted. A blind contour technique is when the image is drawn without looking at the paper (Nichols & Garrett, 1995). I pointed out that

you can see that he started getting quite emphatic with some of the lines, so that's a difference in line quality where you have a sketchiness and a lightness versus what could be termed as more . . . I don't want to use the term "aggressive" here, but you can imagine what I mean by that . . . where a person seems to attack the paper a little bit more . . . almost as if there seems to be attempts to gain control.

With little transition, I immediately described Ward's third assessment drawing, or second free drawing (figure 30):

This was interesting in that he started off very similarly to the first free drawing, which was done in pencil. And he used some of the Cray-Pas to start outlining this form, drawing with breasts here, and then started to—and again, remove the fact that it's a well-done drawing . . . it is a beautiful image. Aside from that, there's a level of decompensation that seems to be happening. . . . He started [with the page oriented vertically], [and he] started attacking the paper with these different colors, started filling this page up with all this activity, and then turned it into a landscape. So what we have is something that evolves . . . the portrait on the bottom part doesn't seem to fit with the composition. This seems again to be disjointedness . . . it is a well-done piece. In some cases, it is a beautiful piece. Putting that aside, it is a piece that seemed to have devolved from what he started within the first [assessment] drawing.

When asked, I stressed that the two free drawings supported my conclusion from the PPAT: evidence of Depression and Schizophrenia. As noted earlier, my tendency to not diagnose led me to qualify my conclusion that there was evidence of Schizophrenia and a Mood Disorder, rather than label it Schizoaffective Disorder. The subtle difference came back to haunt me during my court appearance.

Williams asked me to clarify a statement I had made regarding consulting with some colleagues, especially one in California. I explained that he was an expert on working with people with substance abuse, that I had described to him what I was seeing in the art, and that I had asked if he could provide me with literature to help me ascertain the influence of substance abuse on Ward's imagery. But he had not been able to suggest any literature that I was not already familiar with.

Then Williams again changed the direction of the questioning, asking when the assessment procedures had been administered and the earlier drawings reviewed during my first session with Ward:

> We spent the first hour of our meeting talking, getting to know each other. Mr. Ward had a lot of great viewpoints on art, so we spent some time talking about his interest in art, how it developed. He then did the three drawings, and then we went through all of the other pieces. I did that deliberately because I did not want any influence of the images that he had done previously, that he had been exposed to, to influence the drawings that he was then going to do in the assessment.

He asked if I knew how long Ward had been incarcerated before our meeting and if that had any effect on the art he created that day: "I don't know. I will say this—the drawings that he developed in that session were similar to the ones that he had done previously when he was out. I cannot make a conclusion based on these drawings whether or not he was being influenced by his incarceration or not."

He asked if I had received any additional insights when I reviewed the images with Ward. I explained that the formal elements in his art did not change, so my conclusions did not change. I did point out that it was good to hear Ward explain what the images meant to him. When Williams asked about the "nature of that discussion," I asked him what he meant. Through his clarification, it became clear that he was wondering about the particular meanings behind the *symbols* of the images:

> WILLIAMS: If you would, give me a synopsis of what the intention behind these drawings were, if you can. Or if you need to refer to specific drawings, we can go that route as well.

GUSSAK: *Let me give you a general idea. Mr. Ward made it clear that these were drawings that he had to do. This was stuff that he had in him that he had to force out of him and that it was important that he get it out. There were images that he had in him that he had to put down on paper. For example, it was important for him to use this media to communicate his viewpoints on pathways as a symbol. . . .*

WILLIAMS: *Do the nature of the images chosen have any impact on your assessment?*

GUSSAK: *What do you mean?*

WILLIAMS: *You talked about looking at the lines, the textures, the frag-mentation, the decompensation . . . but does the nature of the subject matter of what's coming out onto the paper have any influence on your evaluation?*

GUSSAK: *No. If anything, some of the ways he was describing some of the symbols helped strengthen my beliefs that these images provided.*

WILLIAMS: *What do you mean? What symbols are you referring to?*

GUSSAK: *Let me put it this way. . . . [I]t wasn't so much the nature of what he said the drawings contained but the way he emphatically explained the drawings and then would spiral off into another direction and become tangential with his explanations. That reinforced some of the diagnostic criteria. . . .*

WILLIAMS: *You indicated some of the symbols were pathways? Were there other identifiable symbols that you pulled out of the artwork or out of the conversation?*

Williams was making the typical assumption that the symbols—*what* Ward had drawn—may mean more than the formal elements—the *way* they were drawn. While this may be true in some situations, in this case the symbolic meaning may not have provided significant support for my assessment conclusion; what *was* significant was the way Ward had explained the particular imagery, which reinforced his fragmented,

disorganized, and grandiose thought processes. I tried repeatedly to explain this:

WILLIAMS: *You said that he provided explanations for some of these symbols. Did he provide an explanation for the use of fire?*

GUSSAK: *In some cases. But again, it devolved into long and anecdotal information that involved the Bible, [his] theological perceptions, and "cleansing." So it wasn't always clear what the symbol of fire [meant for him, but what was important was] how it devolved into a different theoretical and philosophical perspective.*

I was asked to clarify the pathways that Ward had referred to throughout his images. I reluctantly explained Ward's interpretation of their meaning, which I felt distracted from the import of the form rather than the meaning.

Williams struggled with the next question; it eventually became clear that he was asking if the artwork demonstrated consistent evidence of Schizophrenia and Depression, or if it tended to fluctuate, depending on "the level of influence that the mental illness has had upon him." I explained that it remained fairly consistent: "[T]here might have been flashes of imagery that indicate some level of cognizant [*sic*] presence or grounding. But for the most part, overall, there was a level of consistency among the criteria."

He asked me to clarify the period that the portfolio encompassed. I explained that many of the works had been completed in the 1990s, but that I had recently come into possession of some images that had been done shortly before the crime, after Ward was arrested, and while he was in jail. I was asked to provide examples of the more recent work.

I showed him figure 44, demonstrating Ward's need to hide under layers:

[H]e could very well be trying to hide something, trying to cover something up or covering something over. Generally, it involves a level of . . . I don't want to say paranoia as much as a need to hide something. . . . And that's what we have here if you can see closely. In person, again, it is an artfully done piece but also is very revealing in the covering up. Now in defense of the piece, it's not finished. Mr. Ward made it clear that eventually he was going to go back in and pull those figures out. But there's this line quality, and that seems fairly anxious.

In this case, the *meaning* of hiding beneath the layers is congruent with the *element* of layering the materials to cover what is underneath.

The next few images we viewed were revealed as evidence of word salad, prevalent in the work of people with Schizophrenia. I pointed out figure 46 and explained to Williams the meaning and significance of "word salad. . . . In this case, many of the words and terms are quite poetic and certainly show great intellect in terms of the word choices. However, a lot of the words don't really match up and are fairly disjointed." I next indicated figures 47a and 47b:

> *[W]e could originally get only a small section of this piece because of its size, and I wanted to make sure that I got the words when we were in the office. This drawing—and I guess it's not fair to call it a drawing, I would say it is close to 36 by 48 inches, and it is rolled up, and it is filled with all of these words. That's a lot of energy and a lot of . . . word salad, I think is the way to say it. . . . [It represents his] fragmentary thoughts, if you will.*

I then showed Williams figure 43 as an example of a beautiful composition that still reflected "a great deal of disjointedness, decompensation, fragmentation. . . . [Y]ou can see how this one reflects back to some of the earlier ones that he had done. The only difference was this was done in the—County Jail, and he was using the materials that he could use such as coffee and toothpaste."

After I clarified that I had met with Ward that morning to review the latest additions to the portfolio and did not have any additional art pieces not on the compact disc, I was asked for references that had been of particular value in drawing my conclusion. I provided a brief summary of some of these resources. Williams asked whether I had published anything on this case, followed by whether there were any requests made by the defense that I had not yet completed or any that I felt unable to fulfill. I responded in the negative to all these questions. After Williams indicated he had no further questions, Chief, her co-counsel, and Ward conferred to determine if they had any questions. When they decided that they did not, the deposition ended 1½ hours after it began.

∷ ∷ ∷

The deposition was the first interaction I had with the prosecutor and the first opportunity to educate him about art therapy and the role art could play in this case. What I had expected did not occur—my role as an expert witness challenged and the validity of the art disputed. It became clear that the session was as much an educational opportunity for Bill Williams as it was a preparation for the trial. However, I also realized that this was the prosecution's opportunity to prepare its defense against my assertions.

There were several ways in which I could have been better prepared for the deposition. While I felt that my responses and descriptions about the art were fairly clear and comprehensive, I could have provided more succinct definitions of some of the terms I used, such as "projective assessment." I was ready to talk about the art and how it reflected the client. However, I "cherry-picked" the images for the deposition, showing pieces that best illustrated my points. Some may argue that I could have had better control of the proceedings and been clearer in my presentation if I had chosen a set number of images ahead of time to discuss in a particular order. Since I had prepared a computer file of all the works I intended to show during the deposition, it may have been advantageous to present the artwork first and allow it to prompt comments and questions, as I planned to do for the trial. However, I also thought that if I did this, it might tip my hand on my presentation for the trial, possibly providing the prosecution an additional opportunity to prepare systematic rebuttals to all my assertions. The manner in which I displayed the images ensured ambiguity.

I was surprised by the informality of the proceedings and the civility with which they were conducted. Although a certain formality was adopted in structuring the room, swearing me in, and clarifying the rules of the procedure, it felt more like a discussion than a cross-examination. This could have been established to disarm me into becoming overly comfortable and confident. However, I felt that the prosecutor was genuine in his curiosity about the field and what the art could reveal:

WILLIAMS: *I feel like we're getting a semester's worth of education in about two hours.*

GUSSAK: *Don't tell my students. They'll demand their money back.* (Laughter)

The defense counsel seemed to have an honest sense of respect for and camaraderie with Williams, discussing the case and various issues with professional courtesy. When Kevin Ward was brought in, Williams and the court reporter greeted him with civility and maintained a brief interchange of small talk. When I left the room with Williams and the court reporter for a few minutes while Ward conferred with his counsel, Williams gave no indication that he was inconvenienced, and the three of us had a pleasant conversation. I realized that while the opposing attorneys may be seen as professional "adversaries," they merely had a job to do. It would be in their best interests to remain emotionally detached, courteous, and civil—in a word, professional.

I also was aware that this would be the first time Ward would hear some of my conclusions about his mental health status. Although I tried to prepare him for the nature of my testimony, I knew that he would still be surprised. I had been taught that when documenting information about clients, therapists should always assume that they will eventually read what was written. Therefore, the data should be presented in a professional and objective fashion, and the conclusions should be clearly stated, with the supporting evidence reiterated to justify the assessment. I went into the deposition with the same intent; I knew that Ward would be present. Therefore, I would have to offer my remarks in the most objective, comprehensive, and respectful way possible. I believe that I succeeded, presenting all the conclusions with distinct indicators and supporting information in order to eliminate any semblance of magical thinking and opinion. Regardless, Ward was not happy. He expected me to describe him as an incredible artist and use his art to justify his good intentions and otherworldly rationale; he heard me use his art to underscore that he had a mental illness. During the proceedings, he apparently wanted his attorneys to raise many objections. He also wanted the opportunity to speak and was frustrated that he was not allowed to do so.

Although it did not meet the defendant's expectations, my job was to present as objective an argument as I could to support my conclusion that Ward had a mental illness, not to consider his feelings. My duty was to be as unbiased and direct as possible; it was Ward's defense team's responsibility to reassure him that this was in his best interest and allow the testimony to continue as intended, with no formal objection.

FIGURE 1

FIGURE 2

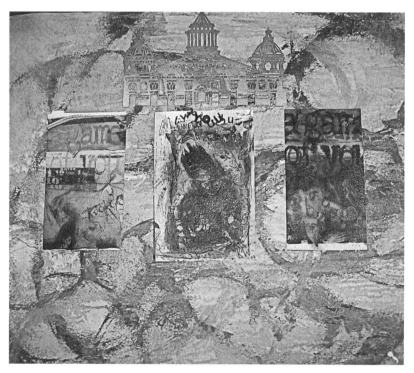

FIGURE 3

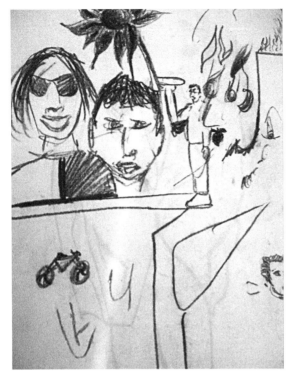

FIGURE 4

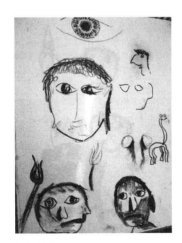

FIGURE 5

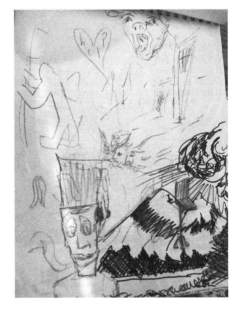

FIGURE 6

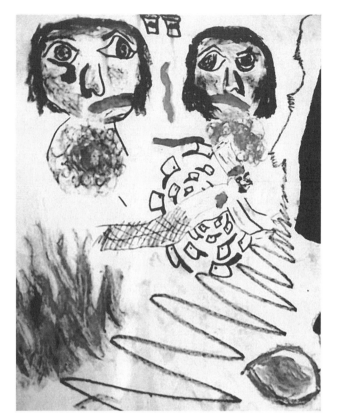

FIGURE 7

FIGURE 8

FIGURE 9

FIGURE 10

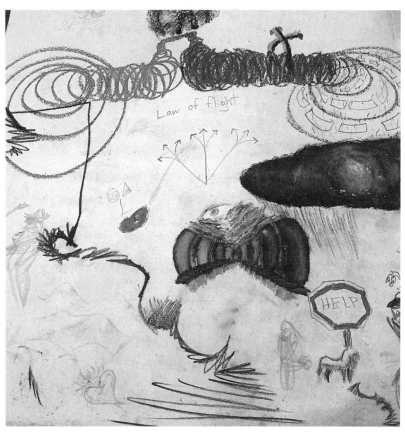

FIGURE 11

FIGURE 12

FIGURE 13

FIGURE 14

FIGURE 15

FIGURE 16

FIGURE 17

FIGURE 18

FIGURE 19

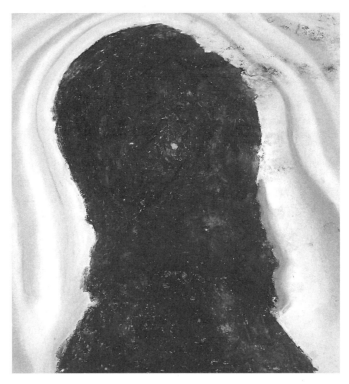

FIGURE 20

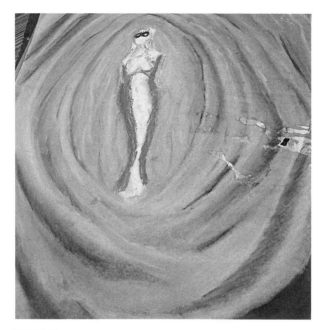

FIGURE 21

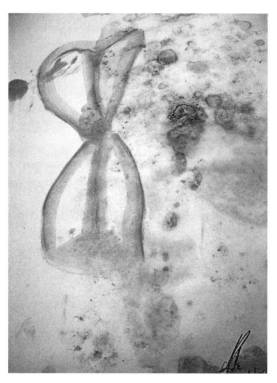

FIGURE 22

FIGURE 23

FIGURE 24

FIGURE 25

FIGURE 26

FIGURE 27

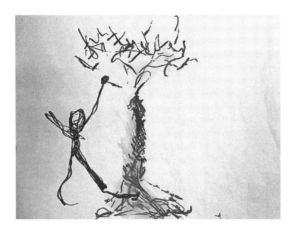

FIGURE 28

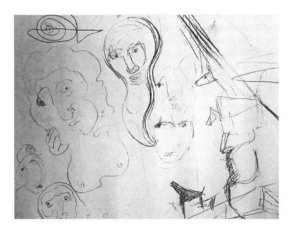

FIGURE 29

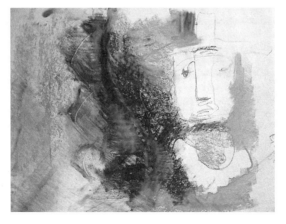

FIGURE 30

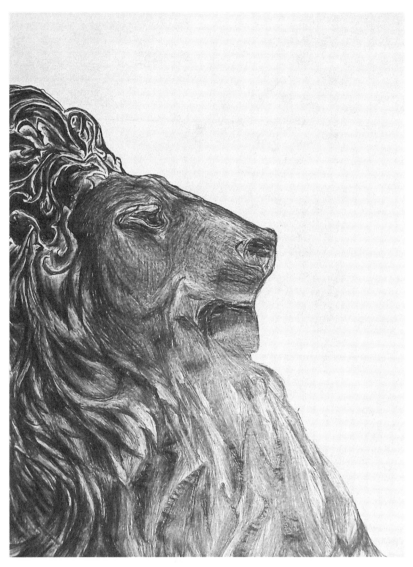

FIGURE 31A

FIGURE 31B

FIGURE 32

FIGURE 33

FIGURE 34

FIGURE 35

FIGURE 36

FIGURE 37

FIGURE 38

FIGURE 39

FIGURE 40

FIGURE 41

FIGURE 42

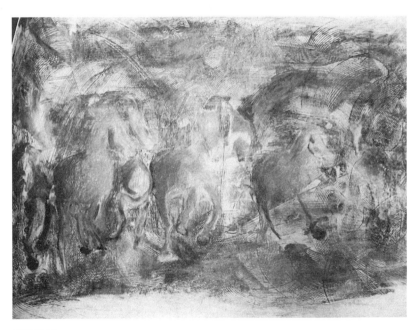

FIGURE 43

FIGURE 44

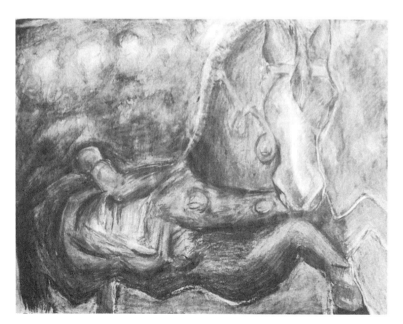

FIGURE 45

FIGURE 46

Figure 46 represents a visual "word salad," in which Kevin Ward strung together words, phrases, and sentences that appear incongruent and often nonsensical. The statements are unclear and are composed with poor organization rather than with any linearity. Because the writing is difficult to ascertain from this reproduction, here are just a few of the phrases that appear in the image:

> How do you assuage your guilty conscience? / Calcified / Bill Withers / Ain't no sunshine when she goes away / Black on Black will / judemental [sic] energy / the vanity & insolence of these men / true religion is so simple & facile / Stand in vigil / I've always been good @ self-flaggelation [sic] / Be-alz-ah-bub / attracted like a moth 2 a flame / It reached its apex | a brazen lies / when feelings (anger, happiness, love, lonliness [sic]) happen stop and check yourself and notice these feelings / *divination / meritocracy / descent ascent

> No longer chorus but vibrations & incantations / jollopy [sic] / Enneagram [sic] Ones / meditative thinking / calculative thinking / Be still and know that I am God / Koan— A puzzling paradoxical statement / most parables are subversive to so-called common sense to wake us up from [the?] sleepwalking in the cultural hypnosis / close my eyes and continue in the daily mantra. / *Amid the cacophony an abiding affection between us.

FIGURE 47A

FIGURE 47B

Figure 47 represents a visual "word salad," but is much more extensive than that in figure 46. Ward wrote it in pencil on a 36 × 48 inch sheet of paper. Because the writing is difficult to ascertain from this reproduction, here are just a few of the phrases that appear in the image:

Love is the greatest quality of character Prov 28:28, 16:32 temperance / judge man impartialy [sic] just as the father judges you / the views are majestic / She experienced great frustration as she strove to perform in the family / She had a certain dejected attitude / The rush of gladness / Sometimes we get tired of being studious & ambitious. / Adventures that were enthralling / She was abashed by the splender of the place | embarrassed | unabashed—not embarrassed. / Students today have gone to the purdition [sic] of egotism and moralizing politicized self-righteousness / ally | nemesis / dissensitizing adultification / / The answer is almost too hackneyed / they made me into a stench / with such nagging she prodded me day after day. / A worldwide cataclysim | One must continue to cultivate ideas within these walls. / Literal | [fiction] | [figurative (sic)] | symbolic metaphorical | Dogma | Dogmatic / He became more brazen all the time. / One must look makeupless & contrite when one goes to cont. / repentant / contrition / the price plays into the product's allure | | exorbitant price | they regard them as less than human / Rufuge—use me as your refuge. | A Golden minnow in a fetid sea / Tilt & their little caveat / write under a nom de palume / waiting for her to come into abloom / you misconstrue my motives / misinterpret / Beguile/ deceive [sic] / I was bewildered / confused / Nonprocreative / and is so lasciviously depicted in the DA Vinci Code / a sychophant / flatterer / cleaving to tradition—cling

FIGURE 48

FIGURE 49A

FIGURE 49B

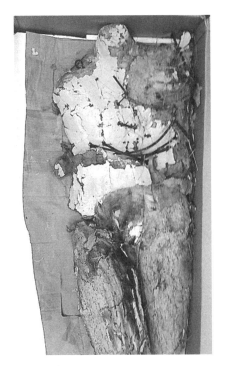

FIGURE 50

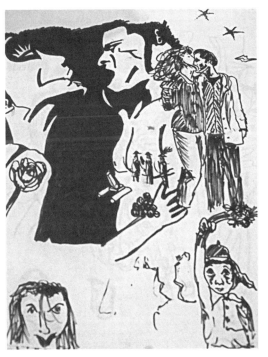

FIGURE 51

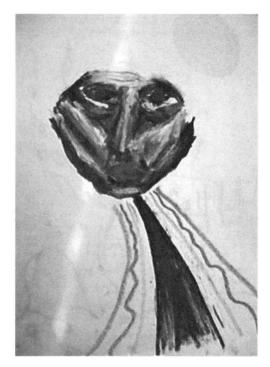

FIGURE 52

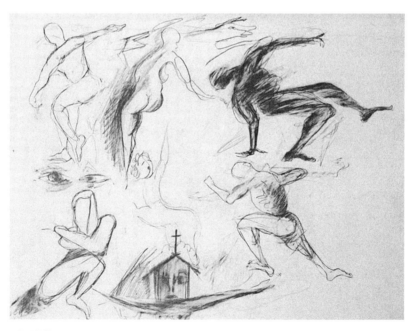

FIGURE 53

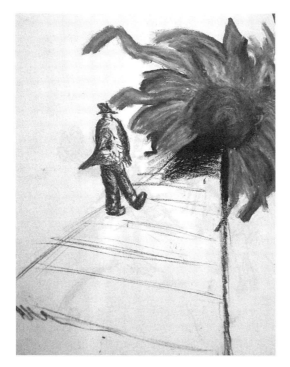

FIGURE 54

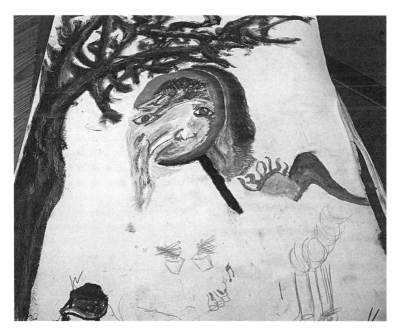

FIGURE 55

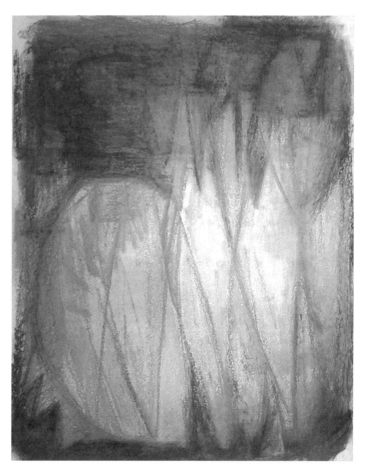

FIGURE 56

5

THE TESTIMONY

In August 2009, I again flew to the Midwest. I was scheduled to testify the next day before the judge, the honorable D. Beam, at Kevin Ward's sentencing hearing. Although not the actual trial originally anticipated, at the risk of sounding callous and selfish, this would still be an opportunity to put the art "on the stand" and perhaps ascertain its effectiveness as evidence in determining mental illness.

PREPARATION

After checking into my hotel room, I set up my computer to review the art that I would present in court the next day. Over the weeks since the deposition, I decided that it was not in the best interest of the case to present all 100-plus images to the court. Such extensive exposure could diminish their impact. Therefore, I chose 29 pieces that represented the defendant's body of work in order to reveal both his talents and his mental illness. Several types of images were left out; none of his photographs were displayed. I felt that they yielded the least information, and many of them show people known to the defendant and his family. I did not want to call attention to those not directly involved with the case.

The 29 images were arranged in a PowerPoint presentation, with a focus on demonstrating revelatory themes and styles. The evening before the hearing, I reviewed each slide on the computer and supplemented my already documented notes with additional information. Along with the slides, I continued to review the data I had gathered about Schizophrenia,

Depression, and Schizoaffective Disorder. I went to bed that evening anxious, but somewhat confident.

I was scheduled to appear before the judge between 10:00 and 10:30 A.M. When I arrived at the court building, I was asked to wait outside the courtroom for the current witness to finish testifying. After sitting outside the courtroom for approximately 15 minutes, I was called inside.

THE HEARING

I entered the courtroom from the back, walking up an aisle between a series of large benches for attendees. Facing them was the elevated judge's bench. Between the general seating and the judge was the witness box; it was in front of and perpendicular to the judge's bench. There was also a sizable table in front of the witness box, with a large screen behind it and a podium next to it, at which the attorneys stood to question the witnesses.

The sentencing hearing consisted of several distinct components: establishing expertise, explaining the assessment procedures, presenting the images with explanation, cross-examination, and redirect examination.

ESTABLISHING EXPERTISE

The testimony began with my swearing-in and confirmation of my name, place of work, and occupational title. The first part of the testimony was essentially answering the defense attorney's questions about art therapy and the particulars of being an art therapist. This was to confirm my level of proficiency. I provided a brief explanation of the educational requirements and the credentials obtainable through the Art Therapy Credentials Board.

The lead defense counsel, Jackie Chief, followed with a series of questions about the history of the art therapy field and the use of art therapy in forensic situations. In doing so, she validated art-based assessments *and* verified that art therapists have been called on to provide expert witness testimony in other cases. This line of questioning allowed me to explain the various assessments that art therapists use and the training needed to provide such evaluations.

My curriculum vita was introduced and accepted into evidence. A series of questions followed that addressed my educational background

and my clinical and practical experience. I was then asked to ascertain how many individuals I had assessed; the aim was to reinforce my experiences to clarify and validate my qualifications to provide assessments.

The next series of questions prompted me to expand on my expertise with assessment procedures, focusing on how I had used various assessment techniques for research studies published and presented at various national and international conferences. After verifying my credentials from the national board, I was asked whether "the specialized knowledge that you possess as an art therapist will assist the Court in understanding the clinical diagnoses which have been rendered by the psychologist and psychiatrist who also served as expert witnesses" and "the information that you have relevant to [the defendant's] case will assist the court in determining a date of onset of mental illness." I indicated that it would.

The defense attorney next focused on how I had become involved with this particular case, beginning with when I was approached by a member of the defense team to inquire about my interest and ability to provide expert witness testimony. I verified that I was paid in accordance with the "Orders of the Court."

This segued into what resources, if any, I had been given to render my initial opinion. I verified that I neither had contact with the other expert witnesses nor reviewed any reports, depositions, or evaluations rendered by them. When asked why I found this to be more a help than a hindrance in assessing the defendant, I pointed out that "it allowed me to approach the art from an unbiased perspective and to determine [by] looking at the art what might be happening, or what might have been going on, with [the defendant] during that time. . . . When I first got the CD there was no identifying information, no indication of what type of information the Court was looking for, or what the defense was looking for." I described the compact disc that contained the images I received from the defense team, including the number of images that were provided and from where they were recovered. I reiterated that I never knew *when* these pieces were completed.

EXPLAINING THE ASSESSMENT PROCEDURES

I testified that I had met with the defendant two times in the previous months and had him complete additional art pieces, from which I could

render a more accurate opinion of his mental state. When asked why this was important, I explained:

> *It's one thing to receive a number of images and to come up with a conclusion based on what you see without actually watching the client [create] the art pieces. Certainly we can make assessments, we can make qualified conclusions, but you don't really have a full sense of an assessment until you actually are able to watch the client do the artwork. Being able to watch him do the pieces provided a great deal of insight of his approach to the art process. What was also gratifying was after completing those three images, my initial assessments remained unchanged. The images reflected what I had seen previously.*

I clarified for the defense what I asked him to draw, reiterating that I administered a standardized assessment procedure, along with two free drawings, as part of the assessment battery.

Chief asked if I had had the opportunity to discuss Kevin Ward's artwork with him:

> *Yes. He provided a great deal of content about the ideas behind the images, about approximately when he did the pieces, and what provoked him to do certain images, and some of the ideas behind the images. But I want to clarify that [this information] was secondary for assessing the images. Content is one thing and there's certainly symbolic meaning that goes with the images, both for what the client says they are and what I may determine they might mean. But more importantly [to me] were the formal elements themselves, how they're drawn . . . the line quality, the space on the page, the compositional format is, as far as I'm concerned . . . more important in providing information on mental health status.*

The notion that the formal elements may be more important in the assessment procedure than a client's interpretation of them may be a debatable perspective in the field. However, given the loose, bizarre, and sometimes delusional statements that Ward associated with the drawings, this approach remains relevant. It was the elements of the drawings and *how* he described the art that seemed more significant than the content of his descriptions. The defense attorney asked me to elaborate:

*[For example,] a sketchy line quality versus a deeply drawn line quali-
ty, a scribbled line quality versus a nicely contained controlled straight
line, provides different information. A sketchy line might . . . reflect
levels of anxiety. A deeply pressed line or a deeply scribbled line may
indicate some level of energetic release, which may be attributed
to manic expression or even an aggressive outburst. If you've given
somebody a sheet of paper that's twelve by eighteen [inches] but they
draw a small image in the bottom-left-hand corner, that provides a lot
more information. . . . [T]he small image might indicate . . . feeling
overwhelmed or helpless, which might be related to levels of depres-
sion, depending on how much detail is connected with that image.
[This is in contrast] to [a drawing] that is so expansive it goes off the
page, which may indicate . . . uncontrollable tendencies or even levels
of mania. Some believe that color [choice] is assessable. As far as I'm
concerned . . . they're wrong. Black and red does not equal aggression;
black and pink does not equal suicidality, so to look at a drawing and
the colors that are used is probably unfair to the artist that chooses
those colors. What's more important is how many colors are used. It
takes a great deal of energy to put down a color, think of another
color, pick it up and use it. A person using fewer color choices—and
this is where watching the client comes in—is a lot more important
[information] than just accepting the single color image without see-
ing what their intention was, but in many cases if they just choose
one color [it is likely] because they lack the energy . . . as opposed to
somebody who uses all fourteen colors that are offered to them and
then they're all over the page. There's also something called color fit,
which indicates whether or not the colors in each image were used ap-
propriately [that is, green and brown tree, blue sky, and so on].*

I was asked about the value of using many images to assess the defendant:

*You can't make a judgment call on one drawing. It's not fair to the cli-
ent, and it's not fair to the other members of your [treatment] team.
You need a battery of assessments. You can certainly look at a draw-
ing and [speculate as to] the current state that that person might be
in. It is a snapshot of how that person might be feeling now, but if
you have hundreds of drawings that [span] a long period of time,
then you've got more than just a snapshot. It'd be pretty much a*

flipbook. . . . By looking at a number of different images . . . you may not realize until after you get the opportunity to lay them all out and review them, that you're seeing patterns emerge; that there's an ebb and flow to the types of images that may occur. The same line qualities may come up at certain points of time. The same shapes may come up at certain points of time. The same level of energy based on how they're doing the drawing may come up at a certain time. So, to be able to look at hundreds of drawings, you're going to notice . . . patterns, which . . . may represent an assessable criterion.

I verified that I had had enough images to arrive at an informed decision and a valid assessment. I also emphasized that although I had come to a tentative conclusion before meeting Ward, it did not change once I did. The compact disc containing the images was accepted into evidence.

I was asked about my initial reaction when first viewing these pieces:

This might sound unusual, but there was a level of comfort [as] I had seen a number of these types of images before; I felt confident that I could come up with conclusions based on [them]. My initial reaction was that this person was suffering some level of mental illness, and that there were some cases where mental illness was probably more pronounced than other times, but pretty much throughout all of the images there was an underlying mental illness.

I told the court that the images seemed to span a considerable length of time. Although Ward's style and talent changed somewhat over time, the elements exhibiting his mental status did not vary much. I offered my opinion that he had talent and obviously knew how to use art materials. I then clarified the patterns that I believed were inherent in his art pieces. I began to explain in general terms what I felt was revealed. However, the defense counsel interrupted me and recommended that if I found it helpful, I could refer to specific art pieces. Thus began the next and longest phase of the testimony—presenting the art.

PRESENTING THE IMAGES

I noted that I had chosen 29 images selected from more than 100 provided and arranged them into a PowerPoint presentation. I was asked by the

defense counsel to "address to the Court what you found in those pieces that was significant and what you thought assisted you in your assessment of mental illness." The lights were lowered. The images were projected onto the screen, which was angled so the judge had a clear view of what was being presented. The district attorney and Bill Williams sat at an angle to the screen, but were able to see the images with minimal effort. Most of the attendees sitting in the public area were able to see most of what was on the screen.

I began with figure 2. I explained that although it was not one of Ward's first pieces, I had decided to start with it because it strongly exhibits his talents:

> [However,] this is one of those cases where . . . the formal elements of the image belie some development of decompensation, where we start to see a loss of focus. We start to see [that] the figure itself tends to blend into the background. What could easily be chalked up as a style actually reflects . . . decompensation and fragmentation. And by fragmentation, [I mean] how the color forms seem to jar with one another. The composition itself seems to start falling apart. It holds together well, which makes it a beautiful piece, but [we're] starting to see . . . decompensation.

I was asked what I meant by "decompensation." I explained that this is usually the term used for a person who starts to lose focus and regress, which may indicate symptoms of mental illness. As an example, I pointed out that

> in the back-right corner, we see this form that starts to emerge, where the pieces themselves start to [not] jibe. There doesn't seem to be a real [organized] composition. It's almost like the form itself is decomposing . . . as much jarring line quality and details that the body had, the face of the person in the forefront is starting to disappear, whereas the figure on the right has no facial features and no real detail. It took me quite a while to realize that there was indeed a person back there. . . . [W]e start to see a breaking apart of the lines . . . you know, [there] certainly is an artistic quality [style that allows] for sketchiness, but what we see here is more of an erratic line placement throughout the [body], the thigh, the legs, and in the shoulders of this person in the forefront. The person in the back has no lines.

Next, I introduced figure 6 as a page "from his visual journal." I explained that it reflects a breakdown of composition "similar . . . to disorganized speech, which might be attributed to levels of Schizophrenia or even Schizoaffective Disorder." This was the first time that I introduced a properly identified diagnosis. For the remainder of the testimony, I would be referring and comparing all emerging visual cues back to this diagnosis.

I indicated that the erratic composition of the unrelated imagery on the page was more likely due to "frequent derailment in thoughts" rather than an organized and conscious decision. I pointed out that while the bottom-right-hand piece is fairly well developed, Ward seems to have digressed into unrelated imagery. I clarified, however, that "although it's starting to become fragmented in composition, it's not that bad. It's still holding itself [together] fairly well."

I emphasized the various energy levels exhibited on this single page. Ward's "deep and strong line qualities" used to depict an explosion at the bottom right is contrasted with some of the other parts of the composition, "specifically in the upper left and the upper right, where you have a fading line quality and a lighter sketchiness, which may indicate . . . less energy." It was almost "as if he was going through mood changes while he was doing the piece."

I introduced figure 32 as an example of the importance of having spoken with Ward about his pieces. I first believed that it was an exercise from an art class where a student might be asked to separate and compartmentalize facial features in separate boxes. However, he explained that he had not completed this work for an art class but had drawn it under his own initiative to illustrate various emotions:

> When asked what these emotions were, he said that the top-left piece represented "a window." The top right indicated "pungent." Middle left was just lips. Middle right was "eyes are different." Bottom left indicated "deadpan." Bottom right indicated "little details." So even when these were supposed to indicate emotion [which they aren't], and even as emotions they're separated and compartmentalized, and by that I mean [there is] a boundary around each of the sections that separate them, it almost [represents] a separation of mind and body, a separation of emotion from intellect.

I explained that such characteristics are also found in those exhibiting a mental illness, specifically Schizophrenia or Schizoaffective Disorder, who compartmentalize or contain their emotions: "Saying that they're emotions, then using non-emotional terms [to describe them] seems to tell me that this was a person who's far removed from any emotions that he might have been feeling at this time, or [he is] unwilling to acknowledge [them][*pause*] . . . [it's] almost a defense mechanism." To maintain some level of professional integrity, such conclusions would best be presented couched in qualifiers; there are no absolutes in such exploration and inquiry. There are too many mitigating factors to allow a clinician to state unequivocally the meaning of an element or a form. Even empirical and statistical conclusions allow for probability and error. Stating absolutes could have left me open to devaluation or invalidation by the prosecution.

The next slide, figure 10, is another page from Ward's visual journal. I told the court that he had referred to the scribble in the center of the page as a pathway, "specifically a pathway going through a dark tunnel." I explained that this symbol would emerge periodically throughout the rest of the images. I recognized the line as a scribble that reveals a hyperactive loss of control. It could "indicate some form of manic reaction, [almost] a loss of control":

> So it's almost like we're starting to develop into a manic expression, and still coupled with some of the delusional concepts behind it is this notion of a pathway. This explosion, this unrelated imagery, it's [reflecting a] disorganized composition. So you have the unconnected fragmentation and the composition related to this energetic release, leaning more toward a schizoaffective possibility.

When asked to present my opinion of the significance of the pathway as a recurring symbol, I reiterated for the court what the defendant said it was. However, I explained that while he insisted that the scribble represented a journey, his descriptions and explanations became tangential and unfocused: "So it was difficult at times to actually get him to focus on the image, which the tangential thought process and the unrelated concepts that he was saying very much reflected [paralleled] the type of compositions where the images themselves were unrelated and tangential and fragmented."

The next image was figure 52. I asked the court to "note the fragmentation of its construction. . . . You have a disembodied head that seems to be floating. And this notion of a head separated from a body—and I can't keep away from this notion of the separation of mind and body, emotions from intellect—but it's an incomplete head, disembodied, floating that he then connects with what he considered a tunnel." When asked to clarify a "disassociation between the mind and the body or the emotion and the intellect," I explained that in my experience, people with Schizophrenia maintain a "separation of mind and body." Those with such a mental disorder develop almost a "schism between . . . their feeling and thinking," which may result in a delusional response.

This explanation segued into the next image, figure 8. I noted that whereas it is beautiful, the defendant had presented it as a mountainscape, yet also recognized it as a woman's torso. In a sense, he was

objectifying the form, the inability to relate to this person—[there is] the removal of the head, the objectifying [of the figure] into a mountainscape, [there is] almost the anxious-like line quality with the scribbling—it's a very controlled scribble, so there's a development of some level of anxiety perhaps, but not necessarily out of control, but all of this might very well relate to an inability to relate to this figure, this person. It's once again, a schism between mind and body, an inability to express emotions or feel emotions or even relate to one's emotions; there's a certain disconnect that's happening here.

Conversely, I explained that figure 17, "Mind Cage," reflects quite clearly what the defendant had been trying to communicate. As he pointed out, "That's how I felt. I'm the person inside the cage. It's the art wanting to get out, without the tools or skills for me to project it, I can see it but I can't get it out":

This seems to represent feelings of helplessness and hopelessness; a feeling of all of these things closing in on him that he just does not have control over. Things that are pretty much coming down around his thought processes. . . . [H]e's got everything from hate and contempt and love and deceit and rage and shame, closing almost oppressively . . . in this cage. The figure in the middle, which he says is him behind these bars, is unrecognizable . . . which to me points to levels

of helplessness and hopelessness, [and a loss of identity] which might
be characteristics of the onset of depression. Very different from some
of the more manic line quality that you saw earlier.

Figure 53 was presented. I explained that Ward had indicated that the
five people in the composition represent "the different people inside of
us." Drawing the court's attention to the bottom image, the house with a
cross on the roof, I explained that it is almost "anthropomorphized," or
is an anthropomorphic representation:

[T]his path starts to become the shoulders of this house; there's a face
within the house; there are breasts on the form. Where the house itself
starts to morph into a specific person . . . [and] eyes that emerge in
images, especially disembodied eyes or even eyes that are added to a
non-corporeal form such as a house, may indicate level of paranoia
or delusions. Such a representation continues to reflect a potentially
bizarre mind-set.

The composition of figure 16, the next piece I introduced, is erratic and
unclear. I called attention to the image that the defendant had referred to
as "Star baby." I presented his explanation—he was once called "Star
baby" by his wife—but what he said and meant was unclear. This served
to underscore Ward's bizarre and tangential descriptions while introduc-
ing his tendency to include unusual words in his images.

Figure 15 was introduced as another example of disorganization and
fragmentation: "There's a disconnection with the forms. You start to see
where the pencil lines themselves are starting to become a little bit more
smudged, little bit more out of control, a little bit less focused, and [is]
yet another example of disembodiment."

The pace of viewing and describing the images began to increase. It
was difficult to determine the fine line between spending too much or too
little time talking about them; I considered the risk of losing the viewers
compared with losing an opportunity to clarify comprehensively what
was being viewed. It was a constant struggle throughout the proceedings.

For figure 14, I called attention to the juxtaposition of facial features
embedded in an inanimate object: the balloon. Figure 54 was presented
as an unambiguous illustration of Ward's pathway: "Compared to some
of the more expansive figures . . . the dark colors representing this figure

[reflect a] lack of energy . . . and then all of a sudden there's this explosion on the page. It's much more controlled and focused, but even within that, he starts to demonstrate [an] explosion."

Figure 7 is yet another page from Ward's visual journal. It was introduced as one of the more pronounced and dramatic examples of fragmentation, disintegration, and decomposition. Despite the confusing and chaotic composition of unrelated images, the defendant was able to clearly identify all the elements:

> They all meant something to him, and I don't want to take that away from him. These do have symbolic [meaning]. But this is why the formal elements of the art are so much more important than the content. The way they're drawn, the relationship of the images on the page. . . . [O]n one level he's indicating that fire represents cleansing, that the buildings on the bottom right represent one thing and that the butcher knives around the table represent something else. Each individually represents something to him with this pathway going through the center. And incidentally, the pathway seems to [bisect] the page, one half from the other. But more important is the way he uses the colors, the way the forms begin to decompensate . . . almost like he's starting to lose control of his own abilities to create the style. You have these butcher knives that are finely drawn, well rendered, and tiny, and yet on another level you have these periods [where he] obviously demonstrated the ability to draw faces. [Yet with] these two faces [we] are starting to see an inability to focus long enough to render them. . . . Not to take away from the meaning for [the defendant].

The next image, figure 19, was presented for two reasons. It established skill and talent while demonstrating a fragmented composition and apparent loss of focus. The extreme variations on the page result in a strong illustration:

> Although there's a great deal more control here and he's definitely more focused . . . [there are] all of these unrelated images that are [on] the bottom [of the page]. You have the Keith Haring–like form on the bottom left with an extra arm. You have this horse, a linear symbol of a horse, where he labels the heart and the ribs—a need to, to label them, this burning building, and this, Spiegelman-type rabbit,

which doesn't seem to belong with any of the composition, and then this scribbling on the right-hand side, which many people will scribble like that because they're trying to figure out colors that might work or try and sharpen the pencils but it seems too controlled for that, to contrived for that. And if that's what he was indeed doing, it's interesting that he would spend so much time and effort and ability to draw that torso, and then lose just enough control for him to create a [disjointed] composition around it. [It seems to indicate] decompensation . . . that he lost his focus. That he started to "fragment."

Keith Haring and Art Spiegelman are two artists who are known for their counterculture imagery and cartoons. The problem was that I was using obscure references to explain two symbols, a mistake that could have easily lost the judge and attorneys or made it seem that I was "showing off." In my presentation, however, referencing these two artists was a form of shorthand to explain a much more complex idea or image. This is common among members of a professional group, but loses its impact if the audience does not belong to the group. In this case, I was so caught up with testifying and describing the art that I forgot who the audience was. This can be a very costly mistake, especially in front of a jury.

Next, figure 55 was presented, emphasizing the

disembodied face that seems to be melting . . . the burning buildings in the bottom right, that doesn't seem to be quite rendered; and then this little tiny pencil sketch in the front right. I don't know if you can see what it is, but [there are] three little piano keys, with a little musical note coming out of it. And then you have this shape, this "amorphic" shape, that's on the bottom left, this blue shape, that could very well be a piano. . . . [W]hen asked about this, [Ward] indicated there was a sickle in it, but then he basically said, "It's piano keys. I always wanted to play the piano." And that was his focus of this drawing. Despite everything else that was going on around this composition, that was pretty much what he focused on. It was a bizarre response.

Figure 22, the next image presented to the court, contrasts with some of the more colorful, explosive imagery. This piece is simultaneously a depiction of an hourglass and a representation of "a woman." I described it as "very simple, very lightly rendered, almost blending into

the background." I indicated that this piece, which is more barren and subdued than some of Ward's previous compositions, may represent Depression.

The defendant had "claimed [that figure 20] was a play on Georgia O'Keefe." I described it as an enigma:

It's well composed, well compositioned [sic], *but there's a great deal of energy that went into it, really pressing down on the materials to make sure that it was colored in the right way. And it's not a matter of just scribbling the black. This was well focused; a great deal of energy went into layering the black on top of the blue. I mean that takes a long time, and that can take a great deal of energy, almost like he's trying to get through the page, if you will—it's a matter of just a great deal of focused energy. Almost as if he's got all this pent-up energy and he's putting it right there in the center.*

I noted that the image is almost indicative of someone trying to contain an emerging loss of control. I explained that at times, when a person begins a manic phase, he may feel the need to control the emerging energy. I reminded the court that the defendant stressed that the act of drawing allowed him to focus.

Figure 33 was introduced to provide an example of this "loss of focus." While I expressed admiration for the well-rendered face, I described the scribble down the page as a visual representation of losing control in the middle of a drawing. This exemplifies how suddenly the loss of focus could come upon Ward, who was unable to stop it. When asked to clarify what such emerging, uncontrolled energy may mean, I indicated: "It continues to support the notion that a delusional tangentiality emerges in these pieces, and that there's an energy, almost a manic level that comes out. . . . [While] I don't diagnose, I can't diagnose, but this assesses, this leans toward . . . Schizophrenia, but adding in the mania, and even levels of Depression, I saw an emerging assessment of Schizoaffective Disorder."

Figure 34 was described as the defendant's "ultimate response . . . an illustration of loss of control, of energy, fragmentation, decompensation, and tangentiality. This is the embodiment of the loss of the composition that I was talking about. There seems to be nothing that holds this piece together." I surmised that if he had had "larger paper, he would have

kept going. . . . [H]e's only contained within the boundaries of the paper given here."

I informed the court that figure 50 is a photograph of a mannequin that Ward had staked down in his yard. I explained that his plan was to eventually set it on fire, that it was indicative of decay, and that it was, in fact, a self-representation. I pointed out Ward's statement that the piece reflected his experience with severe drug use; he put the mannequin in the yard before his substance use, and, as it decomposed, he too decomposed. I noted that this "horrific piece" reflects the mental illness that drove him to create it: "This staking down of a body to allow it to decompose, and then eventually to set fire to it, to cleanse it, [reveals a] delusional thought process, especially when he says 'this represents life for me.' It's a very powerful piece; it stands or, if you will, it lays about four and a half to five feet across. I saw a photo of this when it was staked down in the yard. It's an overwhelming piece." When asked, I verified that I had seen it firsthand and that it was made of wood, albeit unrecognizable, as the mannequin had greatly decomposed.

I presented figure 49 as an example of fragmentation and loss of energy. I wanted to provide the opportunity to see a detail of the face at the bottom-right corner of the page (figure 49b). It is composed of words. I explained that the use of unrelated words is "reminiscent of what clinicians sometimes call word salad. This [reflects the] notion that people with developing Schizophrenia or people with Schizophrenia or developing mental illness will often express themselves through word salad. They will speak in ways [using] unrelated concepts and terms, and some words are strung together that just don't make sense." I told the court that the literature describes people with Schizophrenia as often embedding unrelated words in their drawings, similar to word salad.

Figure 47 offered additional examples of this visual word salad. The control and organization of all the unrelated terms and phrases in these images are in stark contrast to the absence of control in figure 48. While both drawings are composed primarily of words, the second one presents

an explosion of words. We also see—and I don't know if you can tell from this slide that in the upper-right-hand corner, there is a pair of eyes—can you see that? And there's also this arrow on the left-hand side. So we have all of these words, this rambling of unrelated concepts, . . . coupled with these images of these eyes and this arrow that

seems to be flying. This crossing out of words . . . overall the sloppi-
ness of this expression, just seems like he had a need and a drive to get
this out, without really dealing with or really focusing on the need to
stay focused or stay in control, as compared to [figures 47a and 47b].

Figure 44, a composition of layered oil pastels that seem to cover sev-
eral figures, was presented. I explained that in my experience, layering is
not unusual in art by people who have delusional tendencies or paranoia.
I told the court that people with such mental illnesses may overemphasize
layers "because they may want to cover up what's underneath . . . almost
like [they are] hiding things."

Figure 43 was offered as an example of works that Ward had com-
pleted in jail. I explained that he used various materials available in the
prison, such as coffee and toothpaste, leaving the surface of the piece
textured: "Again, a beautiful composition, but we've got a lot of layered
images and a lot of blending in of the forms which seem to be disappear-
ing within the background. Whether or not it's finished I'm not so clear
on, but as it stands, this notion of having to layer upon layer upon layer,
belies this need to cover up." I was asked to reiterate how such layer-
ing may represent diagnosable symptoms. As I indicated with figure 44,
I reminded the court that it may express "the need to hide or the need
to cover up [which reflects] paranoia, which [could be] attributed to . . .
Schizophrenia or Schizoaffective Disorder."

Chief, the lead defense counsel, reviewed my conclusions based on
the images presented thus far. She clarified my position by reiterating
that the images indicated "the diagnosis of Schizoaffective Disorder or
Schizophrenia and a Mood Disorder." She also wanted me to assure her
and the court that although I had selected only 29 of the more than 100
images I reviewed, this fraction represented Ward's entire body of work
consistently. To underscore the point, she recapitulated, "These same
themes that you've pointed out were consistent throughout the pieces that
were available for you to review." I replied that they were consistent, but
reviewing all the art pieces "would be too much. . . . It would be, well
frankly it would be boring." I assured her that "these are reflective of the
entire body of work."

The defense attorney asked the purpose of meeting Ward and conduct-
ing an assessment when I had had so many art pieces to consult. This
question provided an opportunity to explain the value of observing him

complete the art and asking him about his process. The assessment would also allow me to "verify or nullify what I've seen in the art pieces."

I explained the Formal Elements Art Therapy Scale (FEATS), underscoring the effectiveness of the procedure. I was asked to clarify its similarity to other assessments administered by psychologists; I assured the court that it is a valid and effective standardized procedure. While I explained the FEATS, figure 28—Ward's rendition of Person Picking an Apple from a Tree (PPAT)—was displayed.

Although the defendant had completed the assessment images before he and I discussed his other art pieces, I thought it more effective to show the assessment drawings at the end of the testimony, to demonstrate the consistency in style and form over time. I presented my assumptions:

> Well at this point he's falling on the level of depression as well as some levels of developing schizophrenia. . . . [H]e scored low in prominence of color and color fit. He did score somewhat high on implied energy because of the lines that he did, and because of the unique task that he tried afterward, in which he tried to smudge the markers with water. I have to say—and I've administered this hundreds of times to different clients—I've never had anybody crumple up a piece of paper before [completing] the FEATS [drawing], and I've never had anybody try adding water after the FEATS to create an effect that otherwise you just can't get with these types of markers. By far, [the defendant's] was the most unique response I've ever had [for this assessment procedure].

I explained that Ward's score was consistent with Schizoaffective Disorder. However, I did not clarify that I arrived at this conclusion based on the combined ratings for depression and schizophrenia—in hindsight, based on the questions from Williams during the cross-examination, I should have been clearer.

I next presented figure 29, the first free drawing of the assessment process. I explained the procedure, the rationale for this directive, and the materials that Ward had been offered to complete the image. I pointed out that his drawing style remained consistent over time:

> So here we are ten years later from some of those other drawings, and we still see the tangentiality of the forms on the page. We see the

erratic line quality. We see the fragmented composition. We see unrelated forms. Now, having said this, there's some of these images . . . they're beautiful images. This linear drawing on the left is a contour drawing, which is basically just trying to do a complete image without lifting a pencil. On the left-hand side is a beautiful piece. But with everything else going on around it, there seems to be a breakdown of focus . . . basically it seems like he's decompensating. Even in this process. And then from here he chose to do a third drawing. And here's the drawing here.

Figure 30 was then presented:

GUSSAK: *[W]e see the development of a face on the right-hand side. And he started a body, done in blue in the left-hand section of the [composition] . . . a reclining figure. So he did this linear drawing of the face with breasts on the right-hand side, and then he started doing the torso on the left-hand side. Then he turned it [horizontally] and completed [the human figure] as a landscape. So it's reminiscent of that blue form we saw earlier where the torso had the head cut off and the legs, [revealing] an objectification of the form, of the body [figure 8].*

So over the span [of time it took to complete] these three assessment images, although the first one started to show Depression and we started to see an emerging Schizoaffective Disorder, we see a decompensation into [a complete] Schizoaffective realm by the end of this third drawing.

CHIEF: *So what you've described in these last two, I'll call them free-form pieces, was reflective of what you saw in earlier pieces.*

GUSSAK: *Absolutely. And that's what was validating for me, that what I saw here and how these emerged, are reminiscent of all the other images that he had been doing, all the images that I had reviewed up to this point. And please keep in mind that I hadn't even seen the ones that were in your office when I had [the defendant] do these images. All I had were the other images that were on the initial CD. So, when I went back to your office and saw some of those other images [that] maintained a level of consistency through all of the images, it was very gratifying.*

CHIEF: *And when you say a level of consistency, you mean consistency with your previous assessment.*

GUSSAK: *Yes.*

The defense counsel began to explore my experience with people with substance abuse issues. The prosecution was arguing that the crimes were a result of Ward's substance use rather than mental illness; I presume that the defense wanted to preempt this assertion by demonstrating that I could tell the difference between the art completed by those with severe substance abuse issues and those with mental health issues. I explained that many of the adults and adolescents I worked with over the years had a history of severe substance abuse. However,

most of the artworks that I've seen are done by people who are [likely] recovering drug abusers. To be quite frank, I don't have a lot of artwork, and there's not a lot of artwork out there of people that are actually on drugs at the time that they're doing art. For one reason, they just don't have the ability or the focus to do the art, specifically [if they are on] methamphetamines. I did an exhaustive search in the art therapy literature of [art therapists] that had worked with people [who] had been addicted to methamphetamines, and the artwork that might have emerged from them, and there's nothing in our literature of anybody who has any artwork [of] people who are currently [using] methamphetamines. What they do have are people who they're working with through the art therapy process [during their recovery]. Well, by the time you have them afterward and they've been clean for some time, their artwork starts to take on a level of normalcy, takes on a level of average consistency, that there's a level of stabilization. But we don't have that here. We see [a level of] consistency [in his artwork span from] before the meth use to this [current] point, which is way after [his] meth use.

The final image I presented was figure 56, an original drawing that had been obtained shortly before the trial and thus was not available in time to include in the PowerPoint presentation. I explained that Ward completed it while he was in the county jail and that it is consistent with his previous pieces:

[There are a lot] of angular forms and some disintegration of forms. Now we do see a level of focus, but even within that level of focus we see this, these forms that are disintegrating and layered. He's got this tendency to continue to layer throughout the process. [I]t is a beautiful piece, [and] it's also quite reminiscent of some of his other, earlier tangential qualities. The only reason it holds together is because of the colors that he's used. If this was done with the pencils or whatnot, it would maintain its level of tangentiality. The reason it's so overwhelming and beautiful is because of the colors he's used. Otherwise, it's still reminiscent of all of the other pieces that he's done.

After being asked to expound on what I meant by "reminiscent," I answered that the piece is consistent with "a diagnosis of a Schizoaffective Disorder" as seen throughout the artwork.

The final question from the defense counsel provided a summation of the testimony:

CHIEF: *Based on your observations of the artwork, and your research, do you have a professional opinion regarding the nature of the mental illness from which he suffers? I understand that you don't make a diagnosis but I'm going to ask you, is there a type of mental illness with which this artwork would be consistent?*

GUSSAK: *Yes. [Pause] My opinion is that this is consistent with artwork that I've seen with people who have Schizoaffective Disorder.*

CHIEF: *Thank you. No further questions.*

I was then cross-examined by the chief deputy prosecutor.

CROSS-EXAMINATION

I was immediately asked to clarify my original diagnosis. Williams argued that during the deposition, I had not indicated that Ward suffered from a Schizoaffective Disorder. Even after I insisted that I remembered specifically referring to Schizophrenia in the deposition, I admitted that "I can't recall whether or not I said Schizoaffective Disorder, but . . ." He referred to the deposition transcription: "If I were to represent to you that

in this fifty-nine-page deposition, nowhere do you mention Schizoaffective Disorder, would you have any reason to dispute that?" This was not one of my proudest moments. I was thrown off by his questioning and, therefore, was unable to remind him that I had said Ward demonstrated symptoms of Schizophrenia and a Mood Disorder, which, by definition, is a Schizoaffective Disorder. It became clear in the next few moments that he believed that my testimony was made in collaboration with the other two expert witnesses.

The next series of questions was asked rapidly. I assume this was done to disrupt me and not allow me time to think about my responses. Williams focused on when and how I had been contacted by the defense team. This was followed up with questions regarding my qualifications to be a viable expert witness. Defense counsel objected on the grounds that I had already been qualified as an expert witness by the state. However, the judge overruled the objection: "I think we're in a sentencing proceeding; the Rules of Evidence don't apply. . . . I don't know that the court made a ruling on that, so I'll permit this question."

The prosecutor continued, asking if I knew if art therapy "had ever been subjected to a court's determination under a *Frye* test or a *Daubert* test for scientific standards?" I responded that I was not familiar with these rules. Since then, I have investigated the standards to which he was referring. This line of questioning was intended to present my lack of skills and experience in testifying. The defense team viewed it as unnecessary in a sentencing hearing because the judge had approved my status and no jury was present to whom I could defend my competence. In a follow-up interview, Williams admitted,

> I wanted to show that . . . to the best of my research, I could never find where [art therapy had] been scrutinized by a court as to its scientific background. Do I think it would have passed? I do. I present that based on the fact that I had not done a substantial amount of research, but I think that it's certainly something that the courts need to know, that it hasn't gone through that type of scrutiny yet, and certainly if I were presenting that evidence, I know the defense would have done the same thing.

As discussed in the introduction, though, art therapists have been accepted as expert witnesses despite *Frye* or *Daubert* scrutiny. Safran, Levick, and

Levine (1990) discuss the ruling, but the prosecution did not know about this article. When asked why he had not read it, Williams reasoned that although art therapists had testified in front of judges, their testimony had never been appealed; therefore, "it's never made it into an appellate decision, and that's what I have the ability to research, appellate decisions, and . . . so I didn't find anything."

Chief indicated that the prosecutor's action would not have been a surprise if the case had gone to trial: "It's true with any new field, it's hard to be qualified as an expert, and yet they would have fought us tooth and nail on your qualifications if we had a jury. . . . [B]ut I still think we could have met the burden." Even Judge Beam concurred, noting that although it was in the purview of the prosecution to call my testimony into question, the gravitas of a capital case would have made it more likely for an art therapist to pass a *Daubert* challenge: "In general, the courts may afford more leeway for the defense in a capital case than another type of case." Someone who could be sentenced to death may be provided more flexibility in his or her defense.

In the next several questions, Williams tried to minimize my experience, asking if my "primary area of art therapy is in therapeutic activity involving incarcerated individuals." He insinuated that this case and my role as witness were beyond my scope. I explained that I worked "with people who have aggressive and violent tendencies and with psychiatric disorders." By expanding my range of experience in this fashion, I included the defendant.

Williams focused next on the assessment procedure. Referring to my previous statements and deposition, he reiterated that the FEATS is used primarily to assess four diagnostic criteria:

WILLIAMS: *Okay. So it, it can determine consistent with Schizophrenia, consistent with Depression, consistent with Bipolar Mania, or consistent with Dementia.*

GUSSAK: *That's true.*

WILLIAMS: *So it's not a very broad spectrum of determinations that can come out of this, correct?*

He stressed that such an assessment procedure is not designed to ascertain addiction. I explained that one of the criteria assessed by the FEATS

is Organicity, common to those with severe substance abuse issues. When he challenged that I had not uncovered such characteristics in the defendant, I defended my position: "I did make a conclusion that there is no evidence of Organicity or Dementia in this image."

WILLIAMS: *And that would be because, it only takes a determination that's a snapshot of that particular time when the artwork is being drawn, correct?*

GUSSAK: *To be quite frank, if a person has a tendency toward Organicity or Dementia, that snapshot would be consistent, regardless of when it was taken, of a person with Organicity or Dementia.*

WILLIAMS: *So if you have somebody that has a significant history going back many years of drug use, would you expect that to show up under that Organicity determination?*

GUSSAK: *Certainly.*

WILLIAMS: *Okay. But you didn't have that in this case.*

GUSSAK: *Not in this drawing, no.*

In my opinion, he successfully inferred that I *should* have seen such characteristics because of the defendant's extensive drug history.

He then challenged the assessment procedure: "How many times have you gone back and actually done a retrospective analysis, going through a history of someone's artwork?" I replied that I had done so many times, usually as an opportunity to review a client's progress during therapy or as part of my research. He argued that in such cases, I usually would have "more information than you had in this case, correct?" I conceded that this supposition was generally true. He asked, "And when you've got to take the artwork that was done prior to meeting with you, that you could only give a qualified conclusion in those situations, correct?" When I agreed, he asserted that this was what I had done in this case. He asked if the "qualified conclusion is because you have to recognize that there are certain things that you're unaware of that may have impacted the preparation or the creation of that piece of art?" When I asked to what

he was referring, he answered, "Well, you don't know what the resources available to the person were at the time, do you?"

GUSSAK: *No.*

WILLIAMS: *Okay. You don't know whether or not that person may have been under the influence of any type of controlled substances at the time that it was created, correct?*

GUSSAK: *I can assess whether or not I feel that the person has been taking drugs at the time that they've done the images, but for the most part, no, I don't have that knowledge.*

WILLIAMS: *Okay. So those are the types of limitations that I'm referring to. You don't have that and you didn't have that at the time of your initial assessment of [Ward]'s artwork.*

GUSSAK: *Right.*

WILLIAMS: *At any point in time, have you been made aware of [the defendant]'s previous drug use, specifically of controlled substances?*

GUSSAK: *From what I can remember, no.*

WILLIAMS: *And have you been made aware of any type of medications that he may have been on or may not have been on—that he may have been on at the time of any of this artwork was produced?*

GUSSAK: *I was unaware of any medication.*

WILLIAMS: *Okay. I think you noted that throughout the course of this artwork, you found periods of decompensation and fragmentation that were consistent.*

GUSSAK: *This is true.*

WILLIAMS: *And this goes all the way back to the early 1990s.*

GUSSAK: *Yes.*

WILLIAMS: *And that goes all the way up into the most recent images that you've been able to review since he's been incarcerated for the last few years.*

GUSSAK: *Certainly there's a lot of consistency, yes.*

WILLIAMS: *I have nothing further, Your Honor.*

On the one hand, it seemed that Williams was effective in contending that the assessment did not register Ward's history of substance abuse. He was also sowing doubt about my testimony by inferring that, without all the available information, I had been limited in arriving at an accurate conclusion about Ward's mental state. On the other hand, as I had argued throughout, the fact that the art may have been completed during the defendant's most blatant drug use was beside the point. The art remained consistent when he was on drugs and off; the formal elements of the imagery revealed a difficult and insidious mental illness.

The defense counsel then conducted a redirect examination.

REDIRECT EXAMINATION

Chief asked if I had taught graduate-level college courses in art therapy and psychology and if I had been involved in the evaluation of, consultation about, and provision of therapeutic services in psychiatric units. I answered yes to both questions. She then asked if I had worked in conjunction with psychologists and psychiatrists to make assessments and if I was familiar with the *Diagnostic and Statistical Manual of Mental Disorders*, "also referred to as the DSM-IV." When I again answered in the affirmative, she asked me to clarify my "understanding of what a Schizoaffective Disorder is—is it a combination of two different disorders?" I responded:

> *My understanding of the schizoaffective disorder is that it is a person who is exhibiting symptoms of Schizophrenia while simultaneously exhibiting symptoms of mood instability such as Mania or Depression, which is why, although all this time I've been speaking about Schizophrenia,*

because of the reflection of the Depression and the Mania that emerged . . . made me . . . lean toward a Schizoaffective Disorder.

The defense counsel succeeded in bringing my testimony back to its original focus—Ward's diagnosis. In this manner, she was treating the prosecutor's line of questioning about substance abuse as ineffectual:

CHIEF: *And what we've been talking about today is the combination of Schizophrenia and Depression.*

GUSSAK: *Yes.*

CHIEF: *Now, Mr. Williams asked you about responses that you gave to a deposition that was taken in this case . . . this year, correct?*

GUSSAK: *Yes.*

CHIEF: *And his implication in asking you those questions was that you had not indicated during that deposition that you had made the type of finding that you've testified to today.*

WILLIAMS: *Your Honor, I'm going to object. . . . She's trying to characterize the question. The question speaks for itself. If she would like to—*

CHIEF: *I'm going to.*

WILLIAMS: —— [indiscernible], *but the way she mischaracterized the question is improper.*

JUDGE BEAM: *Well, I understand exactly what the point is. I understand your question . . . and the point you're trying to make, so why don't we just ask the question and then we'll go forward.*

This question allowed me to correct the mistake that I had made in the terminology used in my assessment and deposition. Despite my careful restraint from providing a distinct diagnosis, I did so during my testimony. I did not change my conclusion; I changed what I called it. This was the difference between a diagnostic description and a proper diagnosis. When

questioned about this in the follow-up interview, Williams indicated that until I called it a Schizoaffective Disorder, he did not believe that I had spoken with the other witnesses: "I didn't think you had until your statement changed from 'Schizophrenia' to 'Schizoaffective Disorder,' which was one of the diagnoses or conclusions that one of the other experts had drawn. That change in testimony certainly gave me pause, and that's why I had to explore it more."

Chief, when later asked about this, viewed it from a different perspective: "It [was] an attempt to make you second-guess what your opinion was, to make you admit why you were incorrect in a diagnosis, or that you misspoke in court, or you misspoke during the deposition or that you said contradictory or conflicting things." In this case, "it was a semantic thing." Lisa Peters reflected on it as well: "If I was the prosecutor, I would have done the same thing; I would have found the discrepancy and shined a light on it, but I'm not sure the average person would really make the distinction between [the two diagnoses]. So I'm not sure that it would have made a big difference if we were in front of a jury." Regardless, Chief allowed me to clarify my diagnostic conclusion:

CHIEF: *Do you recall in your deposition [on] page 33, being asked by Mr. Williams this question: Based on your initial analysis of these drawings, what conclusions were you able to draw, and your answering, "my initial thought was that this person did have a developed mental illness, quite possibly Schizophrenia. As an opinion, some type of Schizophrenia or some type of schizo-type disorder"?*

GUSSAK: *That's true.*

CHIEF: *Is this consistent with your testimony today?*

GUSSAK: *Yes.*

CHIEF: *Do you also recall in that same deposition, testifying in response to another question by Mr. Williams, page 40, "my overall assessment of this drawing is that I would document that this person has levels of Depression, as well as leaning toward evidence of Schizophrenia"?*

GUSSAK: *That's true.*

CHIEF: *And would that be in fact a definition of Schizoaffective Disorder?*

GUSSAK: *Yes it is.*

CHIEF: *Do you recall Mr. Williams going on to ask you, page 44, whether there was anything about [the results from] the FEATS that supported your conclusion for your assessments, and Mr. Williams question to you being, and you stated earlier that assessment was a Depression, with some evidence of Schizophrenia, correct? And your answer, "I would say evidence of both Depression and Schizophrenia."*

GUSSAK: *Yes.*

CHIEF: *Again, the definition of a Schizoaffective Disorder.*

GUSSAK: *Yes.*

CHIEF: *And finally, in that same deposition, do you recall, page 51, . . . Mr. Williams asking you whether in your initial evaluation, as well as in your first documents, your being able to generate associations with respect to your conclusion, to which he's referring, your conclusion that there were strong indicators of Depression and Schizophrenia?*

GUSSAK: *Yes.*

CHIEF: *Okay. Again, a definition of a Schizoaffective Disorder . . .*

GUSSAK: *Yes.*

CHIEF: *. . . which is the conclusion that you've testified to today.*

GUSSAK: *Yes.*

CHIEF: *No further questions.*

WILLIAMS: *Nothing on that, Your Honor.*

JUDGE BEAM: *You may step down.*

THE SENTENCE

Following my testimony, the court went into recess so Judge Beam could arrive at and prepare his conclusion. The court was asked to reconvene within 2 hours. It was during this break that I learned that the other two expert witnesses, a psychiatrist and a psychologist, had provided lengthy testimony based on their belief that Kevin Ward had a Schizoaffective Disorder before and at the time of the crime.

The mitigation consultant, with whom I had lunch during the recess, reflected on all the testimony and the terms of the plea bargain. He speculated that the judge would reach a verdict of less than the 100 years agreed to as the maximum sentence in the plea agreement. This was my expectation when I returned to the courthouse to hear the final verdict.

The courthouse was packed with people, mostly family members, friends of the defendant's former wife, and journalists. The defendant's mother was present in his support. I sat in the back row. After the judge entered, Ward was offered an opportunity to speak to the court, and he delivered a tearful statement of regret.

The Honorable D. Beam began his concluding remarks. He recognized that there was little indication that Ward had been treated for the mental illness from which he suffered, but did allow that the defense was successful in showing that he was mentally ill. However, these mitigating circumstances were "not substantial." As a plea agreement had been reached, Judge Beam said that when considering the sentence, he weighed heavily on several aggravating circumstances, as specified by state law: the age of the murder victim, the commission of the murder in the presence of the victim's younger sibling, the defendant's having been on probation for a misdemeanor at the time of the crime, and the victim's having been in the defendant's custody. He declared the following sentence: 60 years for the murder of his older child and 35 years for the attempted murder of his younger, to be served consecutively, for a total of 95 years. In his closing statement, Judge Beam indicated that he would recommend that Ward receive mental health treatment while serving his sentence.

The court adjourned, but the question remained: Was my testimony on the art created by Kevin Ward effective?

PART III

: : :

ANALYSIS AND IMPLICATIONS

6

THE CASE STUDY

Summary, Reflections, and Ethics

During my almost 3-year involvement in the capital murder case against Kevin Ward, a distinct and predictable course of action developed, each step requiring careful consideration. Following my initial "blind" review of Ward's art in 2006, the defense attorneys secured approval from a judge to hire me as an expert witness. Although he did not wish to provide too much information about the case, he did indicate that although there was not a formal "*Daubert* hearing conducted in this case . . . I guess it was one of those decisions that I had to make in this instance, as to whether or not I was going to permit it, obviously, to go forward, and that was a decision that I had to make." The judgment is typically made on a case-by-case basis.

I was not contacted again until the spring of 2007. At this time, I was asked to prepare a comprehensive report of my review of the art. I did not hear from the defense team again, except for periodic check-ins from Lisa Peters, for almost 2 years. In 2009, I received a flurry of e-mails from Jackie Chief, the lead counsel for the defense, and Bill Williams, the prosecuting attorney. The prosecutor requested a great deal of information from me; the defense counsel advised me to ignore his request, as she would take care of it. She made it clear that I was beholden only to her. I was asked to plan for a meeting with the defendant, during which I would assess him. On the basis of my assessment, I would write a report for the defense team about Ward's mental state.

A meeting was scheduled for the middle of the summer of 2009. While in Peru (picking up my newly adopted son), I received an e-mail informing me that a plea bargain had been reached and that the case would not be going to trial. Nevertheless, I would still meet with the defendant on

the agreed-on date to conduct an assessment and still submit a report to the defense attorney, who would then admit it to the court as evidence for Ward's sentencing hearing. Yet after meeting with Chief following my initial assessment of Ward, the defense decided that my testimony would be given in person. Consequently, a deposition was scheduled.

Williams later explained that the deposition was necessary because prosecutors may not have the "correct" reports from the defense team's hired experts, so "we have to do these depositions, and we use that as more of a discovery tool, sometimes even as a fishing expedition, in trying to figure out what the direction is that the defense is going with that particular individual, or what we can expect to happen in the courtroom." It gave the prosecution a rudimentary understanding of my testimony, providing an opportunity to investigate the assessment tools that I used and the basis of my conclusions about the defendant and to prepare a cross-examination for the hearing.

At the hearing, my testimony began with detailed questions about my background, education, position in the field, publication history, and experience with related circumstances. Essentially, this was for the defense to substantiate my status as an expert witness. Then followed a comprehensive overview of each art piece submitted as evidence. The prosecution next cross-examined me, calling into question specific statements I had made, my status as an expert witness, and my ability to draw conclusions from assessment tools. The prosecutor's job was to cast doubt on my ability and validity. This is expected in a jury trial; any intense questioning may cause a witness to become confused, seem inadequate, or even appear self-contradictory, which can then be interpreted by a jury member as a weak defense. A rigorous cross-examination is not expected in a sentencing hearing, however, and was therefore a surprise in this case. After the cross-examination, the defense conducted a redirect examination in order to remedy any discrepancies or ambiguities created by the cross-examination. I was then excused.

After all the witnesses had testified, the court recessed so Judge D. Beam could make the decision about the defendant's sentence. The court reconvened within 2 hours. The defendant took the opportunity to make a statement, followed by the judge's sentence. The court was adjourned, the judge left the bench, and the defendant was led away as an inmate of the state's penitentiary system.

AN EVALUATION OF THE CASE

APPROACH TO THE ASSESSMENTS

I could have approached the art in several ways: establish meaning through the formal elements of the images, present possible symbolic content to ascertain personal significance, or some combination of the two. The former method was used. This is not to say that one type of information gathering is better than the other. As it stands, there seem to be indicators throughout the images that reveal symbolic content, not to mention Kevin Ward's description of the meanings he ascribed to these symbols. However, in this case, such details and meanings were unnecessary and may have confused the court.

As a means of explanation, I had a telling interaction a year after the hearing. I presented this case in 2010 at the annual conference of the American Art Therapy Association, underscoring the methods used to ascertain the mental status of the defendant. A well-respected colleague, whose opinion I value, asked me if the murder had been committed "by [the defendant's] hand." Due to the particulars and horror of the crime, I refrained from conveying to the large audience the details of the murder—it was enough for the sake of the presentation that I revealed that the defendant had murdered his older child and attempted to murder his younger. When pressed, however, I did tell my colleague that the murder had been done at close quarters and required physical restraint. She then showed me a little sketch that she had drawn on an index card; it was of the small cartoon-like person in figure 19, at the bottom left of the erratic composition. She told me that she was able to determine from this image, because of the extra hand and arm, that Ward had murdered his child in a physical and "personal" manner. She believed that her assumptions about this symbol's meaning revealed Ward's method of killing his child.

This was a fascinating exchange and one that is quite common in the art therapy field. Many therapists look at the art presented to them by colleagues and infer meaning based on the symbolic content, most quite accurately. From my perspective, people's personal art pieces are rife with symbolic imagery that can be quite revealing. Many books and articles have been written about universal and personal symbols and how they reveal information that may otherwise be hidden, even from a client who

completes an art piece. An entirely separate book could be written about the possible symbolic content of Ward's images. However, several factors contributed to my reasons for focusing on the formal elements of the art pieces rather than the symbolic content.

My colleague made an excellent case, from my perspective, about how the figure symbolizes the murder. While this view was fascinating, if it is carefully considered, one might not help but ask, "So what?" I say this with all due respect for my colleague. Yet it was already known how the victim had died, and it was already accepted that the defendant had killed the child; there was nothing new here.

Many of the images in Ward's drawings point to his personal issues: fire, bloody hatchets, signs that indicate "help," walls, and apparently crying eyes. The defendant explained that some of the images are deliberate symbols; one obvious example is the scribbled line that he believed represents a path, symbolizing a "journey." From a therapeutic standpoint, working with a client to recognize his or her own visual library can be advantageous and provide support to promote therapeutic gain; self-awareness is one of the most important steps for change. However, when it is not necessary to bring about a therapeutic gain, demonstrating symbolic content may not be enough—on the contrary, it may be detrimental.

My job was to demonstrate to a jury or judge that the evidence presented had enough scientific support to be deemed viable. The prosecutor's job was to question the validity of my statements, preferably casting doubt on the empirical and objective support for my conclusions.

The type of approach chosen is based on the type of conclusions needed. Providing anecdotal explanations for the symbolic and literal content of imagery may be convincing enough or even completely appropriate in some cases. The content of compositions can support the defense's arguments and may be essential, depending on the type of case. For example, it may be necessary to use art to tell the story of a witness or victim who has difficulty communicating the import of what is being presented, such as a child in family court or who has suffered abuse (Cohen-Liebman, 2003). One art therapist used drawings to demonstrate how a convicted murderer's daughter felt about her father being on death row, relying on the daughter's personal imagery to tell her story (chapter 7).

Whereas symbolic imagery, when "unpacked" by either the therapist or the artist, may reveal personal issues and emotional tendencies— including the *presence* of a mental illness—it is unlikely that the content

of an image can specify the *type* of mental illness. It is not so precise, and not enough experimental/control studies have been conducted to determine if it is accurate. However, empirical studies have shown that a drawing's formal elements may reveal specific types of mental illness. It is this support that dictated my choice of approach and lent credibility to my conclusions about Ward's mental status.

The value of formal elements over symbolic content is also supported when considering the length of time that may elapse between the creation and the assessment of images. It is important from an assessment standpoint to witness the art making, since the process itself provides information needed to arrive at an accurate evaluation. In Ward's case, however, this was not possible. It is not clear what the symbols meant to him *at the time they were created*, but the formal elements had not changed over the years since he had completed the drawings.

Granted, many art therapists may review the body of artwork by their clients, over the course of treatment, to ascertain personal meaning and fulfillment, and to demonstrate change over time based on the content. In addition, symbolic meaning may be assumed based on a long history of qualitative and anecdotal data gathering. However, a therapist may never be absolutely sure of the meaning of the art. Unless a client explains the meaning of the art within a relatively short time after completing it, the possible symbolic content is filtered through the therapist; his beliefs and the context may ultimately influence the interpretation. Even when a client does explain the meaning of the art soon after completing it, the symbolic content is biased by her current state. Thus time may confound the artist's own interpretation. Specific to Ward's case, the artist was not even a useful historian, impeded by his ever-present mental illness. A true assessor of formal elements does not rely on images not completed in his presence, but enough empirical support was available solely for a fairly accurate benchmark on which to build an objective and potentially unbiased argument about Ward's mental status. In a sense, the formal elements of a piece, rather than the symbolic content, may provide a more accurate "snapshot" of the state of mind of the artist when he or she completed it. While the assessment of formal drawing elements may still not be an exact science, this too is changing as more researchers are developing computer technology for projective, art-based assessments (Kim, Kim, Lee, Lee, & Yoo, 2006; Mattson, 2012).

CORROBORATION, NOT COLLABORATION

One of the most important elements of this case was that I independently arrived at the same diagnostic conclusion as the other expert witnesses: a psychologist and a psychiatrist. Thus, in a sense, the art-based assessment process went through its own blind review and outcome evaluation. This should not really have been a surprise. If the conclusion originally and tentatively presented to Peters had not in some way supported the defense's case, I probably would not have been hired. But it is significant that the art did corroborate the other witnesses' diagnoses.

Everyone contacted in the follow-up interviews stressed this corroboration as imperative in supporting the value of the art as evidence. Peters recalled that she had been excited when, before meeting the defendant, I suspected Schizophrenia with a possible Mood Disorder. Chief signified that this had been one of the major advantages of introducing the art therapist as witness: "[T]he way the diagnosis dovetailed with the diagnosis of the other experts, while the review of the artwork and the conclusions that were reached were done completely independently of the other expert. I thought that was a great strength, that we had the corroboration both ways of the same or similar diagnoses, without the experts having collaborated in that fashion." This statement was made in light of the fact that neither of the other expert witnesses nor most members of the defense team (with the exception of Peters) really knew what art therapy is or what to expect from the art therapist. As Chief continued:

> Our own psychiatric experts weren't familiar with [art therapy]. They had heard of art therapy, but they certainly didn't have any idea about how it could be integrated into this kind of defense. I think in this particular case, it provided very effective corroboration for their diagnoses. I think it really strengthened [the other experts'] position, because a big difficulty with this case was trying to show that the mental health issues predated the methamphetamine [use]. It was very effective in doing that.

Judge D. Beam, who presided over the case, concurred, indicating that with regard to art therapy "as a form of testimony . . . it was helpful in a corroborative sense."

Bill Williams—his suspicions notwithstanding—recognized the importance of the independent corroboration; hence his focus on the semantics of the diagnosis, insinuating that it was not an independent corroboration but a collaboration. The intention of his cross-examination was to cast doubt on my testimony and imply that I already knew what the other expert witnesses had concluded. If he had asked me directly if I had collaborated with them, I would have denied it, thus allowing me to vigorously defend my testimony. The manner in which he challenged my statements was meant to question my assertions without running the risk of forcing an absolute denial. Therefore, it was up to Chief, during her redirect examination, to re-substantiate my opinion and underscore the corroborative diagnostic conclusion.

ADDITIONAL STRENGTHS

Both the defense and prosecuting attorneys agreed that using the art as evidence in this case had offered advantages beyond its corroborative role. Peters believed that the art's ability to tell a story had provided a clear understanding of Ward not otherwise available:

> We're lawyers, but we are also storytellers. I'm not talking about making stuff up, I'm talking about simply communicating and explaining why somebody did something . . . not only why somebody did something, I mean there are obviously all kinds of different stories, but in a case like this where there are certain aspects that are under investigation, and there needs to be some explanation and I think . . . art therapy and art-based assessments can really help tell the story because of the visual aspect. . . . I think it's a very effective communication tool.

She also recognized that the art not only told a story, but did so honestly: "When you're making art, you can't really lie. . . . [T]here's a certain truthfulness to it and about the images that we make."

Similarly, Chief recognized that the art "was very helpful in allowing the judge to understand more about the client and why he acted the way he did." According to her, the art was instrumental in demonstrating to the court that the defendant "had the same symptoms that he had at the time of the incident, he had prior to beginning his meth use and also after he stopped using meth. . . . I think we were successful in convincing

him [the judge] of that." She also reiterated that "[what] I thought was very important was being able to look at a lot of different pieces and show recurring themes over an extended period of time." Even Williams, who remained skeptical, indicated that there had been a benefit to using the art: "The way you described watching the creation of the assessment pieces, the way you described the pieces, you persuaded me that yes, there is legitimacy to that process. . . . [Y]ou convinced me of that process, that there is some legitimacy of using that as a diagnostic tool for that point of time."

Regardless of its acceptance as an assessment tool, most parties agreed that the advantage of using the art was to humanize Ward for those who would review his case, jury or judge. Peters insisted that the crimes were "horrific, so to bring the images in to show who the person was, if he's either suffering or if they [sic] were having other problems I think [our job is] to flesh that person out so they are not just a monster, like the prosecution will present him, so I think that's where the beauty of the art therapy is, it does that."

SOME DIFFICULTIES

There were some challenges. For example, one of my initial beliefs was quickly disproved. I had assumed that because using an art therapist to testify in a capital murder case was so unusual, it would be difficult for the prosecution to refute the conclusions. Peters agreed that the prosecutor might have difficulty countering my points, since he was unfamiliar with art therapy. However, Chief reflected that one of the shortcomings was "just the newness of the field, and I think the judge was wary of the field. I think that he didn't have enough background on it." Williams also indicated that an ignorance of art therapy could have been counterproductive, "because if you're going to put that in front of 12 people, if I haven't heard about it, as someone who's completed 19 years of education, they probably haven't heard about it either." Such issues beg the question of what could have been done differently. As Peters noted, "[A]t this point . . . now we have sort of had a trial run you know from my perspective . . . we would now know what we would need to do differently to make it even more effective."

One thing to keep in mind is that a court hearing, juried or otherwise, relies on a certain amount of theatrics: "A professional, whether a lawyer or expert witness, is judged not by intentions, but by performance . . .

[a word] distasteful to many" (Tanay, 2010, p. 47). The intention of the defense is to portray the defendant as a misjudged or pitiful character, one who has committed a heinous crime but was not his true self at the time. This is to demonstrate that his action was separate from who he is, not the Mephistopheles the prosecution would have the jury believe him to be. Thus both the defense and the prosecution use words and presentations, to a degree, in a theatrical manner to define the defendant. Preparing the case with this in mind is necessary.

Peters had several suggestions about what could have been done differently, albeit "we were sort of in uncharted territory." She said that if she used art again, she

> *would try to get the images more front-loaded. . . . I mean I would have tried to start showing those more quickly. . . . [W]e [did] spend a lot of time talking about the pictures. . . . [Y]ou know part of that is the mechanics of getting the evidence admitted so you could talk about it but that was something that I recall . . . wishing we could talk about the images more quickly. . . . [Although we] certainly . . . got all the information across that we needed to get across . . . you know all the things you testified, we got that across. The images [were] very compelling, so I would want to focus on those more than we did, or in a different way, if possible.*

Peters, in turn, asked me what I felt prepared for and what, despite my experience, I felt ill prepared for. As she pointed out, "You know, giving a lecture to a room full of students, giving a seminar paper is a lot different than testifying and being cross-examined." Clearly, a seasoned professional does not always make the ideal expert witness:

> If an expert has no trial experience, his or her ability to understand the problem is limited. Experts and lawyers make the erroneous assumption that the technical knowledge determines the value of the expert in a given case . . . a scientist without trial experience is not a forensic expert . . . scholarship without persuasiveness is a virtue . . . but a flaw in the classroom or courtroom. (Tanay, 2010, p. 43)

Although I was a strong candidate to conduct the assessments and provide a viable conclusion, my professional credentials did not guarantee that I

would be a strong witness. Because I did not have previous trial experience, I needed a great deal of preparation. It is important to remember, however, that every expert witness is new at some point, and experience is the best teacher.

It would have served the defense attorneys well if they had prepared me, through discussion and role-play, to expect a hostile cross-examination, indirect assumptions, and redirections. The defense counselors concurred. If we had progressed to a criminal trial, more time would have been spent preparing me to appear before the prosecutor. Although the defense lawyers would not have coached me on what I would say to the court, they certainly would have run some mock cross-examinations. This role-playing may have acclimated me to the rapid questions and insinuations, as well as the expected attempts to discredit me as an expert witness. Perhaps the defense team was lax in what they expected from the prosecution during the hearing. As Peters recognized, the defense had assumed that the sentencing hearing would be more cut and dried: "I think that we had a reasonable expectation that you would be able to testify and that we would be able to present the evidence; you know they didn't have a witness to counter your testimony, you know to cross-examine, [so] we had a pretty good idea on how it would be."

Chief also acknowledged that if my testimony were to have been given in front of a jury, the defense team would have done several things differently. She believed that it would have been beneficial to be more specific about the dates of the pieces. This would have explicitly illustrated that the art reflects consistent mental illness rather than drug use. She also thought that "we would have had to spend more time on the individual pieces so the juror could really see what it was you were describing," which she recognized was difficult at times. She also felt that the art could have been presented in a much more advantageous and even more dramatic way: "I think we would have wanted to have the ability to show several pieces at the same time. . . . I would have wanted to have the pictures blown up better, resolution better . . . and have the ability to have them shown side by side, so that when you are saying that you could trace similar scenes, it would be helpful to show them the same scenes [and formal elements] repeating." It should be acknowledged, of course, that such theatrical methods are not just the province of the defense team. A plea bargain had been reached and this was simply a sentencing hearing, yet the prosecution did not treat it as such. As Chief reflected:

I did not expect that there would be the kind of cross-examination at the sentencing hearing that there would be at a trial. For one thing, the cross-examination of an expert is a lot different than the cross-examination of a lay witness. The kind of thing that attorneys sometimes do with expert witnesses, like [asking] "How much are you paid?" . . . doesn't go over too well with a judge. It is kind of a waste of time. To the extent that it was done in this sentencing hearing was done for the benefit of the audience and not the judge. . . . [Williams] was talking to [Ward's former wife's] family.

With or without theatrics, cross-examinations are an attempt to make the witness second-guess him- or herself. Ultimately, this could have called into question the acceptability of my role as an expert witness and allowed the art to be dismissed as valid evidence.

Williams indicated that if the case had been tried in front of a jury, he would have conducted much more research on art therapy and the assessments I would have introduced at the trial: "In this particular situation, since we did resolve the case, and I didn't feel like I was going to be cross-examining on the basis [of] your diagnosis, like I would have if we were in front of a jury; I didn't take it further. I did a little bit more research, but not a significant amount of time after the deposition took place." He did admit that he had become more antagonistic than expected. He began to suspect a discrepancy between my deposition and my testimony when I revealed an actual diagnosis. When I reminded him that I had opened my statements by indicating that I could assess but not diagnose as an art therapist, he replied: "I understand that there is a difference there. . . . [M]y initial gut reaction was, even though there technically is a difference, I didn't feel that there was a difference being portrayed during the course of the trial. . . . [I had a] problem with the way that that was being presented." What Chief chalked up to semantic capriciousness, Williams saw as a reason to disregard the intention of the hearing and to attack my conclusion in the cross-examination.

Was the defendant's 95-year sentence a repudiation of the art as evidence and the testimony of an art therapist? Those I later interviewed did not believe so. The sentence was shorter than the maximum stipulated in the plea bargain due to mitigating circumstances, and the judge indicated in his closing statement that he believed that Ward did suffer from a mental illness and would strongly recommend that he be provided

treatment while in prison. While Judge Beam could not comment on his decision in the follow-up interview, Chief and Peters indicated that, regardless of the sentence, the art-based assessments had been beneficial and had supported the claim of mental illness. So, in a sense, the sentence was not so much repudiation as disregard. And, ultimately, Ward did not receive the death penalty, which was, in the end, a victory. As Chief underscored: "I had a very strong belief that he should have been found not guilty by reason of insanity, because I did think there was a very strong psychiatric component. . . . So, I was disappointed with the length of the sentence he received . . . but for all intents and purposes this was a successful case."

PRESENTING THE ART: WHAT WAS LEARNED?

Upon much reflection, the questions remained: Did anyone who took part in the case of Kevin Ward learn anything about the art and art therapy? Did any of their views change?

One startling contradiction emerged after the hearing was over. Over the years, many of the people to whom I have explained my occupation voice surprise, since, I have found, the common belief is that an art therapist is trained to "read the art" rather than foster clinical treatment. Williams indicated otherwise; he already was familiar with the therapeutic advantages of art therapy as an intervention for mental illness, but not with the use of art therapy as a diagnostic or assessment tool: "My initial impression on the art therapy was more in the use . . . as treatment and not necessarily as a tool for diagnosis. . . . [Therefore,] I did ask, with some skepticism, how you can use these tools, and how do you base the ability to use, particularly the apple tree–drawing task for the diagnosis process."

Chief indicated that she had been unaware that art can be used to assess for mental illness until Peters convinced her otherwise: "The only thing that I knew about [art therapy] was there were art therapists in some of the prisons who were working with inmates, and that there were art therapists in clinical settings who were working with non-inmates, but I thought that what they were doing was primarily geared toward treating people with psychiatric problems, as opposed to diagnosis." It was only after this case that both lawyers realized that art therapy can be employed as a forensic instrument used to provide valuable, assessable data.

Williams admitted that he could have been further convinced of the evidentiary basis of the art in a full trial. However, after wondering how often it could be used in court, he mused that it may be applied in a "forensic type of setting . . . so that it's actually developed enough that it's a usable science. . . . [T]here is some legitimacy of using that as a diagnostic tool. Whether or not that can be applicable specifically toward the one proof of the mental disease or mental defect defense . . . yeah, I think that it certainly has some applicability there."

As mentioned earlier, one of the members of the defense team had to be convinced. Once he heard what the art might reveal, however, he realized that there was an advantage to presenting this evidence before the judge. Peters and Chief were more enthusiastic about what they had learned and about the opportunity to use art again in future cases. Peters described the art assessment as "fascinating" and said she had learned a great deal from the process: "I mean, I just had this gut instinct to contact an art therapist, and I mean, I knew what art therapy was in a very general sense, but I really did learn so much. . . . [Y]ou know, I would definitely try to pursue that again, you know, with the right case." Upon further musings, she added, "It *was* my idea, and, you know, I'm very proud of it. . . . I really felt that I made a contribution to the case [by introducing art therapy]." When asked whether she would use art therapy in a criminal case if the defendant had no history of art making, Chief responded after much thought, "Well, yes, I would."

LEGAL, ETHICAL, AND MORAL CONSIDERATIONS

Often, when I teach ethics courses, a brief discussion ensues on the differences among legal, ethical, and moral issues. In the case of Kevin Ward, all three perspectives were addressed. In order to maintain my professional integrity as an art therapist, all three had to be met and in very different ways.

While "legality" is the easiest term to define, there are at times difficulties in separating the meanings of "ethics" and "morals." For my purposes, "ethics" refers to those principles established by a governing body that provide a system of correct conduct. While ethics rely on a notion of morality, morals are an individual's principles of right and wrong, a person's unique values. Amato explained that ethical standards are "based

on principles, universality, and the rational deductibility of ethical behavior," and she distinguished them from legal standards, simply on the basis of "political processes" (Amato, Blasé, & Paley, 2000, p. 18). Simply put, ethics are the rules that determine what is right or wrong as established by a governing body or professional organization, and morals determine the likelihood that an individual will follow these rules.

Legal issues arose immediately and remained prevalent throughout my involvement in the capital murder case. Legally speaking, once my status as an expert witness was determined by the court, I was allowed to testify. As the Judge Beam indicated, no formal *Daubert* hearing had been conducted, but he declared me an appropriate expert witness using his knowledge of the state laws and criteria.

Although I met the legal criteria, I had to make sure I was faithful to the ethical standards of my profession and credentials: the ATR-BC (Art Therapy, Registered-Board Certified). Codes of ethics developed by professional organizations usually combine legal standards with ethical conduct. Although the American Art Therapy Association (AATA) has its own code, which supervises the professional conduct of its members, I also closely follow the ethics document of the organization that oversees my credentials: the Art Therapy Credentials Board (ATCB). While I try to adhere to all points of this document, several distinct components of the *Art Therapy Credentials Board Code of Professional Practice* (2005)* directly affected my decision making during my participation in the case. Specifically, these standards were

1.1.1.6 Art therapists do not engage in therapy practices or procedures that are beyond their scope of practice, experience, training, and education. Art therapists should assist persons in obtaining other therapeutic services if the therapist is unable or unwilling to provide professional help, or where the problem or treatment indicated is beyond the scope of practice of the art therapist.

1.1.2.3 Art therapists assess, treat, or advise on problems only in those cases in which they are competent as determined by their education, training, and experience.

*The *Code of Professional Practice* that was current at the time of the trial, and thus was my guide for ethical behavior, was revised in January 2005. It has since been re-revised.

1.1.2.5 Art therapists, because of their potential to influence and alter the lives of others, exercise special care when making public their professional recommendations and opinions through testimony or other public statements.

1.1.2.7 Art therapists do not distort or misuse their clinical and research findings.

Although other points in the code address similar issues, these four were the clearest in addressing the ethical concerns I faced. Despite what the court ruled in regard to my professional qualifications, I was ethically bound to acknowledge my own expectations and limitations. I had to be honest with myself about what I felt professionally competent to achieve. While the code does not specifically indicate that I could not provide a firm diagnosis, I believed that doing so would be beyond my scope; however, I felt competent in offering an educated assessment. Granted, I "slipped" while testifying at the sentencing hearing by actually indicating a bona fide diagnosis, but the statement I made at the beginning of my testimony, made on record—that I would assess but not diagnosis—addressed this.

The following ethics criteria provided more of a challenge in this case:

4.1.1.1 Art therapists shall respect and protect confidential information obtained from clients including, but not limited to, all verbal and/or artistic expression occurring within a client–therapist relationship.

4.1.2.2 Art therapists shall obtain written informed consent from a client, or where applicable, a parent or legal guardian before photographing the client's art expressions, video taping, audio recording, or otherwise duplicating, or permitting third-party observation of art therapy sessions.

Maintaining confidentiality is one of the benchmarks of the art therapy profession, which is a distinct challenge that other professionals may not experience. Being discreet is difficult when presenting the art of a client; an art piece is distinctly unique and reflects the creator: "If we do our work well, artwork is as unique and individual as a fingerprint. We can leave names off work . . . but if we're not encouraging stereotyped

artwork, the patient is recognizable" (Agell, Goodman, & Williams, 1995, p. 100). It is for this reason that art therapists are diligent in obtaining release forms that clearly stipulate how particular art pieces may be used, promise anonymity to the best of their ability, and still make their clients aware of the risks involved.

This case was different; it was a public hearing, and the discussion and presentation of the art became part of the public record. Once contracted to testify in this case, I could not protect the anonymity of the client, nor was it expected that I would. Furthermore, the art had not been completed in a therapy session; technically, I was under no obligation to protect the images that Ward had done before I met him, only my assessment of the pieces. In addition, the defense team had obtained permission from the defendant to use his artwork in his defense before I came on board.

Because the art was used in a public hearing, I did not need consent from the defendant to present it and my conclusions or to write about it after the case concluded. All that was required was authorization granted by the court, which had been done before I signed an agreement with the defense team. However, I still obtained a signed release form from the defendant. My professional integrity committed me to this action. I felt that I had to let him know that I respected his work and his right to confidentiality. I demonstrated this by having him sign an additional form, granting permission to present his work in an open forum, including publications and presentations.

Expert witnesses, as a general rule, must understand that their ethical responsibilities are to those who hire them and that ethical considerations for confidentiality may be directly contradicted by the expectations of the contracting attorneys. Ambrogi (2009), in his proposed code of ethics for expert witnesses, indicated under the section "Confidentiality": "An expert witness should assume that all communications with the client or with retaining counsel may be subject to disclosure through discovery and testimony, unless instructed otherwise by retaining counsel" (para. 7).

This raises an obvious conundrum: there are the ethical requirements of the field to which the expert witness belongs, and then there are those specifically for an expert witness. While several professional organizations—such as the American Academy of Otolaryngology–Head and Neck Surgery Foundation—include standards for expert testimony within their codes of ethics, several do not. It behooves an expert witness to be aware of the ethics of his or her given field, while also acknowledging the

expectations of the court and contracting attorneys. First and foremost, members of all professions should "accept only engagements that are within the expert's area of competence and training" (Abrogi, 2009, para. 11). While this may be common sense, Tanay (2010) stressed the need to be forever vigilant with ethical awareness: "[U]nethical professionals would be ill-advised to go into forensic work, as it is much easier to be unethical outside the scrutiny of adversary proceedings. Success in forensic work depends upon rigorous adherence to ethical standards" (p. 37).

The prosecuting attorney questioned my knowledge of my profession's ethical standards during the deposition, and he was right to do so. An expert witness's knowledge of professional ethics and history of ethical behavior should be raised as a potential means to discredit him as a credible and honest witness. In turn, underscoring a witness's ethical authority can strengthen her position with the court. I did not make clear the extent to which ethical considerations had directed the decisions I made, since this line of questioning was not pursued.

Moral considerations require different deliberations. While some moral issues may be considered universal, with a clear line drawn between right and wrong, many are not. A person's morals can be regarded as a direct reflection of who he is. Issues I grappled with included my own stand on the death penalty and my feelings about assisting a man who had killed his child. For that matter, even describing this case to people elicits certain responses, including outrage that I had helped defend such a person.

Throughout the trial, I never indicated my stance on the death penalty, and this book is not the place to voice my opinion. However, in order to address any moral conundrum, it was important for me to make clear— first to myself and then to the defense team—that I would testify neither for nor against the client; rather, I would testify strictly on the art. Some would see this as semantics or rationalization. I agree that it was a combination of the two, but it did allow me to present the best case possible while maintaining personal integrity.

This is not to say that I maintained objectivity; that would have been impossible. As Tanay (2010) recognized, "The notion of a single impartial expert witness is an illusion" (p. 36). I obviously wanted my testimony to mean something, to make sure that my conclusions contributed to the success of the side that had hired me. As Tanay further reminded the potential expert witness, "Neither ethics nor a sense of fairness demand that the expert witness walk down the middle in a legal dispute. On the

contrary, it is the expert's contractual agreement that upon taking the witness stand, he or she will effectively testify in support of one side" (p. 37). When I agreed to work for the defense, the expectation was that I would demonstrate how Ward's art revealed that he had a mental illness. I provided the defense team with an initial assessment, which led to their contracting with me to provide this information in formal testimony. It was up to me to decide if I would accept the contract. Once I did, it was my responsibility—ethical, legal, and moral—to fulfill my contractual obligation.

Another issue I struggled with is my tendency to refrain from labeling a person as merely a diagnosis or an illness. I feel that this is reductionistic and that it is likely that a person, once given a label, becomes forever identified as such (Becker, 1963/1991). Moon (2000) pointed out that some art therapists object to this form of interpretation and diagnostic labeling simply because they believe that there "is always more to a person than his or her illness and more to images than pathological symbolization" (p. 62). A great deal of my own work as an art therapist has focused on using art to allow clients to strengthen their identity and rise above the limitations placed on them—"art therapists can assist in reversing the labels associated with deviance and delinquency" (Gussak, 2007b, p. 147)— and on those with a mental illness. Focusing on a client's strength allows for therapeutic gain—integrity, self-efficacy, and independence—through the art-making process.

Contrarily, in this case, the goal was to apply to the defendant a label perceived as interfering with his ability to rationally comprehend what he was doing. The hypocrisy was apparent to me—while the defense team and I believed that the art could be used to humanize the client and reduce the prosecutor's attempts to present him as a monster, I was being asked to simultaneously define him in terms of his illness and, therefore, as not fully responsible for his actions. Furthermore, I could focus on his art only as a reflection of his mental illness and not of his talent. This caused an internal conflict between my identity as an art therapist and that as the expert witness I had become. However, it would be unethical *not* to do what was asked of me. If successful, I would essentially help save the life of a man who, if mentally ill, might not be held accountable for his crimes. This was a challenge I had to morally struggle with throughout my involvement in the case.

LET'S NOT FORGET . . .

. . . the defendant in this case. While the focus was his art, Kevin Ward remained in the background. However, he must have had a strong reaction to this process. What did he think about his art being deconstructed as it was? Needless to say, his narcissistic investment in his own artistic identity made it difficult for him to witness—and condone—the dissection and categorization of his art into mere diagnostic criteria.

When he learned that an art therapist would be brought on board as part of the defense team, he intended to take the opportunity to expound on the meaning and importance of his artistic vision. My use of Ward's art to stress his mental illness rather than his talent was painful for him. I consistently considered this when testifying during the deposition and hearing. As Jackie Chief observed:

> [T]here were some real difficulties, too, in terms of working with the client. The client was very invested in his artwork, and the idea that [it] might reflect something that could be considered a mental illness was a difficult concept for him. . . . I think that was difficult. . . . [F]or one thing, it almost seemed like we were saying to him that something that was so important to his life and the idea of who he was, was a reflection of a psychiatric illness. I think there were reflections of that illness in the artwork, but that's not what created the artwork. I hope he understands that that is not all the artwork means.

As I had continually made clear, I was hired to testify on the art. Ward knew why I was hired, and I reminded him several times. Of course, being told what to expect and hearing the testimony were two different things. Again, when conducting assessments and writing reports, a therapist must always imagine presenting his or her conclusions to the client, and couch them accordingly. Yet the dilemma here is apparent—in many respects, my testimony could not be softened. I was not hired to provide therapy for Ward, but to determine how his art could be used to support his defense.

My involvement in this case was only one example of how art therapists may contribute to the forensic process during any stage in capital murder cases.

7

ART THERAPISTS AS EXPERT WITNESSES

Three More Capital Cases

- A man kidnapped, beat, raped and killed three women in the Midwest over a 3-year period in the 1980s. A fourth would-be victim escaped. The defendant, Benjamin Stevens, was convicted of three counts of murder and four counts of rape. His prison term has since been commuted to six consecutive life sentences.
- In the early 1980s, a jury in the Midwest convicted Randy Thomas of having murdered two people. Originally sentenced to death, he appealed and his conviction was commuted.
- In the early 1990s, three people were shot to death at a convenience store; exactly one week later, three more were killed at a nearby pizza parlor. Edward Ronalds was tried and convicted of all six murders. He remains on death row.

These three cases differed considerably from one another and from the case in which I testified as an expert witness. What they had in common, though, was that art therapists contributed to the defense or appeals of the three men convicted of capital murder.

The three art therapists who provided support for these cases represent all the unknown art therapists who have testified in legal proceedings. They are also pioneers in the field of art therapy. One of them is a co-founder of the American Art Therapy Association (AATA), one is credited for being one of the earliest developers of art therapy education programs, and one is acknowledged for helping to establish art therapy on the West Coast. Two are Honorary Life Members of the AATA; two are past presidents of the AATA; and all have been greatly influential in

the field of art therapy, as educators, practitioners and policy developers: Myra Levick, Sandra Kagin Graves, and Maxine Junge.*

Although all of them became involved in late stages of the legal process, even years after the trials, their contributions varied considerably, exemplifying the various roles that art therapists can play in the forensic process.

ASSISTING, BUT NOT TESTIFYING

While not called in to provide testimony, an art therapist may be consulted by an expert witness chosen by the defense team. The art therapist may be asked to assess the defendant and write a report for the witness, who could, in turn, use it to supplement his own testimony. The art therapist is contracted because the expert witness recognizes that additional information can be obtained through evaluating the art of the defendant, a procedure that he is not professionally trained to conduct. Even if the witness is a counselor or psychologist who understands projective assessments, he may realize that an art therapist may validate a method that may seem somewhat unorthodox.

Benjamin Stevens, a black man in his late 20s, has been incarcerated in a maximum-security prison in the Midwest since the mid-1980s, after he was convicted of kidnapping, beating, raping, and killing three women with a pistol in 3 consecutive years. After being raped, a fourth woman escaped. Stevens was convicted of three counts of murder and four counts of rape and was sentenced to death. The state's Department of Public Advocacy sought an appeal to determine if he should indeed be executed or retried, based on the argument that he had received ineffective representation during his trial. It was determined that he deserved a review to decide if the case warranted a retrial based on his mental status. In the early 1990s, the Department of Public Advocacy contacted an art therapist to assess Stevens for his mental status. The art therapist was Sandra Kagin Graves.

*They all voiced some regret about not having had the opportunity to present and write about their forensic experiences and were extremely generous in agreeing to be interviewed and in providing their reports (which include details of the assessment drawings) and case files, on all of which this chapter is based.

A former president of the American Art Therapy Association (1985–1987), Graves is credited with having established one of the first art therapy graduate programs in the United States, at the University of Louisville. With Vija Lusebrink, she developed the Expressive Therapies Continuum (Kagin & Lusebrink, 1978), now regarded as a key model for understanding how art therapy is effective at various stages of treatment. Graves was consulted because of her extensive history with and knowledge of art-based assessments and her experience as an expert witness in other cases. This was the only death row case in which she has been involved.

Graves spent 3 days with Stevens in the maximum-security section of the state penitentiary and conducted interviews and assessments with Stevens's parents and two sisters. She understood that in order to provide a comprehensive report, additional information had to be gathered from the appellant's family. At their home, Graves asked Stevens's parents to complete a Kinetic Family Drawing (KFD) and a House-Tree-Person (HTP) drawing. Both procedures were developed by psychologists, not art therapists.

To conduct the KFD, the clinician requests that the client complete a drawing of the family doing something together (Burns & Kaufman, 1970). It is often done with simply a lead pencil on an 8½ × 11 inch sheet of white paper. The appellant's mother and father were asked to draw their family when Stevens was younger. The intention of this assessment is to determine family dynamics and the client's feelings about individual members of the family, while learning about the artist's current status. These conclusions are deduced from a variety of contextual and formal elements (that is, how the artist completes the drawing).

A person completing an HTP sequence is asked to draw a house, a tree, a person, and a person of the opposite sex on separate sheets of paper. These may also be done with a lead pencil on standard-size paper (Groth-Marnat, 1999). This assessment procedure has several variations, including a kinetic version, in which the house, tree, and person are on the same sheet of paper, with the person undertaking an activity. As with the KFD, the information can be obtained from contextual and formal elements.

Because Graves conducted the assessments to gather information for Stevens's review and not specifically to determine characteristics of the individual family members, her conclusions do not appear here. She used

the information gathered from the images drawn by Stevens's parents to determine the assessments she would ask of Stevens and relied on some of this data to provide a comprehensive understanding of him for her report.

With a graduate student in attendance, Graves conducted a variety of art-based assessments on Stevens during her 3-day visit. Before he was asked to complete any drawings, Graves obtained a comprehensive social history of him and a summation of the crime, as he understood it.

Stevens had bad memories of his childhood, recalling many instances when his parents would "whup him." He indicated that although he believed that his mother had done so with good intentions to control his behavior, his father had "whupped him" simply because he was an aggressive and abusive man. He recounted many episodes when he acted out, resulting in his mother physically reprimanding him; eventually, his poor behavior escalated until, around age 12, he began to get in trouble with the law.

His recollections moved from his troubling behavior and his mother punishing him to his sexual exploits without any real segue. He had had his first real sexual experience when he was very young, and he eventually became actively promiscuous and developed various obsessions and addictions. Graves identified a tendency to shift from recollections of his violent behavior to stories of his sexual episodes, recognizing that his thought patterns often shifted among sex, violence, rape, and his mother. He revealed that eventually his thoughts deviated into combinations of sex and violence, during which he imagined making love to his neighbor before beating her.

Eventually, Stevens joined the military; his service was unimpressive as a result of escalated drug and alcohol use. Ultimately, he was dishonorably discharged. His sexual imagination, coupled with violent interactions, continued to increase. Eventually, this culminated in his picking up women, forcing them to have sex with him, shooting them, and leaving their bodies. After killing the women, he felt "peaceful for a few days," but eventually would have the urge to repeat this behavior. One episode resulted in his killing a woman before having sex with her body. It was toward the end of this run that he became engaged. He finally was caught after one woman escaped.

Following the interview, Graves conducted several art-based assessment procedures. Along with the HTP and the KFD, Stevens was asked

to complete a free drawing, for which Stevens chose his fiancée as his subject; a "vision drawing"; and Rhyne's Visual Constructs exercise. The last tool requests a pictorial representation of 15 separate emotions delineated in Rhyne's (1978, 1979) directive. Graves indicated that these emotions were "scared, excited, hate, love, angry, sad, threatened, guilty, weak, passive, safe, excited, going crazy, being sane, weak and powerful, passive and safe"—a slight variation on Rhyne's (1978) constructs.

Rhyne (1978, 1979) statistically established that fundamentally there are universal symbols that represent various specific emotional constructs. The understanding of these symbols provides a consistent analysis of behavior and may offer additional insight into a person's mental and behavioral status if there are any deviations from these standard representations. Graves relied on this directive to determine what deviations—if any—Stevens may have had from the established norm, ultimately determining if he demonstrated mental instability or cognitive dissonance.

The drawings of Stevens's HTP were described as highly controlled; at times, he used a ruler to make sure he drew straight lines. Graves described the house drawing, which Stevens indicated was "his dream house" in Rio, as impoverished (no environment or details), with two chimneys coming out of either side of the roof. She believed that this indicated poor reality testing, weak ego boundaries, and potential dissociation. The tree "is also split, appearing as two single-dimension trees, barely connected to [sic] the top." There is no ground line and little foliage, all of which Graves believed was indicative of "psychotic or dissociated tendencies."

Stevens first drew a man turned toward the left side of the page, in which he "colored in black the face and hands." He identified this as a drawing of himself at age 15, "when he was happy and with someone he cared for." According to Graves, the figure appears paranoid and has "sharp and hostile fingers." She revealed that the remaining details indicated ambivalence, psychosexual problems, strong dependencies, and poor control.

He drew a second figure, a white woman facing forward with a rigid posture, her arms drawn stiffly at her side. Stevens indicated that although his mother was not white, the drawing is of her at age 24. He recollected that others had thought that his young mother was actually his wife, as "she was always picking me up and hugging me, loving me." Regardless of this fond memory, according to Graves, the figure Stevens drew would be unable to hug anyone, much less display affection.

The following assessment, the KFD, included his family with another woman; although the woman was identified with a name, it was never made clear who she was. The figures are sitting at a large table and eating Thanksgiving dinner; the table is so large that it seems to "dwarf" the figures. Although the place settings are precisely depicted, there is no food on the table, perhaps indicating "a lack of nurturance." All the figures have closed eyes, except for the mother. The father is the smallest, appearing the weakest. The drawing seems to reflect a great deal of control.

The next two drawings were considered more "free." The first is of Stevens's fiancée, the only one in which he used color. It is well executed and quite controlled. The figure in this drawing looks remarkably similar to the portrayal of his mother in the HTP, albeit this woman is wearing a skirt. She has no hands, once again a figure who has no control over the environment. A transferential relationship with his mother seems to be more apparent.

Stevens next completed his "vision drawing": a landscape with two trees, birds, and two running figures. The landscape was depicted with a single line floating in the middle of the page. The single-lined images representing the birds float near the ground line, and the "lollipop trees" do not connect. According to Stevens, there is a figure running, but as Graves accurately noted, it "is barely discernible as a human figure." Stevens indicated that the figure is running because it is being chased by a voice that he alternately labeled "the white rabbit" and his "father." This threat is drawn as an ambiguous scribble on the right-hand side of the page. Contrary to his behavior during the execution of his previous drawings, Stevens became quite emotional. This image revealed to Graves a "tremendous amount of regression."

The remaining time was spent with Stevens completing Rhyne's Visual Constructs exercise. Graves asked Stevens to "quickly draw his reaction to an emotion as [it] was called out to him," using a separate sheet of paper for each of the 15 emotions. Her report includes a narrative synopsis of the process and his images:

> The order of the drawings were scared, excited, hate, love, angry, sad, threatened, guilty, weak, passive, safe, excited, going crazy, being sane, weak and powerful, passive and safe. When we got to anger he began to cry. He said that when he gets angry he says things to himself he doesn't want to say. "Mama always said you should never get angry.

I was wupped for anger, I don't want to deal with it." He could not draw anger until later. He then said that his Dad stabbed Aunt Delores in the back when they were young (more Stevens' boys mythology and interesting in that one of his victims was killed by shooting her in the back). Some of the drawings he described, others he did not comment on.

"Scared" is drawn in red and resembles fire with jagged, sharp points. "Hate" is a black spiraling scribble. "Excited" is drawn in yellow and shows his family as stick figures when he was young. "Love" is drawn as a purple circle, which he described as "perfect love." "Anger" appears as a "bullseye" with a red circle in the center. It is closed in by a purple line. "Sadness" he drew in blue and described as a wall, on the other side is "what I want to be." The drawing is of a head floating in the center. The face is frowning and the eyes are closed. The "wall" looks like a ladder. He spontaneously drew "depressed" in black, as a large circle, the ladder-like form and a head smiling. He said that depressed was wanting to be totally left alone. "Threatened" was drawn in red and is a human figure with eyes closed, frowning, enclosed in a circle. He said of threatened, "I want to run to someplace where I feel secure and no one can get in but me." "Guilty" was done in black, depicted by an eye with tears. "Going Crazy" is a single red line drawn diagonally across the page. . . . "Being sane" was totally blank, he could think of nothing to draw. "Weak" was drawn in black as a person in a fetal position with no arms. "Powerful" was also drawn in black as two stick figures, one quite a bit larger than the other. He said "this man has all the power over the other." "Passive" was done in blue, as a woman with no arms, and "safe" was a red heart with a faceless female stick figure in the center. He said it was "the love of mama."

Themes of isolation, powerlessness, severe hostility, denial, grandiosity, feminine identification, victimization and immobility are prevalent throughout these drawings.

No details are provided in the report about how Graves arrived at these themes from the way the emotions were drawn.

Graves concluded from these sessions that Stevens had a "psychotic disorder of an obsessional [sic] nature." She believed that he "established obsessive-compulsive rituals to quell excessive anxiety over sexual identity. As his obsessions increased, so did his delusions. When his behavior was combined with drugs and alcohol, he was deadly." Graves wrote her

report and conclusions, and sent them to the state's Department of Public Advocacy. The lead attorney on the case folded Graves's comments into the rest of his report, which he submitted to the court for review. Eventually, it was determined Stevens warranted a second consideration. In the spring of 2010, his death sentence was commuted to six consecutive life sentences.

It was never made clear how much of an impact the art therapy report had on this outcome or how it was received by the prosecutor and the court. It was not until Graves and I spoke as I began to research this case that she learned what had happened to Stevens. Once her report was written, her job was complete. Regardless, the commutation of Stevens's sentence was considered a success.

TESTIFYING FOR, BUT NOT ABOUT, A DEFENDANT

An art therapist may be contracted to provide support for an appeal. This may include gathering evidence to support a claim of mitigating circumstances. The art therapist may not work directly with the appellant, but with those most familiar with him, such as a family member or loved one.

In the early 1980s, the bodies of two men were found dumped outside in an unincorporated area in the Midwest; they had died from gunshot wounds to their heads. Two years later, Randy Thomas, a white man in his early 30s, was convicted of this crime. Details of the case are fairly limited, and the only information available to me was from the trial transcripts, appeal documents, and art therapist's recollections.

The records indicate that the night before the bodies were found, the victims went to the home of a member of Thomas's family to sell her cocaine. Shortly after, Thomas appeared with a gun at the house where the sale was taking place, tied up the victims, and shot them. Ultimately, a jury found him guilty of the two murders.

Thomas's right to a jury for the sentencing hearing was waived; the judge ruled that Thomas was eligible for the death penalty and, after listening to mitigation evidence, sentenced him to death. Immediately following the sentence, the state and defense counsels decided that no post-trial motions were necessary, and none were filed.

In the late 1980s, despite arguments that the court-appointed counsel had been, according to the trial transcripts, "so ineffective that [Thomas]

was deprived of due process of law," the state supreme court upheld the conviction. Later, in a petition for a post-conviction hearing, Thomas argued that his previous counsel had "failed to discuss with him the mitigation phase of the sentencing hearing and failed to ask him about possible witnesses for that portion of the hearing." Such witnesses may include loved ones and friends who would attest to any positive attributes of the defendant and ultimately testify on his or her behalf. Such mitigating testimony can support an argument that the defendant should not be put to death: "Mitigating evidence is extremely important under the [state's] capital sentencing statute. Once an aggravating factor is found sufficient to impose the death penalty, there must be mitigating evidence sufficient to preclude the imposition of the death penalty." The state supreme court recognized that such mitigating evidence may have "fortified counsel's contention that the evidence of the Defendant's role in the offenses was subject to doubt and did not justify sentencing the Defendant to death." The supreme court remanded the case to the circuit court for an evidentiary hearing.

In the mid-1990s, Thomas's first evidentiary hearing began. The "Defendant presented the testimony of his trial counsel, several mitigation witnesses and [an] investigator." It was at this hearing that the defense sought to present expert witnesses who could support the mitigation claims. Part of this evidence was the positive relationship that Thomas was alleged to have had with his daughter, Rhonda, who by this time was an adult. An art therapist was brought in to substantiate this relationship by assessing Rhonda. The art therapist was Myra Levick.

A co-founder, the first president (1969–1971), and an Honorary Life Member of the American Art Therapy Association, Levick is credited with having been one of the first educators in the art therapy field; she taught at Hahnemann Graduate School in Pennsylvania (now Drexel University) for more than 40 years. Over the years, Levick lectured at many institutions and contributed in numerous ways to the field, not least of which was creating the Levick Cognitive and Emotional Art Therapy Assessment (LECATA), an art-based assessment tool for children. She also spent a great deal of time providing art therapy services and support to prison inmates. As an influential art therapist, Levick testified as an expert witness in various legal cases. Although well known for her work with family and abuse cases (Safran, Levick, & Levine, 1990), she also was called on to use her art therapy skills in criminal cases, including this

capital case. Before testifying at the evidentiary hearing for Thomas, she had testified at one other capital trial. Unfortunately, the records for that case were largely unobtainable; what was available was minimal.

What is unique about the Thomas case is that Levick provided support for the defendant, but never met him. Her task was to assess Thomas's daughter through art-based techniques.

The mitigation specialist understood that the original defense team had been negligent in not having Thomas's young daughter testify on her father's behalf at his first trial. As the defense attorney for the post-conviction hearings noted, "a good mitigation specialist would have talked to everyone," including Rhonda, and would have figured out some way to use their testimony. As she explained, Thomas's relationship with Rhonda was "wonderful"; she loved him very much, and what would have arisen in the sentencing phase was how much of a loss for her Thomas's execution would be. The new mitigation consultant suggested that an art therapist meet with Thomas's daughter to ascertain their relationship and determine if an art therapist might have been effective in obtaining such information at his first trial—thus finding the first defense team negligent.

The initial reaction of Thomas's defense attorney was similar to that of Jackie Chief's co-counsel on Kevin Ward's defense team: she was reluctant to employ an art therapist as an expert witness. In fact, when the mitigation consultant first suggested to the defense counsel that she use an art therapist for this case, her response was, "Oh come on!" Eventually, the consultant managed to convince her to try it, and she contacted Levick. Despite such initial reservations, she changed her mind. She developed a more positive opinion about what art therapy could offer after she spoke with Levick. Of course, as Thomas's attorney reminded me, "We had her do the work [assess Thomas's daughter] but we had no obligation to use it, since she was consulting for us."

Due to conflicting schedules, Levick was unable to travel to the Midwest, so she worked in conjunction with another art therapist, who lived there. He would meet with Rhonda and administer the assessments, send Levick the drawings and comprehensive notes on the session, and consult with her by telephone to review the details of the meeting and his preliminary impressions. From this, Levick would determine a suitable judgment and write a report for the defense attorney. She would then be available to testify in court, if necessary, intending to meet with Rhonda before the hearing.

Levick had the art therapist administer five drawing procedures in the defense attorney's office: a free drawing, a childhood memory, a family picture, a picture of Rhonda with her father, and a portrait of her father. Levick's report focuses on the content of the drawings and the way Rhonda described them. Little is provided about the formal elements, such as line quality and space, and the images were not available for review.

The first directive was a "free drawing"; Rhonda was asked to draw whatever she wanted. She chose chalk pastels and drew a landscape, with grass, a blue sky, and birds "like the ones her children had shown her to make." She then added her father and herself, reminiscing about the day they had spent at the beach. She indicated that her father was very important to her and that he was, and always would be, honest with her. Although Rhonda said that the drawing was about a day she had spent with her father as a young girl, the figures were of equal height and appeared to be the same age. Neither figure had hands or feet, "indicating the helplessness she feels and projects onto her father."

The second drawing, a "childhood memory," began with a pencil outline of a rectangle to the right of the center of the page. Rhonda added a chalk outline to the rectangle and radiating lines, providing a sense of perspective. She filled in large areas of the page with the chalk while leaving some areas blank. Beneath the rectangle, she drew a bed on which sat a small figure with legs and arms outstretched; the darkness of the image was diffused with yellow chalk, "creating a feeling of light coming into the room." She indicated that this scene was about how she had felt after her father was incarcerated in the early 1970s and her mother had to leave for a job. She was left with her great-aunt, who was "not a nurturing person." She felt abandoned. The scene was described as "appearing like a prison cell," possibly reflecting a strong connection with her father.

The third drawing, a "family picture," seemed to be a bit more difficult for her; she had to be reassured that her artistic skills would not be judged, exhibiting some possible anxiety with the task. She drew only heads, perhaps reflecting "her own feelings of inadequacy." All the faces were smiling and "include her grandparents at the top, her three children below, her current husband . . . and herself at the bottom. To the right, almost as large as two rows of faces, is her father, a prominent figure in the composition."

She was then asked to draw the fourth picture, depicting "her and her father, with the advice that perhaps she start by thinking about what their

relationship meant to her 'today.'" She began quickly, "with a red heart in the center, a flower on each side, a sun above the x-shaped birds in the sky . . . blue lines under the heart and the flowers. . . . She said the blue is water surrounding both flowers and giving them nourishment." After she completed this drawing, she explained in detail the love she had for her father, who had always been there for her emotionally.

When asked to complete the fifth and final drawing of this session, a "portrait of her father," she asked if she could use words. When assured that she could, she wrote a "loving description of him."

The assessment completed, Levick sent her summary and conclusions to the defense team. Although she anticipated a call to appear in court, she was not asked to testify. When a new hearing was scheduled in the late 1990s, though, Levick was once again contracted to assess Rhonda.

This time, she was able to conduct the assessment herself. She flew to the Midwest and administered another battery of drawings to Rhonda in the defense attorney's office. This assessment was more structured, with clear directives and limited materials: oil pastels and 12 × 18 inch white paper. She asked Rhonda to complete three drawings: her family when she was a child, her and her father as she sees them in the present, and her awareness of his incarceration. The art therapist who had administered the first series of assessments to Rhonda was present and continued to act as a consultant throughout the procedure.

Rhonda was informed that she might include anyone she wished in the first drawing, "her family when she was a child." She told Levick that she was going to draw a barbecue that was often held at her paternal grandparents' house. She began with grass at the bottom of the page, drew a table on one side of the paper, and added a barbecue grill with smoke coming from it on the other. She drew her grandfather at the grill and eight other people at the table "with iced tea," identifying them as various members of her father's family. Her mother was not in the drawing. She titled it "Afternoon at Grandma and Granddad's (summer time)." All the figures were complete, with "gender differentiation and appropriate size relationships between adults and children." She indicated that in the drawing, she was between 5 and 7 years old, around the time she lived with her father during the summer and mother during the school year.

Rhonda began the next drawing, "her and her father as she sees them in the present," with a table and two bookshelves. She added two figures to the table: a small one in profile, which she identified as herself, and a large

one behind the table facing forward, which she identified as her father. She filled the bookshelves with books and drew other books on the table; she explained that the picture showed her and her father doing research for a business they would begin together. She titled it "Research for Business (Library)." While completing this image, she spoke of her father's ambitions, including his desire to become a doctor. Levick ended this section of her report with the observation that "she looks like a little girl, not the young woman she is. The drawing clearly represents a fantasy, albeit a long standing one, and has little connection to the reality of the present day."

The final drawing of this series was to focus on "her awareness of his incarceration." She recalled that her father had been arrested when she was living with him and his second wife; she was in the sixth grade before she realized that her father was "locked up" and not coming home soon. She drew a door and walls, creating the illusion of a narrow room, and added a blue bed and a little girl crying on the floor beside it. She titled the picture "Alone," explaining to Levick that this was how she had felt after she learned that her father was in jail. Levick indicated, "The drawing reflects distance and emptiness."

Levick's report includes a summary that reflects as much on Rhonda as on the relationship between her and her father. It underscores the woman's deep attachment to her father and her frequent, strong identification with him. The imagery generally revealed patterns of loss, abandonment, and feeling "closed in." She had been, and remained, close to her father. The report also indicates that she never developed adequate coping skills to deal with her loss. She concluded, "Although Rhonda's attachment and identification with [Thomas] goes somewhat beyond that which normally develops between fathers and daughters, he has obviously always been there for her, and more importantly, never emotionally abandoned her."

Based on the content and strength of the assessment report, Levick's findings were deemed supportive of the defense attorney's argument. Unlike Sandra Graves, Levick would present her testimony in court.

TESTIFYING FOR SENTENCE MITIGATION

An expert witness may be contracted by the defense attorney after a client has been convicted of murder in order to gather evidence for the sentencing phase. Her job may be to demonstrate mitigating circumstances that

were not considered during the trial, such as a physical or mental illness, but could convince the judge or jury that the defendant should not be sentenced to death. Similar to my experience in Kevin Ward's defense, an art therapist may be called in to demonstrate through the defendant's art his state of mind at the time of the crime.

In the early 1990s, Edward Ronalds, a white man in his early 20s, was arrested for the murder of six people: three were shot to death at a convenience store, and, a week later, three more were killed at a nearby pizza parlor. No cash was taken, and the killings were said to have been committed for personal satisfaction and in a brutal fashion. Ronalds became a suspect after it was shown that the bullets from the gun that he had in his possession matched the ballistics of the bullets used to kill all six victims. During his trial, while his defense attorney was explaining that Ronalds's mental capacity was diminished due to epilepsy, Ronalds stood up and blurted out, "I'm guilty." In the mid-1990s, he was convicted of all six murders. An art therapist was asked to provide testimony during the sentencing phase of the trial on the art he had completed in his childhood. The art therapist was Maxine Junge.

A prolific writer and contributor to the field of art therapy, earning her the distinction of being named an Honorary Life Member of the American Art Therapy Association, Junge has been an art therapist since 1973. She began teaching at Immaculate Heart College (now Loyola Marymount University) in the art therapy program, the first such master's program in California, and, in the mid-1980s, became the chair of the department. In addition to teaching, Junge conducted clinical work in a variety of settings and testified as an expert witness. She has since retired, but continues to write books about and for the field.

During the mitigation investigation, Ronalds's art teacher from his freshman year in high school was interviewed. He remembered that Ronalds had been very good in painting and design. He was described as "careful and creative" and had "keen observational skills." The defense team thought that his art might be helpful, so all his drawings—those he had completed in high school, some recent images, and a "draw a person drawing" assessment—were admitted into evidence. Junge was contracted to assess these art pieces and testify on her findings in court.

To provide additional information in her testimony and have an opportunity for observation, Junge met with Ronalds the night before the sentencing hearing in his jail cell to interview him and have him complete a

short art exercise. She asked him to use the markers provided and, on an 8½ × 11 inch sheet of white paper, write his initials. After doing so, he was asked to embellish or decorate them anyway he wanted. He wrote his initials very small in the top-left corner of the page. There was very little embellishment, with few colors; he seemed to be resistant to venture beyond the parameters established by the initials.

Junge testified the following day. The defense was not successful, and, in the summer of 1996, Ronalds was sentenced to death. His case has since come up for appeal, but the sentence stands.

::: :::

Sandra Kagin Graves, Myra Levick, and Maxine Junge provided professional services to gather and present mitigating evidence to help prevent or reverse the death sentence for three convicted killers. Graves assessed Benjamin Stevens and wrote a report on his mental health status that would be used by the defense team during his appeal. Levick did not become involved in Randy Thomas's case until his post-conviction hearing, 13 years after the original sentence was imposed. Junge applied her expertise at the sentencing hearing; Edward Ronalds had been declared guilty by a jury, but the court had to ascertain if he should receive the death penalty. In two of these cases, the testimony concentrated on the art of the appellant and the defendant; in one case, it focused on the art of the appellant's daughter. Graves did not testify in court, and thus her story ends here. Both Junge and Levick testified as expert witnesses before a judge.

THE HEARINGS

ESTABLISHING STATUS

Both hearings began with the court establishing the art therapists' status as expert witnesses. As discussed in the introduction, this process may vary somewhat, depending on the state in which a case is being tried, but fundamental standards are common to all jurisdictions. The court

is provided with a potential witness's educational history, curriculum vita, and status in her profession. With review and possible challenges by opposing counsel, the court ultimately accepts or rejects the application. Even though most of this process is negotiated behind the scenes before the trial, the art therapists, when called to testify, were systematically and extensively questioned about their professional history, educational and academic background, and expertise. This was not merely an exercise in redundancy, but reminded the court about the witnesses' experience and limitations, provided a formal transcript and record for future review, and allowed the members of the jury to come to their own conclusions about the qualifications of those called in to testify.

Maxine Junge's background review in the case of Edward Ronalds was fairly simple and quick; her testimony began with her response to questions regarding her background and her profession as an educator and art therapist, including her publication history. Based on these responses, the court found "the witness [to be] qualified to testify as an expert in the field of art therapy."

The establishment of Myra Levick as an expert witness in the case of Randy Thomas proved to be more complicated. Her experience began as expected. The transcript reveals extensive questioning by the defense attorney and Levick's responses about herself, art therapy, and her qualifications as an expert witness. Her testimony included where she went to school, the professionals and faculty members she studied under, her role in founding the American Art Therapy Association and serving as its first president, her publications, and the details of her curriculum vita. The afternoon session concluded with a series of questions about Levick's role as an expert witness in other cases, followed by her acceptance as a witness by the court.

During this seemingly straightforward and innocuous process, however, the first glimpse emerged of the ferocity that the prosecution would demonstrate in questioning her statements. After the defense attorney concluded her questioning, the prosecutor objected to granting her expert witness status:

> Levick already testified she never personally saw "Rhonda" until 1995. She has no first-hand knowledge. And in addition to which your Honor—Rhonda did testify at the . . . post-conviction hearing. So there was testimony from Rhonda. Who better to testify with regard

to their relationship than her? So I object to that on both being cumu-lative and actually not being relevant or reliable as to anything that went on in 1995.

The prosecutor did not object to her qualifications, but to the veracity of Levick's future testimony on the relationship between the Thomas and his daughter, a relationship that had not yet been clarified. By calling into question even the need for such verification, the prosecutor was trying to preemptively discredit any assertions by the witness by claiming that her testimony was unnecessary and hearsay, providing some foreshadow-ing of how the prosecution would address Levick throughout the pro-ceedings. Regardless of the reason, it did not work. The court allowed Levick's testimony.

PRESENTING THE FINDINGS

Levick and Junge were asked to explain the directives and assessments they had administered and present the art and their findings in court. Junge's exchange with the attorney was fairly straightforward. She described the body of work as pieces that Ronalds had completed from the tenth grade to the night before the hearing.

The next series of questions posed to Junge focused on an art thera-pist's ability to assess artistic imagery. She answered that "art therapists like to see a series of things and like to see them if possible over time and to look for themes and patterns." When asked to explain the pro-cedures an art therapist might use to evaluate artwork, she described specific assessment techniques and the art therapists who had designed them. The questions transitioned from general inquiries of the field to Junge's specific involvement with this case. She informed the court that she had "received some of Mr. Ronalds' school records . . . some psy-chological testing that was done and some, I think, neurophysiological testing as well."

Junge was then asked why she felt that it was important to look at the artwork before reviewing the records. She replied that she "wanted to come clean, as it were, fresh to the artwork without having any outside information that might tend to bias me. I want to be able to see as freshly as I could to make my own preliminary judgments before I got outside information at all." This is a common practice among therapists who

conduct assessments or preliminary reviews of art. While art therapists have been trained to evaluate art, their perspective can become skewed based on history and trends revealed in clinical reports. As demonstrated during the sentencing hearing for Kevin Ward, triangulation of data is that much stronger when each clinical examiner does not have access to the conclusions developed by the others until after the results of the art therapy assessment are evaluated on their own merit. Then such additional data could prove valuable and can be considered.

Levick was also asked to justify her assessment approach and the use of the directives that composed her assessment. What became clear was that although she had not formally assessed the client with standardized tools, the manner in which she had asked Rhonda to complete the directives was essentially an assessment in approach and structure; each directive had been administered for a specific reason. For example, when asked about the free-drawing procedure, Levick replied, "The free drawing . . . is to provide an opportunity for someone to do a spontaneous drawing without any direction, not to feel intimidated by being asked to do something specifically, and also to serve as a baseline for the other images, to get some sense of where that person is." When asked if the drawings that Rhonda completed recently reflected how she had felt about her father 13 years earlier, Levick refused to speculate: "[B]ut it cannot come from nowhere. I can only tell you that developmentally one does not create images at the age of 28 that did not have some root in early childhood development."

Following a brief overview of what the first assessment session revealed, Levick was questioned about the second session, which had taken place 3 years later. Each drawing was described in detail and assessed. Levick stressed that the images continued to reflect Rhonda's relationship with her father 16 years earlier:

> I will repeat that you can't draw those images without roots in early childhood. The literature points very clearly to the fact there are two viewpoints: Freud says if you haven't made it by the time you are five and have all the things necessary, you are not going to make it. . . . [Erik] Erikson and other investigators have come along and said in adolescence we have a chance to rework things. Rhonda did not have that chance. But certainly all of these images are rooted in her early childhood development.

After each drawing was presented, Levick was asked if she had changed her opinion about Rhonda's relationship with her father between the drawings received in 1995 and those received in 1998. She simply stated, "No. It just reinforced them."

Levick's approach was similar to Junge's on one significant point; she did not review any preliminary diagnostic conclusions or information about the crime before providing her own preliminary assessment. It was important, however, for Junge to meet with Ronalds and witness the art-making process: "Art therapists don't like to just look at the artwork. . . . [O]ne of the ways we [art therapists] work is by watching the process as well as the content of the . . . treatment process. So it was very important for me in making my assessments to meet with [the defendant], ask him to do a little bit of art, get a sense of him, hear him talk about some of the art that he made. And we did." To evaluate the art without meeting with the client, watching him complete an art piece, and asking him questions does a disservice to both the client and the therapist. As I have under-scored repeatedly, art therapists do not simply "read" art—they use it, in conjunction with several informational resources, to develop an accurate picture of a client. In order to be found credible by the court, an art therapist must disavow any sense of "magical thinking" and make clear that the conclusions were arrived at through close evaluation of complete data, substantiated through research and literature.

Levick and Junge then presented the art to their respective courts. In Junge's case, enlarged images of Ronalds's drawings were displayed on easels for the court to reference. Levick showed Rhonda's original art. In presenting their findings and opinions, the art therapists qualified their statements with no definitive assertions, relying as much on what they had been told by the artists as on their own assessment skills. For example, Junge was questioned about an image of a sailboat that the defendant had completed when he was in the tenth grade:

I think the assignment was to do two different kinds of weather [scenes], I believe, something like that. . . . And the work is constructed so that the strips are cut, and so day can sort of turn to night. Depending upon the way you turn it, you can see day or night, and one side is a foggy day, and the other side is a bright red day. And in the middle of the picture is a very, very large sailboat with a huge sail, a hull that you cannot see too much of, and a very little ocean for this

large sailboat to sail on. And my impressions at the time were, first of all, this is an ingenious construction, it really is. And, secondly, I thought this revealed a world in which night and day are very close, but the red day is very hot. It's dangerous. There's no wind in this day. There's no way this sailboat, even though it's at full sail, could sail, and it almost feels like it could burn if the sailboat stays there. The overall impression for me was of a contained depression. It felt like the sailboat could not move . . . was stuck. There was not enough water for it to go anywhere. There was no wind. It was stable, contained, could not in a way get out of this world, and I found that very dramatic.

Junge noted that Ronalds noticed the absence of water and reflected on "the scariness, the gloominess of the foggy part of the picture, and he said it was almost like chaos and decay." He also indicated that "the day that was red . . . something must not have been too good because it's all red. 'I usually like blue skies. I usually like the ocean. . . .' [T]hen he talked about the foggy side of the picture and he kept on thinking . . . about the darkness, the chaos. The stormy side and wondered about that."

The importance of this exchange is twofold. It clarifies the role of the client in providing valuable feedback in ascertaining possible meanings of the illustrations and the importance of quoting the artist's own words. It also is an example of how often an illustration may be a catalyst to help an artist remember how he felt in a previous state, leading to a tangible history.

PRESENTING THE CONCLUSIONS

In response to the defense attorney's questions, Levick and Junge were provided the opportunity to discuss the artwork and present their conclusions. Before explaining Rhonda's drawings from the first assessment session, Levick was asked if she had formulated an opinion based on the images. She answered, "Rhonda felt extremely close to her father, that his incarceration created a feeling of abandonment and loss. She identifies with her father in a way that is not quite typical for an adult person." When she presented each art piece, she was asked if it supported this conclusion and confirmed that it did. The defense established the thesis

first, and then made sure that all components supported this assertion. This approach kept the testimony extremely focused.

Levick also determined that at the time of Thomas's original sentencing hearing, Rhonda could have been deemed a reliable witness, provided the defense team had taken advantage of the services available. She stressed that art therapists could have been found throughout the country, including in the city where Rhonda lived. After she confirmed the ease of finding an art therapist through library references and the American Art Therapy Association's membership database, Levick was asked if her conclusions would have been any different 16 years earlier. She replied that she would not be able to speculate about that without pictures, pointing out that it would be "wild analysis." "But," she continued, "I would have to suspect that they would be very similar and, in fact, as a preadolescent I suspect they would be even more chaotic and disturbed. She has learned to compensate in a variety of ways." She concluded the examination by the defense attorney by reiterating that it was quite likely that Rhonda and her father had had an honest and close relationship at the time of his original hearing.

Similarly, Junge presented her conclusions before showing Ronalds's art: "I found him to be, and find him to be, a probably severely and chronically depressed young man who has had a series of troubles for many, many years, and I found him to be . . . [*pause*] I think I might at this point leave it at that, unless you would like to ask me some specific questions." The defense's stance during Ronalds's criminal trial was that he had epilepsy, which was described as a debilitating illness that would have prevented him from committing the crimes. Junge's testimony indicated that he suffered from Depression, a condition possibly related to epilepsy, but not part of the original defense. So why was her testimony focused on a different disease from that claimed by the defense? Junge was testifying at the sentencing hearing to determine if Ronalds should be put to death for his crimes. At this point, it did not matter if she verified that he had epilepsy; it was more important to establish his poor state of mental health. By indicating that he had long-term Depression, she was signifying that he had a mitigating circumstance, likely a mental illness, that should be considered before imposing a sentence. Significantly, Junge relied on the art completed by Ronalds since he was in the tenth grade, and she stressed that the artwork consistently reflected a long history of Depression, present

substantially before the crimes were committed. It is not clear from the available data whether Ronalds had a history of mental health evaluations; if he did not, it would therefore be difficult to ascertain if he long suffered from mental health issues or if the Depression was situational. By supporting the claim that the Depression was not situational, the defense could avert the death penalty. The art provided tangible evidence that he had such a history.

Generally, when the defense rests, the prosecution has the opportunity to cross-examine. At the end of Junge's testimony, the prosecutor had no questions, thus ending her participation in the hearing. Levick was not quite so lucky.

CROSS-EXAMINATION

Similar to the manner in which Bill Williams argued against my assertions at the sentencing hearing for Ward, the attorney prosecuting Thomas attempted to demonstrate, by means of various questions and insinuations, that art therapy was irrelevant to this particular case. However, Williams was not nearly as aggressive. The prosecutor asked Levick where art therapy had been developed and what it is used for, suggesting that it is used primarily for children and that "initially it was designed for people—pardon the expression—but who are crazy." Levick relentlessly tried to dissuade the prosecutor from these conclusions. Nevertheless, he was trying to make art therapy irrelevant and inapplicable because Rhonda was a reasonably healthy adult, thus discrediting the need for and accuracy of Levick's testimony.

The prosecutor also attempted to demonstrate that art therapy is inexact and, through apparent ambiguity and flexibility, can be considered self-contradictory and unreliable. He asked Levick a number of questions about structure, settings, materials, and length of initial sessions, requesting some concrete parameters. She noted that the answers to such questions depend on the needs of the client. His response was dismissive: "[S]o that I am clear then, art therapy can be conducted pretty much anywhere by any number of people using the types of materials for almost any length of time?"

The prosecutor also attempted to discredit some of Levick's conclusions by contradicting her statements with possible alternative meanings for the various pictorial representations. Not made clear until later, he

was basing these other viewpoints on a book that he had read before the trial. For example:

PROSECUTOR: *What does "closed eyes" specifically mean in your field?*

LEVICK: *It means it is avoidance, which is what I said about her side view also.*

PROSECUTOR: *Does it also mean covert hostility?*

LEVICK: *Covert hostility? No, I have not heard that interpretation of closed eyes.*

After several such exchanges, Levick retorted: "You know, there are so many things that have been written, and people make conclusions and ideas without documentation. I don't assume any of those things unless I have some kind of association or current history or some other form of information [before] I could make that conclusion."

In another example, the prosecutor suggested that emphasizing hair was indicative of sexual preoccupation. After Levick responded that she had never heard that interpretation, he attempted to press the point. Levick remained adamant:

No. I will tell you what I have taught though in terms of hair and large heads, in that we know children between the ages of birth and five, have the largest spurt of growth physically than any other period in our lives. What we see in children's drawings and what we have learned from veterans is in trying to develop equilibrium, children will emphasize the head. They will put bows on top of the hair. They will make the hair stand out more. Heads will be bigger than the figures. That we see normally with children as they grow up. This is certainly an indication of an earlier learning for Rhonda that all children learn normally.

Rather than permitting Levick to normalize Rhonda's responses, the prosecutor continued to assert that specific details in her drawings could be attributed to various psychological issues and pathologies, including narcissism. When this claim was refuted, the prosecutor then presented

a number of possible interpretations, including anger, aggression, and anxiety. Levick, refusing to be baited, insisted:

> *I can't speak for what another art therapist would see or conclude. I do see anxiety in the image, but not because the hair is drawn that way, but because of the shaky lines. That's an indication of anxiety: incomplete lines, lines that are sort of shaky, as you see on the side of the male figure coming down the side, the way the arms are drawn. Not necessarily the hair. I see anxiety in other indications of it, and I certainly suspect that she was anxious.*

The transcript reveals that the prosecutor continued to rearrange Levick's testimony and offer alternative meanings for a variety of details in Rhonda's drawings in order to infer that there were numerous possible "interpretations," not one of which was stronger than the others. Ultimately, he was stressing that multiple meanings equal no meaning. However, Levick remained firm in her conclusions and continued to stress the legitimacy of her report. At one point, the prosecutor directly questioned the validity of her assessment:

> PROSECUTOR: *Just because you do not choose them—that doesn't mean that those other interpretations are not also possible or that somebody else may draw the same conclusion?*

> LEVICK: *They are possible. That doesn't make them valid.*

Levick underscored that with proper education, experience, input from the client, and reliable references, art therapists reach conclusions that are more apt to be correct than others. It is the role of the art therapist to maintain her composure, remain consistent, and justify her conclusions with proper support.

The prosecutor continued to cross-examine Levick for most of the day, not only refuting her conclusions by calling into question the validity and applicability of art therapy, but also using the opportunity to remind the jury that the appellant was a convicted murderer. What Levick underscored, and continued to reiterate, was that his status was not part of the equation, since she was not testifying about him, but about his daughter:

PROSECUTOR: *Would it affect your opinion in any manner that he was arrested for attempted murder and convicted of aggravated battery and sent to prison?*

LEVICK: *My opinion of the relationship, no.*

PROSECUTOR: *As you sit there, do you now—are you now aware that, in fact, he wasn't convicted of a single count of murder, but murdering two people. Are you aware of that?*

LEVICK: *Now I am aware.*

PROSECUTOR: *Would that affect you opinion in any matter?*

LEVICK: *Of the relationship, no sir. When someone has a perception of a relationship and they communicate it in drawings or verbal psychotherapy and this is true throughout the literature, the perception remains the same regardless of the circumstances. I cannot determine what her perception of her relationship should be based on what I know or do not know about her father. What I base my conclusion on is her perception of that relationship as she presents it in the drawings and that's the report I have written.*

Regardless of the assertions and accusations put to her—which included calling into question her biases, alleging that Rhonda had attempted to skew her images to correspond with the wishes of the defense, questioning the role of the defense attorney in the assessment procedures, and criticizing the language she used to answer her questions—Levick remained consistent, referring to the art as her evidence. The underlying message that was communicated was that it was about the art and that conclusions based on the art do not change.

There are, of course, times when the judge can also ask questions. Levick took these opportunities to educate about art therapy and to underscore why she had conducted the assessment. When the judge asked specific questions about some images, such as an open door in one of the drawings completed at the second assessment session, Levick explained how she assesses a client:

[Was there] any significance to the door being opened? There may be. I did not ask for an association to that. Again, I want to stress the fact that when I do an evaluation . . . I try to be very careful not to open up something that I can't follow through [with] and [provide] closure [for] because I don't know if I will have the opportunity to see that person afterward and ethically not create some situation that they would be uncomfortable with. What was important to me [in this drawing was how] she was talking about how she felt in this room. If I then had the opportunity to work with her I would say, okay, Rhonda, you did this picture during the evaluation, now, tell me, you left the door open. How come one has a window and one has a door? In the case of the evaluation that was not what I was focusing on. It could have had many significances. I was responsible in getting my association, the same as the analyst would get associations to a dream. I can't answer that specifically.

REDIRECT EXAMINATION

After Williams cross-examined me, Jackie Chief, Ward's defense counsel, was able to ask questions through her re-cross that allowed me to reassert and defend my claims. Similarly, Thomas's defense attorney clarified some of the points that Levick had made through her redirect examination. She was also able, despite the resistance of the opposing counsel, to discredit the book from which he had read when presenting alternative "interpretations" of symbolic content. Although the prosecutor attorney fought the defense's attempt to introduce the book into evidence, a compromise was eventually reached whereby the defense and the judge could examine it off the record and determine if it could be introduced as evidence. If it could, the defense attorney would then have an opportunity to discredit it. After a 10-minute recess, details of the book were provided for the record:

DEFENSE ATTORNEY: *Dr. Levick, during the break you had an opportunity to review one of the books that counsel for the State relied on during his cross-examination.* [The book's author and title were introduced into the record.] *Do you consider that treatise to be an authoritative treatise in the field of art therapy?*

LEVICK: *Not in art therapy. It happens to be an excellent overview of psychological custody. There are those that do projective testing, he [the author of the presented text] refers to [Emanuel F.] Hammer who is the one who has written major work [on assessments] and he refers to Hammer and other people in there. Those are tests that are done by psychologists that art therapists are expected not to do. We don't do psychological testing. I can do them because I was trained as a psychologist in addition to being an art therapist, but we do not teach psychological testing and that's why I have worked so hard and others in my field have worked hard to develop our own credibility in art therapy. But that's a very good diagnostic. . . . It has nothing to do with art therapy.*

DEFENSE ATTORNEY: *Are there any particular limitations that you gleaned from your brief review of that treatise concerning its use?*

LEVICK: *Well, the limitations are, and it says so, it should not be used by anyone who is not well trained in looking at psychodiagnostics. You do not take any single item out of context and make it a conclusion. Most of those tests have been tested over and over again.*

A psychologist, not an art therapist, had written the book; thus the defense attorney was able to stress its inapplicability to the case. What is significant about this exchange between Levick and the defense attorney is that it undermined the prosecutor's argument that anyone can come up with any conclusion based on possible symbolic content in artworks. This questioning reasserted the need for proper education and credentials to provide art-based assessment procedures, underscored that Levick had demonstrated these credentials, and confirmed that symbolic content should not be taken out of the context of the entire image, situation, and directive.

The testimony soon ended. Amusingly, as a side anecdote, although Levick had completed her testimony, the judge asked her a series of questions about how to assess stick figures in adult images. It is clear from the transcript that he had his own agenda. This exchange provided further evidence of the court's acceptance and validation of Levick's expertise in assessing drawings.

A BRIEF COMPARISON

Their distinct views of the field of art therapy, perspectives on the use of art-based assessments, and theoretical approaches were reflected in Sandra Kagin Graves's, Myra Levick's, and Maxine Junge's preparation for and testimony at the hearings at which they appeared as expert witnesses. Their experiences differed significantly not only from one another's but also from mine.

I was contracted at the beginning of the case of Kevin Ward to provide evidence for the defense at his capital murder trial. After a plea bargain was made, my services were used for the sentencing hearing. Graves, Levick, and Junge were called in at different stages in the forensic process, after the defendants had been convicted of murder and two had been incarcerated for some years. Similar to mine, Junge's testimony would lend itself to mitigating considerations during the sentencing phase, while the other two cases relied on building mitigating evidence to reverse a sentence of death.

After meeting and assessing the defendant, I testified not only on art that he had completed over a number of years before meeting me but also on drawings that he did in my presence. In contrast, Graves did not testify in court, and Levick assessed the daughter of the appellant. Junge testified directly on the defendant's art.

My clinical and assessment approaches were significantly different from those of Graves, Levick, and Junge. They assessed the content of the art, underscoring the possible symbolic and contextual meaning of the images and successfully relating them to mental health status. I chose to focus solely on the formal elements of the art, which do not change over time and can specify types of mental illness. All of us relied on different tools: only Levick and I used free drawings as part of the assessment protocol; only Junge and I had access to artwork completed before the commission of the crimes. Yet each of us contributed significantly to the defense's case. Drawing on their knowledge, skills, and experience, Graves, Levick, and Junge were able to provide and present evidence that was used to challenge and appeal a death sentence. All but one of the four cases had a favorable outcome.

Despite the different approaches taken by the art therapists, the arguments made by the defense teams in all four cases relied on forensic art therapy.

8

FORENSIC ART THERAPY REVISITED

A term coined by Marcia Sue Cohen-Liebman, "forensic art therapy" is the use of art to help resolve legal matters in dispute (Cohen-Liebman, 1999, 2003; Gussak & Cohen-Liebman, 2001). Cohen-Liebman (2003) offered three significant advantages for using drawings in a forensic context:

- As interviewing tools, drawings are used in a supportive capacity in the investigation of legal matters.
- In the capacity of charge enhancement, drawings provide contextual information that can contribute to the determination of charges as well as the identification of additional arenas to investigate.
- Drawings as judiciary aids provide evidentiary material that is admissible in judicial proceedings. (p. 171)

Gussak and Cohen-Liebmann (2001) noted that clients of forensic art therapists may be children, adolescents, and adults—even though the literature on the use of art therapy in a judicial context has usually focused on using art with children, particularly those in family courts or who are victims of abuse, or with parents who are engaged in custody disputes (Lyons, 1993). Children often do not know the correct words to explain a situation and may need illustrations to support their limited vocabulary. Art can also facilitate rapport between a child and an investigator, which subsequently allows for more substantial information gathering.

As emphasized by Cohen-Liebman (2003), the drawings done by child victims can be used as evidence in various judicial situations. Some states

have even passed laws that permit the use of drawings to assist child witnesses (Cohen-Liebman, 2003; Haralambie, 1999). A drawing not only offers a narrative of a situation, but may reveal details of a crime that may not otherwise be communicated, leading to further investigation and corroboration of other evidence.

Despite the importance of Cohen-Liebman's (2003) points, one of their limitations is apparent. They generally focus on gathering evidence from children. The cases outlined in this book have provided an opportunity to expand the advantages of using art in forensic contexts to include three more.

- Art is a viable assessment tool that can ascertain mental health status at the time of both the crime and the trial or hearing.

One of the defenses often used in capital trials is the plea of mental illness or insanity, especially as "every capital punishment state in the United States exempted the currently insane from the ultimate penalty" (Mello, 2002, p. 101). Three of the four cases discussed in this book focused on how the art revealed the respective defendants' mental status. Jackie Chief stressed her belief that a majority of those on death row suffer from some form of mental illness or deficit: "[M]ost of these death row cases are egregious crimes, and many of the people have either intellectual deficits or some mental health problem." Bill Williams was a bit more specific about such a plea: "[I]f you've got a mental illness that rises to the level of an inability to assist or the inability to understand right from wrong of the actions, then you've got what's more frequently termed an 'insanity' defense, but just to put it as 'mental illness' isn't quite enough . . . but I think that it is something that should be taken into consideration." Of course, as a means to mitigate the ultimate sentence, Williams's musings on the mental health defense were measured:

> *Obviously, there could be people with mental illness that are committing crimes, not because of their mental illness, but just because of their choices that they've made in other areas. So, you have to be able to work with and rely on the defense attorneys . . . and hopefully they are willing to work with you and not bring that issue into every single case, but just when it is really important.*

In his career as a prosecuting attorney, Williams has been a strong proponent of mental health care for those in the judicial system, but he clarified the difference between mental illness as a genuine defense and as a defense tactic without support. The burden of demonstrating that a mental illness is present and interfered with a defendant's ability to differentiate right from wrong *at the time a crime was committed* falls on the defense. When evidence supports this contention, the defense has a strong case.

Many of the psychological assessments available indicate state of mind at the time of the assessment, whereas conclusions on a history of mental illness rely on past psychiatric and medical reports. Unless a psychiatric evaluation is conducted within a reasonable time after an offense was committed, conclusions based on mental status at the time of the crime generally rely on hearsay and opinion. When a collection of artistic output produced over a period of time is available, a pattern of mental illness, aggression, and violent tendencies can be reflected through it. Such tangible evidence can assist either the defense or the prosecution in ascertaining the condition of the defendant before, during, and/or after the commission of the crime.

Such assessments can also be used to corroborate information obtained through other means. Any strong researcher will underscore the importance of triangulating data to strengthen conclusions. One of the key accomplishments in Kevin Ward's case was the corroboration of my testimony by the evaluations made by the other expert witnesses: a psychologist and a psychiatrist. In turn, my art-based assessments, albeit a unique approach, reinforced their conclusions. What is more, it may be easier to predict what psychology-based assessments that rely on checklists or multiple-choice questions (such as the Beck Depression Inventory [Beck, Rial, & Rickets, 1974; Beck & Steer, 1993] or the Minnesota Multiphasic Personality Inventory) may be trying to ascertain than what an art-based assessment is trying to determine. Many of the prison inmates with whom I have worked made it clear that they knew by the way certain psychological assessments were worded and presented what was being assessed. Such awareness, in turn, may propagate malingering in order to gain privileges, such as single-cell placement, and additional services, such as medication (Gussak, 1997a). Conversely, I was hard-pressed to find any inmate who could clearly identify what an art therapist was searching for when using the art as an assessment tool. This notion informs the next advantage.

- Art can be used as a means to reveal and ascertain the truth of a defendant's statements and information.

One of the advantages of the use of art therapy with prisoners is that art does not lie; it can reveal the truth about the client who draws the images. Lisa Peters recognized this as a strength of the art. A defendant's artwork can support—or contradict—statements made during assessment and testimony. While I am not asserting that art is a lie detector, it can assess the relationship between what a defendant is saying and what he may actually be feeling or thinking. Such a notion was particularly valuable when I worked as an art therapist in the prison system. In an environment where the inmates lie for a number of reasons, the art provides an avenue to the truth.

Some clients are not able to convey the truth. Art and art therapy are valuable tools for gathering information from those with cognitive delays and disabilities and with mental illnesses that may make verbal expression difficult. In some cases, the words are just not available to clients; in extreme situations, clients may not be able to speak at all. Art provides a means of expression that can convey truthful situations and responses. As Ward demonstrated, a person with Schizoaffective Disorder may not be able to cognitively process information and relay thoughts in a coherent or an accurate manner. For example, while Ward continually stressed that the scribbled lines bisecting many of his drawings represented a spiritual pathway, in actuality, they reflected his tendency to lose control. "Defenses of denial, minimization, schizoid distancing and avoidance to deal with . . . issues of poor self-image, identity confusion, feelings of inadequacy and loss of connection to his surroundings"(Gussak, 1997a, p. 9) can be revealed and overcome through artistic imagery.

- The display of art and the demonstration of artistic imagery can humanize a defendant.

The very act of art making can reflect and elicit a humanizing component in an otherwise apparently reprehensible defendant. Ward's defense attorneys recognized this, wishing to counter the prosecutor's attempt to demonize him. The tendency for people to objectify and dehumanize those who have committed atrocious crimes is a simple and primitive defense mechanism. This is parallel to how Fox (1997) described the

relationship within a correctional institution between the corrections offi
cers and the inmate population. Some members of the staff may believe
that "the great danger . . . is in seeing the inmate as being a person like
themselves [*sic*]" (p. 47). If they do so, they run the risk of empathizing
with their wards, which they believe can, in turn, undermine the secu-
rity they wish to maintain. Therefore, the inmates are kept at a distance
by objectifying them—negating their identities as both fellow humans
and specific individuals. This occurs deliberately by labeling inmates
with "departmental identification numbers instead of names, . . . [know-
ing] inmates by cell location," and dressing inmates in identical clothing
(Hall, 1997, p. 38). Such degradation, presented as a method of control
and security, further drives a wedge between the inmates and the officers.

What can be regarded as an effective defense mechanism employed
by corrections officers occurs more subtly in society. People do not want
to be associated with someone who has committed an atrocious crime,
so much so that they dissociate themselves from this deviant subcul-
ture. Murder, particularly that of a child, is reprehensible and merits
extraordinary punishment. However, defensiveness and self-protection
forces society to conflate the criminal and the crime: he is a murderer,
not a man who committed a murder; the rest of his identity has been
obliterated.

At the same time, people are fascinated by the art made by those who
have killed; questions arise about the relationship between the art and the
artist. Such curiosity is reminiscent of rubbernecking—a perverse desire
to gaze on the creations of someone who committed a repellant act.

The contradiction is apparent. Art is recognized as a form of self-
expression, the emphasis being on "self." The very act of creating con-
firms that there is a self to express. We can relate to someone simply
through her act of creating; our "self" recognizes her "self." Taken to the
extreme, people are fascinated that Adolf Hitler fancied himself an art-
ist. Web sites are dedicated to his watercolor landscapes and architectural
drawings, and a movie was made about the young wannabe (*Max*, 2002).
The notion that Hitler created art does not deny the reality that he was
evil, but it reminds us that he was indeed a person. While popular culture
portrays Charles Manson as Satan, his music, writings, and art images
demonstrate that he is an ordinary person responsible for some unspeak-
able acts. Whereas people are repelled by the crimes of John Wayne Gacy,
the notorious serial killer in Chicago who murdered 33 teenage boys and

young men and buried most of them in the crawl space of his house, they tend to be interested in the many paintings he created while waiting to be executed.

The art creates a bridge between the average person and the individual considered to be a callous and heartless ogre. The viewers may begin to see elements of themselves in the person who has been regarded as alien. An art piece can underscore that its creator was, at one point, considered a member of society—and, if not for an incomprehensible act, would still be one.

Granted, the attempt to humanize a killer through art can backfire. If the art is so horrible and out of the range of an average person's comprehension, then it enlarges rather than lessens the separation of the viewer from the artist. In a trial, this reaction can be taken advantage of by a prosecutor, who can use the art to further demonize a defendant. It is up to the defense team to recognize the visceral response the art can produce and seize the opportunity to use the art as a bridge rather than a wall. If the defense is successful, the jury members may consider themselves the defendant's peers and, theoretically, may be less likely to recommend a sentence of death.

::: :::

By exploring the role of the art therapist in capital murder cases, I have attempted to accomplish two things: provide an opportunity to expand the work already accomplished in the fields of criminology, psychology, and art therapy; and highlight a particular case in which art was put on trial and found to be a valid indicator of mental illness. With its detailed explanations of the experiences of expert witnesses and the methods they used to draw their conclusions, this book contributes to the literature on the pragmatic and successful application of art-based assessment procedures to legal proceedings. Not only will art therapists, psychologists, and counselors benefit from the information provided, but criminologists, attorneys, and judges will discover that art therapy can be used to gather information, corroborate evidence, and make evaluations.

Although this book recounts an experience that emerged by chance, it is imperative that art therapists testifying as expert witnesses have certain

knowledge and skills in order to succeed in the legal arena. It is, unfortunately, not enough that they understand assessment tools and legal procedures. They must be able to work with difficult and undesirable clients and to present their findings in sometimes hostile environments. Only then *might* they succeed. If I had been aware of these challenges before agreeing to testify in a capital murder case, the pitfalls I encountered along the way would not have been so pronounced or surprising. Having said this, my success in using the techniques of art therapy to come to and support a diagnostic conclusion stresses that it is the art, more than the art therapist, that makes the case.

REFERENCES

Agell, G., Goodman, R., & Williams, K. (1995). The professional relationship: Ethics. *American Journal of Art Therapy, 33* (4), 99–109.

Amato, L., Blasé, C., & Paley, S. (2000). Ethics. *American Journal of Art Therapy, 39* (1), 12–27.

Ambrogi, R. (2009). Proposed: Expert witness code of ethics. *IMS-Expert Services.* Retrieved from http://www.ims-expertservices.com/newsletters/feb/expert-witness-code-of-ethics.asp#8.

American Psychiatric Association (2000). *Diagnostic and statistical manual of mental disorders* (4th ed., rev.). Washington, DC: American Psychiatric Association.

Amos, S. P. (1982). The diagnostic, prognostic, and therapeutic implications of schizophrenic art. *Arts in Psychotherapy, 9,* 131–143.

Anderson, F. (2001). Needed: A major collaborative effort. *Art Therapy: Journal of the American Art Therapy Association, 18* (2), 74–78.

Arnheim, R. (1977). The art of psychotics. *Art Psychotherapy, 4* (3–4), 113–130.

Art Therapy Credentials Board (2005). *Art Therapy Credentials Board Code of Professional Practice* (rev. ed.). Greensboro, NC: Art Therapy Credentials Board.

Badcock, C. R. (1983). *Madness and modernity: A study in social psychoanalysis.* Oxford: Blackwell.

Beck, A. T., Rial, W. Y., & Rickets, K. (1974). Short form of Depression Inventory: Cross-validation. *Psychological Reports 34* (3), 1184–1186.

Beck, A. T., & Steer, R. A. (1993). *Manual for the Beck Depression Inventory.* San Antonio, TX: Psychological Corporation.

Becker, H. S. (1963/1991). *Outsiders: Studies in the sociology of deviance.* New York: Free Press

Bellak, L., & Abrams, D. A. (1997). *The T.A.T., the C.A.T., and the S.A.T. in clinical use* (6th ed.). Boston: Allyn and Bacon.

Bender, L. (1981). The creative process in psychopathological art. *Arts in Psychotherapy, 8,* 3–14.

Bennett, W. W., & Hess K. M. (2006). *Criminal investigation* (8th ed.). Florence, KY: Wadsworth.

Betts, D. J.(2003). Developing a projective drawing test: Experiences with the Face Stimulus Assessment (FSA). *Art Therapy: Journal of the American Art Therapy Association, 20* (2), 77–82.

Betts, D. J. (2006). Art therapy assessments and rating instruments: Do they measure up? *Arts in Psychotherapy, 33* (5), 422–434.

Blau, T. H. (1998). *The psychologist as expert witness* (2nd ed.). New York: Wiley.

Bleuler, E. (1911/1968). *Dementia Praecox or the group of Schizophrenias* (J. Zinkin, Trans.). New York: International Universities Press.

Brooke, S. L. (2004). *Tools of the trade: A therapist's guide to art therapy*. Springfield, IL: Thomas.

Buck, J. N., & Hammer, E. F. (1969). *Advances in House-Tree-Person technique: Variation and techniques*. Beverly Hills, CA : Western Psychological Services.

Bucklin, L. (2010). Rule 702 of the Federal Rules of Evidence now incorporates the Daubert/Kumho/Joiner requirements. Bucklin.org. Retrieved from http://www.bucklin.org/ fed_rule_702.htm.

Burns, R. C. (1987). *Kinetic-House-Tree-Person drawings (K-H-T-P): An interpretive manual*. New York: Brunner/Mazel.

Burns, R. C., & Kaufman, S. H. (1970). *Kinetic Family Drawings (K-F-D): An introduction to understanding children through kinetic drawings*. New York: Brunner/Mazel.

Cadena, C. (2007). Word salad and schizophrenia: What is it? Retrieved from http://www.associatedcontent.com/article/242737/word_salad_schizophrenia_what_is_it.html.

Caiger-Smith, M., & Patrizio, A. (1997). *Beyond reason: Art and psychosis: Works from the Prinzhorn collection*. Manchester, Eng.: Hayward Gallery.

Cane, F. (1983). *The artist in each of us*. Craftbury, VT: Art Therapy Publications.

Carpenter, W. T., Jr., & Strauss, J. S. (1979). Diagnostic issues in Schizophrenia. In L. Bellak (Ed.), *Disorders of the Schizophrenic Syndrome* (pp. 292–319). New York: Basic Books.

Cheng, E. K., & Yoon, A. H. (2005). Does Frye or Daubert matter? A study of scientific admissibility standards. *Virginia Law Review, 91*, 471–513.

Cohen, B. M. (1985). *The Diagnostic Drawing Series handbook*. Alexandria, VA: Cohen.

Cohen, B. & Cox, C. (1995). *Telling without talking: Art as a window into the world of Multiple Personality*. New York: Norton.

Cohen, B., Hammer, J., & Singer, S. (1988). The Diagnostic Drawing Series: A systematic approach to art therapy evaluation and research. *Arts in Psychotherapy, 15*, 11–21.

Cohen-Liebman, M. S. (1994). The art therapist as expert witness in child sexual abuse litigation. *Art Therapy: Journal of the American Art Therapy Association, 11* (4), 260–265.

Cohen-Liebman, M. S. (1999). Draw and tell: Drawings within the context of child sexual abuse investigations. *Arts in Psychotherapy, 26* (3), 185–194.

Cohen-Liebman, M. S. (2003). Drawings in forensic investigations of child sexual abuse. In C. A. Malchiodi (Ed.), *Handbook of art therapy* (pp. 167–180). New York: Guilford Press.

Cox, C. (2000). Are you assessing what I'm assessing? Let's take a look. *American Journal of Art Therapy, 39* (2), 48–68.

Crespo, V. (2003). Art therapy as an approach for working with schizophrenic patients. *International Journal of Psychiatry, 8* (3), 183–193.

Cuneo, K., & Welsh, M. (1992). Perception in young children: Developmental and neuropsychological perspectives. *Child Study Journal, 22,* 73–92.

Davies, D., Cole, J., Albertella, G., McCulloch, A. K., & Kevekian, H. (1996). A model for conducting forensic interviews with children victims of abuse. *Child Maltreatment, 1* (3), 189–199.

Deaver, S. P. (2002). What constitutes art therapy research? *Art Therapy: Journal of the American Art Therapy Association, 19* (1), 23–27.

Diamond, S. A. (1996). *Anger, madness, and the daimonic: The psychological genesis of violence, evil, and creativity.* Albany: State University of New York Press.

Farley, R. H. (2000). *Child abuse and exploitation investigative techniques* (3rd ed.). Washington, DC: Department of Justice.

Feder, B., & Feder, E. (1998). *The art and science of evaluation in the arts therapies: How do you know what's working?* Springfield, IL: Thomas.

Fincher, S. (1991). *Creating mandalas.* Boston: Shambala.

Fortune, G., Barrowclough, C., & Lobban, F. (2004). Illness representations in depression. *British Journal of Clinical Psychology, 43,* 347–364.

Fox, W. M. (1997). The hidden weapon: Psychodynamics of forensic institutions. In D. Gussak & E. Virshup (Eds.), *Drawing time: Art therapy in prisons and other correctional settings* (pp. 43–55). Chicago: Magnolia Street.

Fraenkel, J. R., & Wallen, N. E. (2009). *How to design and evaluate research in education* (7th ed.). New York: McGraw-Hill.

Freud, S. (1899/1965). *The interpretation of dreams* (J. Strachey, Trans.). New York: Avon.

Galenson, D. W. (2005). *Old masters and young geniuses: The two life cycles of artistic creativity.* Princeton, NJ: Princeton University Press.

Gantt, L. (2004). The case for formal art therapy assessments. *Art Therapy: Journal of the American Art Therapy Association, 21* (1), 18–29.

Gantt, L., & Tabone, C. (1998). *The Formal Elements Art Therapy Scale: The rating manual.* Morgantown, WV: Gargoyle Press.

Garai, J. (2001). Humanistic art therapy. In J. A. Rubin (Ed.), *Approaches to art therapy: Theory and technique* (2nd ed.) (pp. 149–162). Philadelphia: Brunner-Routledge.

Gordon, J., & Shontz, F. (1990). Representative case research: A way of knowing. *Journal of Counseling and Development, 69,* 62–66.

Groth-Marnat, G. (1997). *Handbook of psychological assessment* (3rd ed.). New York: Wiley.

Groth-Marnat, G (2003). *Handbook of psychological assessment* (4th ed.). New York: Wiley.

Gussak, D. (1997a). Breaking through barriers: Art therapy in prisons. In D. Gussak & E. Virshup (Eds.), *Drawing time: Art therapy in prisons and other correctional settings* (pp. 1–11). Chicago: Magnolia Street.

Gussak, D. (1997b). The ultimate hidden weapon: Art therapy and the compromise option. In D. Gussak & E. Virshup (Eds.), *Drawing time: Art therapy in prisons and other correctional settings* (pp. 59–74). Chicago: Magnolia Street.

Gussak, D. (2004). A pilot research study on the efficacy of art therapy with prison inmates. *Arts in Psychotherapy, 31* (4), 245–259.

Gussak, D. (2006). The effects of art therapy with prison inmates: A follow-up study. *Arts in Psychotherapy, 33,* 188–198.

Gussak, D. (2007a). The effectiveness of art therapy in reducing depression in prison populations. *International Journal of Offender Therapy and Comparative Criminology, 5* (4), 444–460.

Gussak, D. (2007b). The deviant adolescent: Creating healthy interactions and re-labeling through art therapy. In D. Arrington (Ed.), *Art, angst, and trauma: Right brain interventions with developmental issues* (pp. 132–149). Springfield, Ill: Thomas.

Gussak, D. (2009). The effects of art therapy on male and female inmates: Advancing the research base. *Arts in Psychotherapy, 36* (1), 5–12.

Gussak, D., & Cohen-Liebman, M. S. (2001). Investigation vs. intervention: Forensic art therapy and art therapy in forensic settings. *American Journal of Art Therapy, 40* (2), 123–135.

Gussak, D., & E. Virshup (Eds.). (1997). *Drawing time: Art therapy in prisons and other correctional settings.* Chicago: Magnolia Street.

Hacking, S. (1999). *The psychopathology of everyday art: A quantitative study.* Doctoral dissertation, University of Keele.

Hall, N. (1997). Creativity and incarceration: The purpose of art in a prison culture. In D. Gussak & E. Virshup (Eds.), *Drawing time: Art therapy in prisons and other correctional settings* (pp. 25–41). Chicago: Magnolia Street.

Hammer, E. F. (Ed.). (1980). *The clinical application of projective drawings*. Springfield, IL: Thomas.

Haralambie, A. M. (1999). *Child sexual abuse in civil cases: A guide to custody and tort actions*. Chicago: American Bar Association.

Harris, D. B. (1963). *Children's drawings as measures of intellectual maturity: A revision and extension of the Goodenough Draw-a-Man test*. New York: Harcourt, Brace & World.

Hays, R., & Lyons, S. (1981). The Bridge Drawing: A projective technique for assessment in art therapy. *Arts in Psychotherapy, 8* (3–4), 207–217.

Honig, S., & Hanes, K.M. (1982). Structured art therapy with the chronic patient in long-term residential treatment. *Arts in Psychotherapy, 9*, 269–289.

Jakab, I. (1969). Art and psychiatry: Their influence on each other. In I. Jakab (Ed.), *Psychiatry and art* (Volume 2, *Art interpretation and art therapy*, pp. 91–123). New York: Karger.

Julliard, K. N., Van Den Heuvel, G., & Susanne, K. (1999). Langer and the foundations of art therapy. *Art Therapy: Journal of the American Art Therapy Association, 16* (3), 112–120.

Kagin, S., & Lusebrink, V. (1978). The expressive therapies continuum. *Art Psychotherapy, 5*, 171–180.

Kaiser, D. H. (1996). Indications of attachment theory in a drawing task. *Arts in Psychotherapy, 23* (4), 333–340.

Kapitan, L. (2010). *An introduction to art therapy research*. New York: Routledge.

Kim, S. I., Kim, K. E., Lee, Y., Lee, S. K., & Yoo, S. (2006). How to make a machine think in art psychotherapy: An expert system's reasoning process. *Arts in Psychotherapy, 33*, 383–394.

Kraepelin, E. (1919). *Manic-depressive insanity and paranoia* (R. M. Barclay, Trans.). Edinburgh: Livingstone.

Kramer, E. (1993). *Art as therapy with children* (2nd ed.). Chicago: Magnolia Street.

Kwiatkowska, H. Y. (1978). *Family therapy and evaluation through art*. Springfield, IL: Thomas.

Lacks, P. (1984). *Bender Gestalt screening for brain dysfunction*. New York: Wiley.

Landgarten, H. B. (1987). *Family art psychotherapy: A clinical guide and casebook*. New York: Brunner/Mazel.

Lane, J. (1982). "Encapsulating" and "examining" schizophrenics: Proposal for treatment within a short term framework. *Pratt Institute Creative Arts Therapy Review, 3*, 49–57.

Levick, M. F. (2001). *The Levick Emotional and Cognitive Art Therapy Assessment (LECATA): Procedures*. Boca Raton, FL: Levick.

Lowenfeld, V., & Brittain, W. L. (1987). *Creative and mental growth* (8th ed.). New York: Macmillan.

Lubet, S. (1998). *Expert testimony: A guide for expert witnesses and the lawyers who examine them.* Notre Dame, IN: National Institute for Trial Advocacy.

Lusebrink, V. B. (1990). *Imagery and visual expression in therapy.* New York: Plenum Press.

Lyons, S. J. (1993). Art psychotherapy evaluations of children in custody disputes. *Arts in Psychotherapy, 20,* 153–159.

Mannarino, A. P., & Cohen J. A. (1992). Forensic versus treatment roles in cases of child sexual abuse. *Pennsylvania Child Advocate Reporter, 7* (6), 1–7.

Manning, T. M. Aggression depicted in abused children's drawings. *Arts in Psychology, 14* (1) (1987), 15–24.

Mattson, D. C. (2012). An introduction to the computerized assessment of art-based instruments. *Art Therapy: Journal of the American Art Therapy Association, 29* (1), 27–32.

McNiff, S. (1998). *Art-based research.* Philadelphia: Kingsley.

Mello, M. (2002). *Deathwork: Defending the condemned.* Minneapolis: University of Minnesota Press.

Mills, A., & Goodwin, R. (1991). An informal survey of assessment use in child art therapy. *Art Therapy: Journal of the American Art Therapy Association, 8* (2), 10–13.

Moon, B. L. (2000). *Ethical issues in art therapy.* Springfield, IL: Thomas.

Naumburg, M. (1958). *Art therapy: Its scope and function in the clinical application of projective drawings.* New York: Grune and Stratton.

Naumburg, M. (1966/1987). *Dynamically oriented art therapy: Its principles and practice.* Chicago: Magnolia Street.

Naumburg, M. (1980a). Art therapy: Its scope and function. In E. F. Hammer (Ed.), *The clinical application of projective drawings* (pp. 511–517). Springfield, IL: Thomas.

Naumburg, M. (1980b). Case illustrations: Art therapy with a seventeen year old schizophrenic girl. In E. F. Hammer (Ed.), *The clinical application of projective drawings* (pp. 518–561). Springfield, IL: Thomas.

Neale, E. L., & Rosal, M. L. (1993). What can art therapists learn from the research on projective drawing techniques for children? A review of the literature. *Arts in Psychotherapy, 20,* 37–49.

Nichols, J., & Garrett, A. (1995). *Drawing and coloring for your life.* Overland Park, KS: Gingerbread Castle.

O'Connor, T. (2006). Admissibility of scientific evidence under Daubert. Megalinks in Criminal Justice. Retrieved from http://www.apsu.edu/oconnort/3210/3210lect01a.htm.

Oster, G. D., & Gould Crone, P. (2004). *Using drawings in assessment and therapy: A guide for mental health professionals.* New York: Brunner-Routledge.

Panter, B. (1995). Preface. In B. M. Panter, M. L. Panter, E. Virshup, & B. Virshup (Eds.), *Creativity and madness: Psychological studies of art and artists* (pp. xi–xii). Burbank, CA: Aimed Press.

Prinzhorn, H. (1922/1995). *Artistry of the mentally ill*. New York: Springer.

Rabin, A. I., Doneson, S. L., & Jentons, R. L. (1979). Studies of psychological functions in Schizophrenia. In L. Bellak (Ed.), *Disorders of the Schizophrenic Syndrome* (pp. 181–231. New York: Basic Books.

Raskin, D. C., & Esplin, P. W. (1991). Statement validity assessment: Interview procedures and context analysis of children's statements of sexual abuse. *Behavioral Assessment, 13*, 265–291.

Rhyne, J. (1973/1996). *The gestalt art experience*. Chicago: Magnolia Street.

Rhyne, J. (1978). Expanding our comprehension of visual imagery. In *Proceedings of the Ninth Annual Conference of the American Art Therapy Association* (pp. 95–97). Mundelein, IL: American Art Therapy Association.

Rhyne, J. (1979). Drawings as personal constructs: A study in visual dynamics. *Dissertation Abstracts International, 40* (5), 2411B. (University Microfilm International No. Tx375–487).

Robbins, A. (2001). Object relations and art therapy. In J. A. Rubin (Ed.), *Approaches to art therapy: Theory and technique* (2nd ed.) (pp. 54–65). Philadelphia: Brunner-Routledge.

Rosal, M. L. (1992). Illustrations of art therapy research. In H. Wadeson (Ed.), *A guide to conducting art therapy research* (pp. 57–65). Mundelein, IL: American Art Therapy Association.

Rubin, J. A. (1999). *Art therapy: An introduction*. Philadelphia: Brunner/Mazel.

Safran, D. S., Levick, M. F., & Levine, A. J. (1990). Art therapists as expert witnesses: A judge delivers a precedent-setting decision. *Arts in Psychotherapy, 17*, 49–53.

Schetky, D. H., & Benedek, E. (1992). *Clinical handbook of child psychiatry and the law*. Baltimore: Williams & Wilkins.

Schneider, B., Scissons, H., Arney, L., Benson, G., Derry, J., Lucas, K., Misurelli, M., Nickerson, D., & Sunderland, M. (2004). Communication between people with Schizophrenia and their medical professionals: A participatory research project. *Qualitative Health Research, 14* (4), 562–577.

Shapiro, D. L. (1991). *Forensic psychological assessment: An integrative approach*. Needham Heights, MA: Allyn and Bacon.

Silver, R. (2002). *Three art assessments: The Silver Drawing Test of Cognition and Emotion; Draw a Story: Screening for Depression; and Stimulus Drawing Techniques*. New York: Brunner-Routledge.

Stake, R. (2000). Case studies. In N. Denzin & Y. Lincoln (Eds.), *The handbook of qualitative research* (pp. 435–454). Thousand Oaks, CA: Sage.

Stetler, R. (1999). Post-conviction investigation in death penalty cases. *Champion Magazine*. Retrieved from http://www.nacdl.org/public.nsf/o/8de19bfcaf51a7e2 852567c40050c38a.

Tanay, E. (2010). *American legal injustice: Behind the scenes with an expert witness.* Lanham, MD: Aronson.

Teneyke, T., Hoshino, J., & Sharpe, D. (2009). The Bridge Drawing: An exploration of psychosis. *Arts in Psychotherapy, 36*, 297–303.

Ulman, E. (1965). A new use of art in psychiatric diagnosis. *Bulletin of Art Therapy, 4*, 91–116.

Ulman, E. (1992). Art therapy: Problems of definition. *American Journal of Art Therapy, 30* (3), 78–88.

Ulman, E., & Levy, B. (2001). An experimental approach to the judgment of psychopathology from paintings. *American Journal of Art Therapy, 27*, 179–190.

Ursprung, W. (1997). Insider art: The creative ingenuity of the incarcerated artist. In D. Gussak & E. Virshup (Eds.), *Drawing time: Art therapy in prisons and other correctional settings* (pp. 13–24). Chicago: Magnolia Street.

USLegal.com (n.d.). Grand jury law and legal definition. Retrieved from http://definitions.uslegal.com/g/grand-jury.

Wadeson, H. (2002). The anti-assessment devil's advocate. *Art Therapy: Journal of the American Art Therapy Association, 19* (4), 168–170.